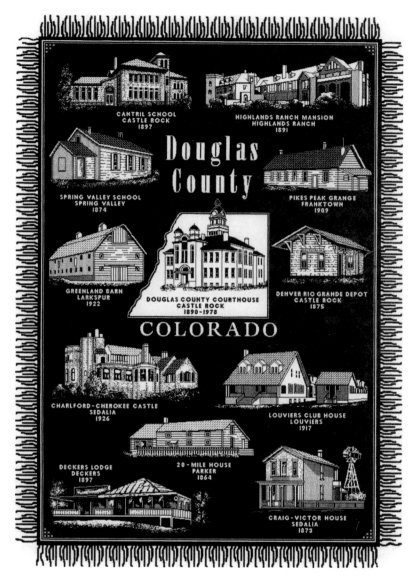

Douglas County

CANTRIL SCHOOL
CASTLE ROCK
1897

HIGHLANDS RANCH MANSION
HIGHLANDS RANCH
1891

SPRING VALLEY SCHOOL
SPRING VALLEY
1874

PIKES PEAK GRANGE
FRANKTOWN
1909

GREENLAND BARN
LARKSPUR
1922

DOUGLAS COUNTY COURTHOUSE
CASTLE ROCK
1890-1978

DENVER RIO GRANDE DEPOT
CASTLE ROCK
1875

COLORADO

CHARLFORD-CHEROKEE CASTLE
SEDALIA
1926

LOUVIERS CLUB HOUSE
LOUVIERS
1917

DECKERS LODGE
DECKERS
1897

20-MILE HOUSE
PARKER
1864

CRAIG-VICTOR HOUSE
SEDALIA
1873

Historic Douglas County Inc. created this commemorative coverlet to illustrate the historic structures of Douglas County. The purpose of the organization, according to its website is "to expand and enrich public awareness of Douglas County history through education and communication, and through support and coordination among local historical organizations and other related groups." Historic Douglas County Inc. is a nonprofit 501(c)(3) organization. *1992.001.0678.001. Historic Douglas County, Inc.*

CHRONICLES

of

DOUGLAS COUNTY

COLORADO

CASTLE ROCK WRITERS

THE
History
PRESS

Published by The History Press
Charleston, SC 29403
www.historypress.net

Copyright © 2014 by Castle Rock Writers
All rights reserved

First published 2014
Second printing 2015

Manufactured in the United States

ISBN 978.1.62619.179.2

Library of Congress CIP data applied for.

To Derald Hoffman, teacher, mentor, and friend, for his many contributions to the Douglas County community.

The mission of Castle Rock Writers is to provide education and support to aspiring and published writers in our region and beyond, through ongoing critique groups, training events, workshops and writers conferences.

CONTENTS

FOREWORD

Douglas County has been many things to many people in its rather short history.

The earliest people in the county were transitory hunter-gatherers, moving from place to place in search of food and shelter. Those early people were mobile, not entirely unlike the population today. We build more permanent structures and live less closely with nature, perhaps, and though the opportunity to hunt woolly mammoths is limited, we still want to provide for our families.

Explorers came to Colorado to see what was out here on the other side of the "Great American Desert," a phrase coined by Stephen Long, one of the earliest visitors to Douglas County. The term will be familiar to anyone who has driven through Nebraska, Kansas, Oklahoma or Texas toward Colorado, waiting for the glimpse of mountain that says "not far now." We are still explorers, looking around the next bend in the trail or over the next rise in the road for something new.

Mountain men and gold seekers came to Colorado to find their fortune, to escape the stifling cities of the east coast and to begin again. They would be amazed that this stretch of land has become one of the wealthiest counties in the United States, as our gold rushes are found in technology, entrepreneurship, financial services and real estate development.

Pioneer farmers, ranchers and homesteaders turned this land into a productive agricultural center. We try to hold on to that agricultural past, which still exists in the echoes of places not yet been planted with sprouting houses, fenced with highways and tamed into commercial centers.

A side-effect of being one of the fastest-growing counties in the United States is that new people may not feel as connected as "old timers" to what a local place is about. Projects like this one by the Castle Rock Writers connect new residents with the history of a place that may seem as if it is without a history. This project has been a labor of love for the writers. They have researched the prehistoric origins of the area, interviewed longtime residents, gathered published accounts and then pulled them all together. They have created a work of many voices but captured one story.

As one of the book's first readers, I hope you have as much fun reading it as I did.

SHAUN BOYD, ARCHIVIST
Douglas County History Research Center
Douglas County Libraries
Douglas County, Colorado

ACKNOWLEDGEMENTS

Jean Jacobsen and Alice Aldridge-Dennis, project managers

Cherie Abbott, Douglas County Emergency Management coordinator

Mike Acree, former Douglas County sheriff

G. Larry Adams, head of the Remember Our Veterans (ROV) project

Susan Consola Appleby, author

Edwin Bathke

Barbara Belt, interviewer for Douglas County Libraries

John Berry, docent at Castle Rock Museum

Shaun Boyd, archivist, Douglas County History Research Center

Janet Brunger and Bill Brunger, U.S. Army Veteran

Debbie Buboltz, author

David Casiano, former Parker mayor

Cherry Valley Elementary School staff

Joseph M. Clements

Cory Cummings

Curt Cummings

Peggy Cummings

Mike Dennis

Carol and Chris Doubek

John Evans, Parker attorney and former Douglas County state senator

Amy and Dave Flanagan

Jackie Friesen

Blake Graham, assistant archivist, Douglas County History Research Center

Danna Hamling, Larkspur Historical Society

Jim Hansmann, curator of Castle Rock Museum

Bruce Hier

Angel Horvath, president of Castle Rock Historical Society

Joseph "Chip" Howard Jr.

Mary Ellen Howard

Greg Howard

Tim Howard

Jake Jacobsen

Dorothy Kelly, board member of Castle Rock Historical Society

Evelyn Kriek

Leeds and Jan Lacy

Helen and Joseph Lenda

Angie De Leo, executive director, Castle Rock Museum

Sue Luxa

Keith Mathena, Douglas County Emergency Management deputy

Kaye Marsh

Rosario Menocal, president of American Federation of Human Rights

Betty Meyer

Ann Milam

Kenneth A. Miller

Tim Moore, Douglas County Bureau chief

Jack Muse

Stevie Ramsour Nelson

Bev Higginson Noe

Bill Noe, Larkspur Historical Society

May Palmer, Parker Area Historical Society

Robbie Hier Person

Steve and Gay Ramsour

Dave Rhodus

Pat Salazar

Alice Salvador, wife of George Salvador

George Salvador, U.S. Army veteran

Larry Schlupp

Libby and Dennis Smith

Adam Speirs, archivist, Douglas County History Research Center

Tony Sperling, Douglas County deputy sheriff

Sheila R. Stephens

Bob Terwilleger

Lora Thomas, current Douglas County coroner

Gordon Tucker, PhD

Laurie Marr Wasmund

David Weaver, Douglas County sheriff

Sandra Whelchel, Parker Area Historical Society & author

Lou Zoghby, U.S. Army veteran

WHEN DINOSAURS RULED

by Derald Hoffman

S eascapes viewed from property in Douglas County, a tropical rainforest covering the plains, lava flows and Jurassic Park in your back yard? These scenarios are not just possible: they are probable. Many residents of Douglas County will be thrilled to know that, at one time in the prehistory of the county, the area was beachfront property.

Douglas County's prehistoric story began much like the rest of the places on planet Earth. About 13.8 billion years ago, a tremendous explosion occurred somewhere in space. Whether matter was created at that time or whether matter blew apart, no one knows for sure.

During the next few billion years, the universe filled with billions of galaxies with billions of stars in each galaxy. According to Terence Dickinson in his book *The Universe and Beyond*, the vast Milky Way galaxy consists of over 200 billion stars. It would take 80,000 years just to travel across the Milky Way, and this galaxy is only one of 100 billion galaxies.[1]

Planet Earth was once part of a huge mass of gas and other hot materials, which included stars, moons, planets, asteroids and many other objects. The mass hurtled through space. Earth took billions of years to cool down and finally become a place where life could survive. The right amount of nitrogen, oxygen and carbon dioxide was needed to sustain life.

Some of the oldest rock in Douglas County is called "Pike's Peak granite,"[2] and the Rampart Range in western Douglas County consists of it. This is between 1.4 and 1.7 billion years old. Some of this granite is also

in Roxborough State Park. The oldest ridges in the park are the granite foothills of the Rocky Mountains.

Life began in the ocean with small creatures that evolved into larger ones. During the Cambrian period, 590 to 505 million years ago, small creatures as simple as earthworms, mollusks, corals and arthropods multiplied. Millions of years later during the Devonian period, jawless fish,[3] cartilaginous fish and sharks entered the picture. Not until the late Permian did amphibians, mammal-like reptiles and primitive anapsids develop.

The dinosaurs entered the scene during the Triassic, Jurassic and Cretaceous geological periods. The Triassic period, 248 to 213 million years ago, was named by the Germans because the rocks of that time were identified in three separate sequences. The Jurassic period, 213 to 144 million years ago, was named after the Jura Mountains, which separate France and Switzerland. Lastly, the Cretaceous period, 144 to 65 million years ago, was named after the Latin word for "chalk," the most prominent rock type found in southern England. Dinosaurs first appeared 220 million years ago during the Triassic and died out about 65 million years ago at the end of the Cretaceous.[4]

Before the Pike's Peak granite was formed, large pockets of molten rock below the Earth's crust pushed their way into older rocks and solidified. Little is known about the next one-half billion years, but scientists believe tropical seas surrounded islands made of granite.[5] About 543 million years ago, the Precambrian period ended. Igneous and metamorphic rocks were dominant around the town now known as Castle Rock.

The Lyons Formation can be seen in Roxborough, with sandstone that dates back to about 280 million years ago, when Douglas County appeared to be a sand planet. This formation gets its name from the town of Lyons, Colorado.[6]

Around 150 million years ago, during the late Jurassic era, dinosaurs lived in Douglas County, with many racing along an area in Roxborough State Park called "the Dinosaur Freeway." Later, the county was a seafront beach along an inland sea that stretched from Texas to the Yukon. Still later, the entire Front Range was a tropical rainforest. That all changed approximately 37 million years ago when Mt. Princeton, near present-day Buena Vista, erupted and showered Douglas County with twenty to thirty feet of superheated ash.[7]

About five hundred species of dinosaurs lived throughout the world,[8] and more are being discovered yearly. When dinosaurs first appeared, all landforms were together in a huge continent called Pangaea. Through the movement of

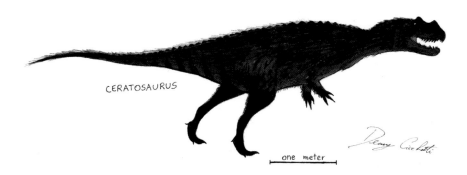

Ceratosaurus, a theropod, was a meat eater that lived in the region where Colorado is located today during the Tithonian stage of the late Jurassic. *Artist Danny Cicchetti on Wikimedia Commons.*

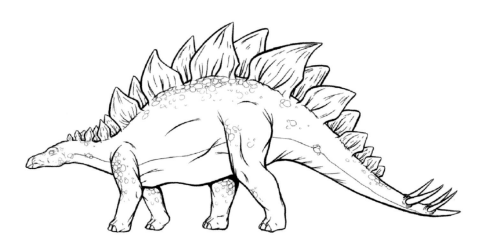

Stegosaurus is the "state dinosaur" of Colorado. This plant eater had rows of plates and spines along its back and tail. *Jean Jacobsen Collection.*

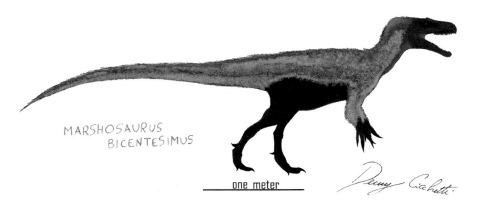

MARSHOSAURUS
BICENTESIMUS

one meter

Marshosaurus, a theropod, was another meat eater that lived in the region during the Tithonian stage of the late Jurassic. *Wikimedia Commons.*

tectonic plates, the continents broke apart, and they continue to move today. The process occurs very slowly, so it is hardly noticed. The United States of America drifts away from Europe by about four inches per year.

The next few hundred million years found Douglas County sinking into mud and lime at the bottom of a sea. Later, the sinking stopped, and land rose up and became surface again. When the sedimentary rock eroded away, the ancestral Rocky Mountains emerged.[9]

Around this time, the Fountain Formation appeared, evident in several places along the Front Range, including many outcroppings in Roxborough State Park, The formation gets its name from Fountain, Colorado, where it was first noticed. Its red color is due to iron oxide.[10]

Millions of years later, the Triassic period ended and again, in Roxborough, the Lyons Formation could be seen. At this time, the shoreline was slimy.[11]

Moving forward in time to 150 million years ago, the Morrison Formations occurred in Douglas County. They are often called the Long Neck Meadows as dinosaurs such as diplodocus, stegosaurus, triceratops, apatosaurus and many other theropods (meat eaters) and sauropods (plant eaters) were here at that time. As an aside, stegosaurus is Colorado's state fossil.[12]

To visualize the time of the dinosaurs, students of history can travel back in time through the following creative story. The setting is near present-day Roxborough Park, which was then a flat landscape. Imagine a steamy mist on an early morning:

Ceratosaurus woke up, stretched and decided he was very hungry. This Morrison Formations meat eater looked like a "horned lizard." He was eighteen feet tall when he stood on his powerful back legs. He had short strong arms and each hand had four fingers. His large teeth jutted out—too big for his mouth and scary to his prey. With the horns on his head, he looked like a medieval dragon.

Nearby he could see some marshosaurus theropods, similar to himself about sixteen feet high when on their back legs. He quickly left and headed for an area of lush vegetation, where he hoped some sauropods would be having their breakfast of ferns among the trees. He cruised down the "Dinosaur Freeway" approaching speeds of fifteen miles per hour. No speed limit slowed him down; the open trail was well traveled.

Ceratosaurus saw tall figures through the mist so he slowed down to study their forms. A family of diplodocus dinosaurs munched away on the juicy leaves of trees and ferns. Now, it was time for his breakfast. If only one of them would rear up on his hind legs, he could rush in for the kill by attacking the vulnerable underbelly, as he had many sharp teeth and claws that could rip and tear.

Suddenly a family of marshosaurus approached from behind, so he moved off the highway to let them by. They, too, were looking for a tasty meal, and although they were slightly smaller, they were active hunters, with sharp curved teeth that had serrated edges. They had long heads and powerful front arms. When they saw the diplodocus family, they rushed in for the kill, choosing one of the smaller family members. They had learned from past hunting that it was difficult to bring down an eighty-nine-foot, fully grown diplodocus—better to have a smaller meal than no meal at all. As was hoped, the rest of the family members, instead of staying and fighting a large number of predators, lumbered off as fast as possible.

The kill happened fairly easy. The diplodocuses' heads and tails were well balanced, but in a fight, they were a bit awkward. With one well-chosen bite in the neck, the fifty-foot dino went down with a crash. The marshosaurus family tore off huge chunks of flesh, in the midst of devouring a considerable amount when an allosaurus dinosaur walked confidently onto the scene.

The allosaurus had been nearby, inhaling the scent of warm blood. A theropod, thirty feet tall when standing on his back legs, was a hunter and scavenger. He had massive hind legs, an S-shaped neck and jaws that could bulge sideways to tear off great chunks of meat. His sharp, serrated teeth with two-inch-long crowns helped him cut into the meal.

This dino's short heavy arms, with three fingers on each hand, extended into ripping claws, which were each six inches long. Allosaurus regularly hunted the largest sauropods.

The marshosaurus family, numbering only three, grabbed one last hunk of meat and decided it was time to leave so as to avoid a fight with their larger cousin twice their size. Ceratosaurus, watching from a distance, had hoped that when the marshosaurus family had their fill, there might be some left for him.

Such is a spring morning in the life of late Jurassic dinosaurs as they lived and died in what later would be Roxborough State Park in northwest Douglas County.

Around 100 million years ago, Colorado had an eastern coast of Dakota sandstone. Dinosaur tracks run through the Dakota Hogback in Roxborough State Park, with broad-leafed trees, conifers and herbaceous ferns dotting the landscape.[13]

During another sea invasion around 70 million years ago, Castle Rock was submerged under about six hundred feet of water, part of a sea that stretched from Texas to the Yukon. This sea was full of mosasaurs (giant lizards) and sharks. Filling the sky, pterosaurs spread their wings of twenty-five to thirty feet. Over 1,100 skeletons of these flying lizards have been found in Kansas's lakebeds. Their bones were hollow, which made them light, but they were still very strong. They could probably soar on the wind currents much like present-day raptors.[14]

At the end of the Cretaceous period, about 66.5 million years ago, a giant asteroid the size of Denver hit the Yucatán Peninsula of Mexico. This sent up such a mass of debris, it blocked the sun for a considerable time. The resulting lack of vegetation put an end to the last of the dinosaurs.[15] According to Stephen J. Gould, an atheist biologist who taught at Harvard, if this had not happened, humans may not have arrived on Earth. Gould's reasoning was that the large lizards had dominated the planet for over 155 million years. Mammals would not have been able to survive, but after the extinction of the dinosaurs, mammals began to develop on planet Earth. Eventually the humans arrived.

By 66 million years ago, the Rockies had pushed up through the inland sea and land emerged again in Douglas County, with a tropical rainforest arriving almost two million years after the asteroid caused the extinction of the dinosaurs.[16] The area enjoyed one hundred inches of rain per year. In 1994, Steven Wallace, a Colorado Department of Transportation

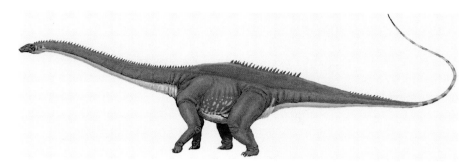

Diplodocus, a sauropod, was a plant eater that lived in the region during the Tithonian stage of the late Jurassic. *Wikimedia Commons.*

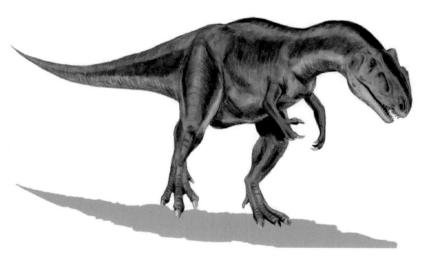

Allosaurus, a theropod, was a meat eater that lived in the region during the Tithonian to Kimmeridgian stages of the late Jurassic. *Wikimedia Commons.*

paleontologist, found fossils of one hundred species of plant leaves near the railroad flyover in Castle Rock.[17]

Douglas County was a red dirt world 55 million years ago, a subtropical rainforest, with crocodiles in the local rivers and numerous aquatic plants lining the shoreline. Evidence of this is found in layers of colored clay rings near present-day Parker. Local clay deposits provided the bricks for Coors Field, built in the early 1990s.[18]

Mt. Princeton erupted about 37 million years ago, and the superheated ash and lava traveled some ninety miles to the area around Castle Rock. A blanket of ash cooled to become solid rock twenty to thirty feet deep. All living creatures were roasted alive, and many fossils have been found revealing what kind of animals lived at that time.[19] This influenced Castle Rock, as the solid rock would be called "rhyolite." This distinctive hard rock would create a quarry industry that would last from 1880 to 1905.

The next major event occurred around 34 million years ago. Severe flooding caused massive erosion around Douglas County with river channels cutting through the layers of welded ash.[20] The granite kept intact some of the rhyolite, but a great deal of softer rock washed away as far as New Orleans. Today, in Castlewood Canyon State Park, the conglomerate of rocks that washed down to this area is still visible.

Making a big leap from millions of years ago to about sixteen thousand years ago, Douglas County entered the period of the mastodons, saber-toothed tigers, giant sloths, small horses and mammoths, along with people.[21] An area near Roxborough State Park called Lamb Spring has been excavated, and many species of mammoth were found. One mammoth was dated to thirteen thousand years ago.[22] Paleo-Indian hunters also used this site.

Paleo-Indian hunters also used caves in Castlewood Canyon State Park,[23] with evidence of organized hunting for large bison. Their arrowheads, cutting and scraping tools and spear points have been found in archaeological digs along with mammoth bones. Later, this area became the home of the Arapahoe and Cheyenne Indians. The Utes from southwest Colorado, the Kiowas and Sioux also journeyed through the area at times. They were probably unaware that, before their presence, the land was covered in seawater or rainforests or was inhabited by gigantic creatures that roamed the earth in search of prey.

2

PALEO-INDIAN HERITAGE

by John Longman

What was it like in Douglas County when its first humans showed up ten to twelve thousand years ago? The last ice age had ended, and the high mountains to the west had eroded from a fifteen- to twenty-thousand-foot plateau the height of the current Rocky Mountains. The average temperature was ten degrees Fahrenheit colder, and the climate was wetter. Large animals such as saber-tooth tigers, giant sloths, rhinoceroses, camels, small horses, mammoths and mastodons roamed the area. Smaller animals like bobcats, cougars, foxes, coyotes, bears, antelope, deer, elk and bison (American buffalo) frequented the area, too. Game was bountiful, but sometimes the conditions were harsh even for accomplished hunters.

Paleo-Indians were hunter-gathers who followed animal herds, which they killed for their meat. They were the first peoples who entered, and consequently inhabited, the American continents during the final glacial episodes of the late Pleistocene period.[24] Their name, Paleo, actually comes from the Greek word *palaios*, meaning "ancient." They inhabited the southwestern United States and northern Mexico between ten and forty thousand years ago. They are known for inventing spears with stone points that could be thrown by using an atlatl. They used animal skin and plants for clothing.[25] As they pursued the animals, they would set up open campsites or use caves, when available. The requirements for their encampments were proximity to water, game and shelter, such as caves.

THE LONG TREK TO, AND OFTEN, THROUGH DOUGLAS COUNTY

How did these humans get here and where did they start their journey? Based on evidence of climate conditions and analysis of the teeth found in the remains of ten- to fifteen-thousand-year-old skulls, they came from present-day Asia. The reader can imagine coming to Douglas County before roads, without maps and carrying everything on one's back.[26]

What compelled these travelers to come here? Scholars can only speculate, but it was probably because they were following herds of game animals. A group of Asian people may have crossed the Bering Land Bridge, continued into what is now Alaska and eventually made their way deep into the continent. The estimated entire human population of the earth at that time was five million people.[27]

PALEO-, ARCHAIC AND LATE PREHISTORY INDIAN SITES

Scientists and archaeologists discovered several Paleo sites in Douglas County. At Lamb Spring in northwest Douglas County, they found scattered evidence of human habitation along with the bones of many animals such as camels, mammoths, horses, sloths, llamas and wolves. This evidence dates back to between eight and fifteen thousand years ago. The fact that significant evidence exists leads one to conclude the Paleo-Indians spent some time here. However, they probably did not impact the land as much as twenty-first century inhabitants do because of their low numbers. Man-made stone implements are scattered within the Lamb Spring site along with the bones of animals. Evidence of man-made kills is conclusive. However, the entire site, forty acres, is not by any means fully excavated or explored.[28]

Another site is the Franktown Cave, where East and West Cherry Creeks merge and flow through rolling hills and meadows to steep-walled canyons. The creek area provided a permanent source of water and many other resources needed by the people to survive, including, food, shelter and wood for cooking and heat.[29] The rocky outcrop furnished stone for making tools. The cave, the largest rock shelter documented in Douglas County, is naturally divided into upper and lower areas. The lower area yielded the most artifacts,

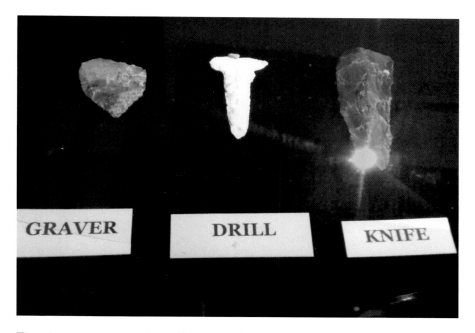

These items were excavated near Franktown, Colorado. Drills were used to bore holes through wood, bone or leather. Gravers had a small sturdy point used for boring holes in delicate materials such as shell. *Jean Jacobsen Collection.*

which consisted of animal hides, wood, stone tools, ceramic artifacts, fiber and corn. Approximately four thousand artifacts were found between 1942 and 2003. Some of the artifacts include weaving tools, a moccasin, woven yucca sandals, a rabbit fur robe, a sinew net, digging sticks, arrow and atlatl fore shafts and other items made of bone and wood.[30] Occupation of the cave began about 6,600 BC.[31]

Three other recorded prehistoric sites exist in Douglas County: Bayou Gulch near Parker, Helmer Ranch near Waterton and Roxborough State Park Archaeological District. Explorers and hikers who find a site they believe to be Paleo-Indian, Archaic or prehistoric Native American, are asked to not disturb it, but to contact the forest service, the sheriff or the state archaeologist. The site may be part of a human burial, sacred to the Native Americans. Large public works developments often result in the discovery of ancient Indian habitation. Southwest of Parker, Colorado, is the 1,140-acre Rueter-Hess Reservoir and Frank Jaeger Dam located in Newlin Gulch, a tributary of Cherry Creek. This project will supply water

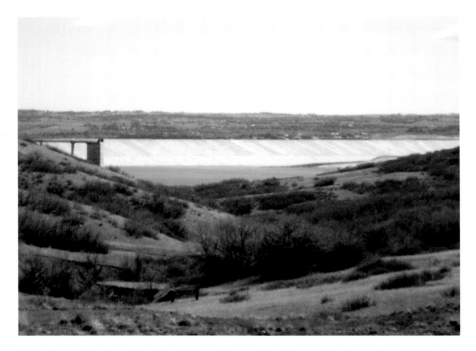

This photo, taken from Hess Road, shows Rueter-Hess Reservoir in the spring of 2014. *Jean Jacobsen Collection.*

for Parker and Lone Tree communities. During the Environmental Impact Study by Centennial Archaeology, Inc., two large Indian habitation sites were uncovered. The URS Corporation, a leading provider of engineering, construction and technical services, discovered, excavated and analyzed a smaller spring and summer campsite.

Three sites were identified and named: Hess, Oeskeso and Open Camp. At the Hess and Oeskeso sites, tools and ceramics were found, along with plants and animal bones, which indicate the site was occupied from early spring to late fall. Evidence of basin hearths and roasting pits were found. In addition, the Oeskeso site had storage pits. Plant materials of cattail and biscuitroot, along with pine nuts and acorns, suggest a nice variety in the inhabitants' diet.

Gordon C. Tucker, Jr., PhD gave a lecture on February 11, 2014 for the Parker Area Historical Society at the Parker Senior Center. He presented URS's findings of the spring and summer campsite. The site was inhabited over a seven-thousand-year time frame with periodic gaps of up to one

thousand years, likely due to climate change. By analyzing the materials found at the site, the company determined the trading range between the sites was approximately three hundred miles, which extended from northern Wyoming to New Mexico and Texas. Various types of corn and types of rocks found at the location illustrate a wide trade network. Even though the site was near a small creek without a lot of fish, numerous fish bones were scattered over the area. The site also had a wide variety of animal bones, such as those of elk, deer and rabbits. There was also evidence of a wide-ranging diet, including corn, squash, native seeds, berries and native plants.[32]

ORAL HISTORY

David Creed is a member of the Tlingit Indian tribe of Alaska. The tribe is known for valuing kinship, emphasizing art and spirituality and orally passing on tribal stories. *John Longman Collection.*

The legacy of these early people can be found in the oral history of many tribes. David Creed, a member of the Tlingit Tribe from southern Alaska, tells stories of the migration across the Bering Land Bridge and the exploration of the west coast of Alaska.[33]

The Utes claim to be the 10,000-year descendants of the Paleo and Archaic Indians. There are probably as many stories about the creation of mankind as there are groups and tribes in this world, and the Utes are no exception. This is one of their stories. Before the animals were forced to not speak, Coyote (the Trickster) was asked by God to take a sack of sticks to a sacred valley but was told to not look inside and only open the sack when he reached the sacred valley. Coyote, being young, curious, rebellious and out of sight of God, almost immediately opened the sack and looked inside. Immediately, most of the contents of the bag ran out. In the bag had been all the peoples of the Earth. Only the Utes obediently remained in the bag and were set free in the sacred valley. Upon Coyote's return, God asked

him what had happened. Coyote told him. God told Coyote that henceforth, as punishment, he would have to scavenge for food after dark and travel on all fours, never to speak again.[34]

Although the Paleo world was at times harsh and unforgiving, the people survived to tell their stories and pass on their survival skills to other generations. As the trading areas grew in size and as interactions between various tribes increased, cross-cultural marriages took place. Assimilation was slow, but over time, the traditions and practices of separate tribes blended into new ways for the next generation.

3

NOMADIC TRIBES AND EARLY EXPLORERS

by Jean Jacobsen

Nomadic Tribes in the 1500s

According to Ute Indian folklore, the Utes have inhabited the mountain areas of the southern Rocky Mountains and present-day Douglas County for thousands of years. This legend would make these Native Americans the oldest continuous residents of the area.[35] The word *ute* means "land of the sun."[36]

The Ute tribe was divided into bands that usually occupied separate hunting grounds, with the bands vying among themselves for living and hunting areas. The people favored mountains and foothills in the spring and summer for their living areas, and low-lying canyons in the winter. Between seasonal camps, they traversed a range of about four hundred miles.[37] They relied heavily on local resources and hunted game such as deer, elk, bears and sheep. They supplemented this game with bison obtained on annual hunting trips to the Plains. Roots, seeds and berries provided variety, depending on the season.

The people processed hides from animals to use them for clothing and shelter. They constructed two types of shelters. "Wicki-ups," the earliest shelters, were made from poles and brush, but they were not easily moved. As the tribes interacted with the Plains Indians, they adopted the use of tepees, making them from long poles covered by hides. Tepees were much more portable.

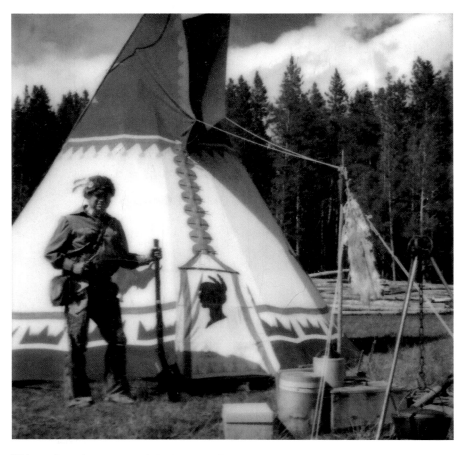

This modern-day tepee made in the style of Plains Indians is used by historic reenactors of the "mountain men" era. *Jean Jacobsen Collection.*

The Indians made their clothing from buckskin and deer hide. Men wore shirts and long pants during cold months, and they sported loincloths with vests during summer. Sometimes, they went bare-chested in good weather. Women fashioned dresses made of buckskin, with short capes covering the shoulders, cutting and sewing the dresses from two deer hides and the capes from the forelegs of animals. They attached a series of rawhide ties across the front of the dresses at knee height. If the women were working in a stream or river, they could tie up their dresses to keep them dry.

The women used animal hides with the hair left on them to make outerwear for the cold months. They crafted their moccasins from elk or

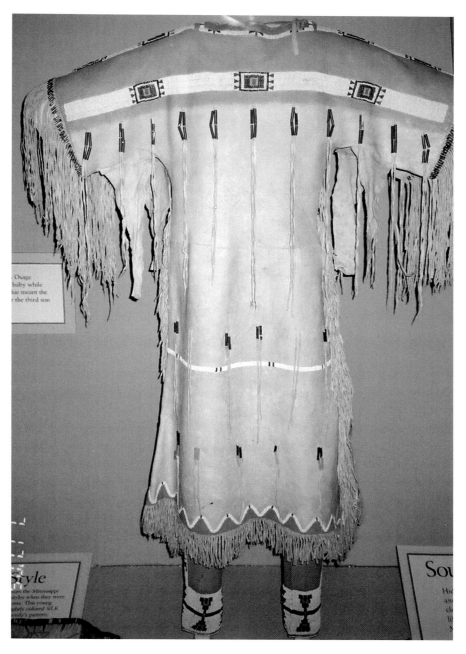

This beaded, buckskin dress is made in Plains Indians style. Rawhide ties could hold up extra material during daily chores. *Jean Jacobsen Collection.*

bison hide, which were more durable than other animal hides. Wrapping the hide around the foot and covering the toes, they then secured the hide around the ankle with a strip of rawhide. During cold months, rabbit or mink pelts made into leggings provided warmth for the legs. The women decorated clothing with geometric designs, painted on using their fingers or tools. Husbands would give their wives elk teeth to sew on their dresses, with each animal providing only two. The more teeth displayed, the higher a woman's standing was in the tribe.

The core of community life happened in multifamily bands who stayed together most of the year. The bands were kinship based. The men were polygamists, having more than one wife. All members of the Ute society played an important role from the grandparents and elderly aunts and uncles who provided childcare to the older siblings who had chores to do. Girls assisted their mothers in the gathering and preparation of food. They learned about the plants that surrounded them and their various uses for seasoning and preserving the hides. Boys learned to make bows and arrows and hunted small game such as rabbits and birds.

The Utes maintained a delicate balance between keeping the band large enough to protect against raids from other bands and small enough to have enough food resources to feed everyone.

Work was gender-based. The women processed hides for clothes and shelter. Women were also responsible for gathering and preparing food, making clothes and moving and erecting their homes. Men were responsible for making weapons and hunting for food. After the Spanish explorers made contact with the natives, horses became part of their culture and men took care of the animals, as well. The tribes considered horses a gift from the gods. They made raids on other bands to acquire them. These raids were also a way for the men to show their leadership ability and bravery, attributes valued in the community.

The Utes' religious beliefs revolved around nature, with animals being their central gods. They believed that people were closely related to the bear. In the spring, they would gather for the annual Bear Dance followed in the summer by the Sundance. Not only were the get-togethers a time for religious ceremonies, but they were also a social time. Courting was a very popular activity during these gatherings. Today these gatherings are known as powwows.

Other tribes lived and thrived in this area. Cheyenne and Arapaho Indians occupied present-day southeastern Colorado before being displaced by Utes and Comanches. Other bands of Pawnees occasionally ventured

into the Plains. The Plains Indians were dependent upon bison for food, clothing and shelter, as much as the mountain tribes were on wild game. Their annual gatherings involved large-scale hunts. Even after the official gatherings were finished, separate bands would continue to hunt on their own to stock up on food and hides for the coming season.[38]

The American Indians and their traditional way of life were never the same after the Spanish explorers entered their world, bringing horses but also disease and conflict. In addition, the never-ending flow of Anglo-European and American adventurers who followed changed their world even more dramatically.

THESE CONTESTED LANDS

The explorers from Spain and France that arrived in the area bestowed Spanish and French names upon many towns and rivers, in honor of their countries. Examining a timeline of the arrival sheds light upon the impact of these two cultures.

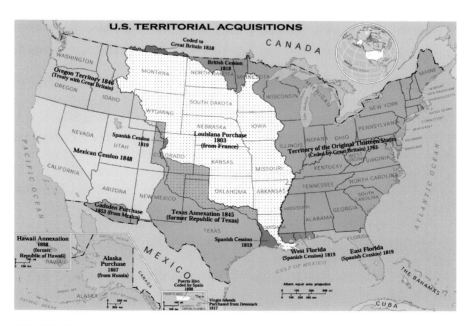

This *U.S. Territorial Acquisitions* map (1700s–1800s) shows lands claimed by United Kingdom, Spain, France and the United States. *Jean Jacobsen Collection.*

Spanish explorers, lead by Francisco Vásquez de Coronado in 1540, were thought to be the first people of European descent to arrive in what is now the southwestern United States. They had two objectives—to claim new territories for Spain and to find the fabled "City of Gold." They introduced horses to the native people, who looked at horses as gifts from heaven and called them "magic dogs."[39] These new people did not respect the land they trod upon, trying to impose their European ways of government, culture and religion on the native peoples. They left death and disease in their wake. They even captured some natives, taking them to Mexico as slaves. The explorers did not succeed in claiming territory for their mother country or in finding gold: they returned to Mexico City in disgrace.

France entered the scene in 1682 by way of Robert Cavalier, Sieur de La Salle, who claimed the Mississippi River drainage for France, completely ignoring the claims of Native Americans. He named the area "Louisiana" for King Louis XIV. At that time, the region "Colorado" was part of the Territory of Louisiana while the southern part around Santa Fe belonged to Spain.

Finally, on a foray into the area in 1706, Juan de Ulibarri claimed the Colorado Territory for Spain. While the Spanish explorers celebrated the conquest, Indians rebelled against the intruders. A new rival, France, found its way into the mix.

One hundred Spanish troops marched to the plains of Colorado in 1720 to assert their claim on the area and send the French back north. The Spanish were blindsided by an ambush from the Indians along the South Platte River and that ended Spain's rule in the eastern part of Colorado.

With Colorado now in French hands, more explorers entered the state. Trade between the French and Indians was friendly, with several Frenchmen even marrying Indian women. These explorers were fur trappers and traders. Some belonged to highly organized companies like the American Fur Company or the Hudson Bay Company. Others were independent operators. Two such trappers, French explorers Paul and Pierre Mallet, named the Platte River as they tried to ford it in a flat-bottomed boat called a "platte." The Mallet brothers were the first to chart the route through Colorado, and the brothers' trail evolved into the present-day route of the Santa Fe Railroad.

In 1754, war between France and England came to a halt, with England the victor. France gave up to Spain all the land they had claimed, as Spain was England's ally. Now Spain owned all of Colorado as well as all the French territory in the colonial United States—at least, until 1800, when Napoleon pressured Spain to give the Great Louisiana Territory back to France.

WESTWARD EXPANSION

By the year 1800, the United States, centered on the East Coast, experienced a high birth rate as well as increases in population due to immigration. Agriculture was the primary economic base, and large families were needed to work the farms. The U.S. population grew from around five million in 1800 to more than twenty-three million by the middle of the century, necessitating expansion into new territories to accommodate the growth.

The United States completed the Louisiana Purchase in 1803, opening the door to westward exploration. President Thomas Jefferson commissioned Meriwether Lewis and William Clark to find a fast route to the Pacific Ocean. The president and the War Department wanted detailed information about the newly purchased Louisiana Territory. It was only natural for them to look to their military personnel for persons who would lead an expedition. This first American expedition, also known as the Corps of Discovery Expedition, journeyed into new land across what is now the western portion of the United States. Departing in May 1804 from St. Louis, the expedition made its way westward on the Mississippi River, over the Continental Divide and to the Pacific Coast. Other survey parties followed suit, participating in explorations of Colorado.

Zebulon Pike was the first choice of President Jefferson and the War Department to explore Colorado. He was twenty-six years old in 1805, when he was commissioned for his first expedition west to the central Plains and the source of the Mississippi River. St. Louis was a well-established "jumping off" place to get to the new frontier. With twenty soldiers, Pike set sail up the Mississippi River. He was to chart the course of the river, note its tributaries, locate rapids and falls and describe in detail the country on both sides of the river. He was directed to visit the Indian nations and make treaties with them. This trip was deemed mostly successful, and thus, Pike was urged by his commander to make another journey.[40]

Pike was then sent to explore and document the southern portion of the Louisiana Territory, find the headwaters of the Arkansas and Red Rivers and assert the authority of the United States government over the Indian tribes along the way. He recorded the discovery of what is now called Pike's Peak, although he never ascended it on that or subsequent trips.

Having mistakenly wandered into Mexico, present-day New Mexico, Pike and his party were captured by the Spanish and imprisoned for a time,

later to be released on the Louisiana border. "One hundred years later, some evidence came to light that Pike intentionally wandered into Spanish Territory. His commanding officer was a spy for the Spanish. They treated Pike and his men very politely, though they did confiscate his journals."[41]

Meanwhile, the nation continued to grow and pioneering families pushed farther westward into the still thousands of acres of uncharted and unexplored territory.[42]

Stephen Long was the next explorer of note to venture into Colorado and Douglas County. Having been commissioned a second lieutenant in the Corps of Engineers in 1814, he joined the division called Topographical Engineers in 1816. He conducted several expeditions north and south of Pittsburgh while the government debated the merits of additional westward treks. The government took three years to agree to fund an expedition to further explore the western territories

In the summer of 1820, Long and his company of scientists camped at the present site of Roxborough Park after surviving hundreds of miles of open prairie, Indian attacks, temperature changes and several side trips.[43] They turned south and marched along the foothills. They were able to see the mountain that Zebulon Pike had sighted during the winter of 1806–07, and three members of the Long party ascended the peak. The leader of this climb was James Duncan Graham, and Captain Long named the mountain James Peak, stating such in the expedition journals. However, today it is known by the name of the explorer who first discovered it, Zebulon Pike.

The exploration team recorded scientific data about the plants and animals of the region, Indian language vocabularies, astronomical and meteorological observations and maps in their journals. These were published in 1823, and the American people were able to read the official publication, *Expedition from Pittsburgh to the Rocky Mountains*. The account painted a picture of what would be called the "Great American Desert," a dry, desolate place that was unfit for cultivation. Maps of the day showed, between the Missouri River and the Rocky Mountains, a long and broad white blotch with the words "The Great American Desert—Unexplored." Congress declined to send out more government-sponsored expeditions. During this time, the mountain men gleaned the riches of the wilderness from the fur trade.[44]

MOUNTAIN MEN

The Plains and the Rocky Mountains awakened to newcomers from 1810 through the 1840s. Their story is at the very heart of the nation's history. The fur traders, trappers, beaver-hunters or "mountain men" as these adventurous men were called, ventured into this new frontier where few other men dared to travel. Danger was their daily companion as they wandered through the far-flung reaches of the West, as free as the wind. They preceded the gold-seekers, missionaries and even cattlemen, opening pathways to the West Coast.

The "mountain men" were typically clad in buckskin pants and shirt and a fur hat of beaver, skunk or coyote. They wore lightweight coats of canvas or outerwear fashioned from Hudson Bay blankets or animal pelts, depending on the season. Footwear was moccasins or heavy boots for winter.[45] Besides their traps, they each carried a Hawken rifle and Bowie knife, commonly referred to as a "scalpin' knife."[46]

The American Indians, the mountain men and the explorers followed wild game trails as they hunted and explored the wilderness. One such trail

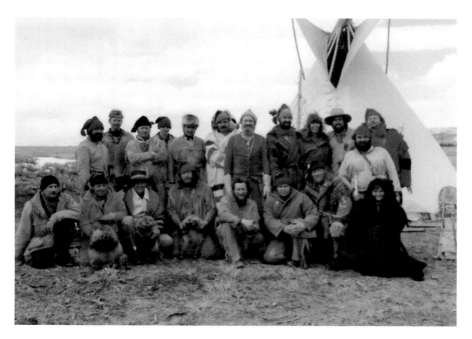

This 1979 photo shows historical reenactors portraying members of Rocky Mountain Fur Company. *Lower left*: Ed Tapp and Bob Smith (others unknown). *Jean Jacobsen Collection.*

The beaver-pelt hat shown is a modern reproduction of a hat made from beaver pelts and worn by mountain men in the 1800s. *Jean Jacobsen Collection.*

would later be known as the Trapper's Trail and would be used by gold seekers and wagon trains as the westward movement continued.

Mule trains from St. Louis used these trails to get supplies into the remote wilderness areas frequented by the mountain men. These trails became widened roads, later used by wagon trains, as settlers hungry for undeveloped land made their way west.

Early supply trains met the mountain men in the spring at a designated time and place in the Rocky Mountains. These gatherings were called "rendezvous." The trappers sold their furs to the traders in return for supplies

for the coming year, and the traders took the furs to St. Louis or Taos for transport east. Some rendezvous attracted as many as 450 to 500 trappers and Native American Indians.[47] Huge amounts of liquor were consumed at these gatherings, which also boasted competitions for shooting, knife and hawk (tomahawk) throwing, as well as featured storytelling. The mountain men thrived due to the high-income earnings of the fur trade. Gentlemen back east valued beaver pelt hats, and the ladies coveted coats and short capes of the precious skins. Among the estimated three thousand men who made a living trapping beaver for their pelts are some famous people, such as Jedediah Smith, William L. Sublette, Thomas Fitzpatrick, Kit Carson and Jim Bridger. Each has his own story of success and fame or failure.

By the 1840s, the fur industry had faded due to overhunting and reduced demand for beaver pelts. The silk trade made an inroad into fashion in Europe, and the famous beaver top hats gave way to ones of silk. Then unemployed, many mountain men became Army scouts, guides to government-appointed explorers or wagon train masters guiding others through the lands they had opened up.

Explorers launched more expeditions to establish routes that pioneer settlers could follow. People pressed on into the West, sometimes having to build forts or settlements to secure the frontier land from the now hostile natives. Cultures collided in a way they had not in any time in the history of the nation, with a clash of lifestyles between the seminomadic Native Americans and landowning Euro-Americans. The uneasy interweaving of the two worlds changed the course of history. Westward expansion was inevitable, with nearly four million people moving to the western territories between 1820 and 1850.

4

OPENING OF THE WEST

by Jean Jacobsen

By 1840 Americans knew much about the continent thanks to adventuresome mountain men and government-sponsored expeditions. The mood of the country had changed. Politicians and journalists alike proclaimed the virtues of expansion, encouraging the United States to follow its Manifest Destiny. Thus the stage was set for the next great explorer.[48]

John C. Frémont spent more time in Colorado than any other explorer. Nicknamed "the Pathfinder," he traveled the West and made Manifest Destiny practical and real to citizens. "He did little original exploring, and mostly followed trails that had already been established. His skill lay in documenting what he had seen, publishing narratives and maps based on his expeditions."[49] He made five trips into the West between 1842 and 1854. For his reports, he used the talents of his wife, Jessie Benton Frémont, daughter of Senator Thomas H. Benton of Missouri. Benton had a plan to make a highway from the Missouri River to the West Coast and chose his son-in-law to help make his dream come true.[50]

Kit Carson, mountain man, was most noted to have traveled in the Colorado Territory. He led three of the four expeditions for Frémont, whose explicit orders were to map the first half of the Oregon Trail and keep an eye out for the best places to build forts along the way. Frémont wanted to safeguard immigrants from the "redskins" who, in the phrase of the day, "infested" the territory.[51]

On one such trip, Frémont and Carson visited Fort St. Vrain. This fur-trading post was located on the right bank of the Platte River, about forty

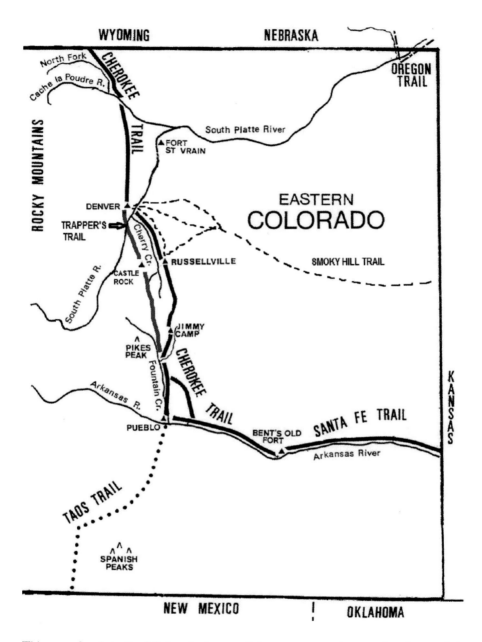

This map of early trails of Colorado shows trails important to explorers and settlers on their way from the East to the western territories. *Jean Jacobsen Collection.*

miles east of Long's Peak. "I was pleased," said Frémont, "to find that among the traders the name of 'Long's Peak' had been adopted and become familiar in the country."[52] This trading post, with thick, strong earthen walls, opened on one side to face the river.

The two men explored the northern, central and southern parts of the territory and followed the Arkansas River to Leadville, traveling on Long's route. The overland stages and the Union Pacific Railroad later followed this route.

A raging blizzard hit Frémont's fourth expedition, the only one Carson did not accompany, during a long winter in the mountains. All of the pack mules froze to death, and many of Frémont's men died. His last trip to Colorado was in 1853, when he was hired to map out the best route for a railroad. He and his wife spent time in California, where she continued writing of his expeditions. She captured the imagination of the nation as she provided information for the immigrants who were beginning to cross the continent to Oregon and California. Although Frémont's reports do not indicate that he ever traveled into Douglas County, he was instrumental in showing people the way into the new frontier. In just a few years, the territory of Colorado was awash with activity.

John Gunnison was graduated from West Point in 1837.[53] Between then and 1853, he participated in several expeditions mapping supply routes to Florida. On others, he surveyed the border between Wisconsin and Michigan, the western coast of Lake Michigan and the coast of Lake Erie. After being promoted to first lieutenant in 1853, he was ordered to take charge of an expedition to survey a route for the Pacific Railroad between the thirty-eighth and thirty-ninth parallels. His exploration sent him through Kansas to Colorado, over the Rocky Mountains by way of the Huerfano River and then through Cochetopa Pass by way of the Gunnison and Green Rivers to the Sevier River.[54]

In 1857, a financial panic, which started in the United States, spread into Europe and the United Kingdom because of overexpansion of the domestic economy. With the interconnected world's economy, the economic crisis affected businesses and families, making them vulnerable to news of a gold rush in Colorado.

Many factors caused the financial panic. The European markets were demanding fewer U.S. goods from U.S. producers. Eastern banks became cautious about loans to western banks, refusing their currencies. Before 1857, the railroads had experienced tremendous growth. Then some overextended their reach, having to file for bankruptcy. By late fall, land values in the

West fell. The question of slavery in new western states also had drastic effects on political and financial securities. To complicate matters, Ohio Life Insurance and Trust Company, a company with large mortgage holdings linked to other Ohio investment banks, failed.

Even worse, a ship from San Francisco with thirty thousand pounds of gold and silver was caught up in a hurricane, and the payload was never recovered. This money was destined for New York to back the paper money in circulation. At that time, all paper money in the United States was backed by gold and silver. The news of this tragedy set the American public into a panic and runs were made on banks. Banks in New England and New York declared a holiday in an effort to stave off runs in their areas. Eventually the panic spread to Europe, South America and the Far East.

Lines of wagon trains, ox-drawn carts and handcarts traveled the dusty trails of the Plains to reach California and Oregon in search of new land. Colorado's influx began in 1858. By 1859, recovery had started, but many people left the eastern states for the western territories looking for land and the promise of gold.

The Trapper's Trail was an overland trail, which wound from Salina, Oklahoma, northwest to meet the Santa Fe Trail at McPherson, Kansas. It turned north along the eastern base of the Rocky Mountains, known as the Front Range. It then proceeded over the Arkansas/Platte River Divide and descended along Cherry Creek into the valley of the South Platte River. Franktown, Colorado, and Russellville, Colorado, developed on this trail. The trail also extended into Wyoming joining with the Oregon Trail. In 1846, Mormon immigrants (known as the Mormon Battalion), Mississippi Saints and other pioneers all used this trail. Ruts from stagecoaches and wagon trains are still visible and walkable in Douglas County. By driving on State Highway 83 from Parker to Colorado Springs, present-day explorers can get a good idea of the trail's route.

A group of Cherokee Indians joined members of an 1849 gold expedition from Georgia to California, where they stayed for ten years. As the group traveled back to Georgia, it stopped to camp beside a creek in an area that would become Russellville, today a quiet residential neighborhood. Gold pans in hand, a few people panned for gold as dinner was being prepared. They found no nuggets of gold but found fine placer gold, enough to be considered noteworthy. Still, the group continued on its way back to Georgia. There, group members told friends about their discovery, and excitement grew, causing the party to plan a return to the location where placer gold was found.

Path by Water with Ox Cart and Two Figures by Frank F. English is a proof-print chromolithograph from about 1861–97. *Public domain, Wikimedia Commons.*

Wagon ruts from wagon trains and coaches are still visible today at certain points along Russellville Road, traveling east off Highway 83 near Franktown. *Jean Jacobsen Collection.*

Brothers William, Levi and Oliver Russell and their Cherokee friends formed two parties consisting of one hundred plus men for the purpose of further gold mining. They rode back to the site where "some color" had been found. The Trapper's Trail, which had supplied the mountain men of earlier years, became known as the Cherokee Trail from that day forward.

The Russellville area teemed with wildlife such as deer, elk and mountain sheep that supplemented basic staples of beans, coffee, salt, bacon and dried apples brought in from St. Louis and other points east.

The stage was set for the Civil War, which had an impact on easterners, with a far-reaching effect on the West. Residents of the eastern states were hungry for good news, so when word of gold strikes reached the East, the word traveled fast.

A second gold rush was born. Gold seekers flocked to the territory with exclamations of "Pike's Peak or Bust." Reports of gold discoveries were greatly exaggerated. The name Colorado had not yet been adopted, so people used the name of Pike's Peak since that was the most widely known landmark. Some stayed in the lowland; others made their way up Mount Vernon Canyon to Black Hawk and Central City. In later years, Leadville became a destination. Many were disappointed that the promised gold was harder to find than they expected. Several burial effigies of Oakes appeared throughout the territory with epitaphs that read: "Here lies D.C. Oakes, Who was the starter of this damned hoax."[55]

At that time, very few women journeyed over the sea of prairie grass. Julia Ann (Holmes) Archibald was one person who traveled with her husband from a Kansas farm near Leavenworth to join the "Pike's Peak" gold rush. A freethinking woman, Julia dressed in an "American costume," as did other reform women of the day. This attire consisted of a calico dress hitting below the knee, pants of matching material, Indian moccasins and a hat. Believing in the right of women to equal privileges with man, Julia's dress gave her the freedom to walk eight to ten miles a day. The only other woman on the wagon train remarked, "It was unseemly to walk among so many men." That woman wore a traditional dress while staying in a hot wagon. However, Julia's "costume" was not without comment from the men. Her manner of dress was a curiosity to them, and they would stand near her wagon watching as she cooked dinner on a stove instead of over an open fire.[56]

As word of gold spread, determined gold seekers forged a fast route to the gold fields. Before this time, anyone headed west either took the Santa Fe Trail to the south or the Oregon Trail to the north to avoid the high peaks of the Rocky Mountains.

A new trail called Smoky Hill Trail became popular. The trail was named for the Smoky Hill River and was an ancient Indian trail, near Abilene,

This "bloomers" apparel from the mid-1800s shows a long and loose divided bathing skirt. Dress reform was a focus of early women's rights activists. *Public domain, Wikimedia Commons.*

Kansas. The isolated buttes that surrounded the river often appeared to be in a smoky haze—thus the name. Although the Smoky Hill Trail was much harder and more dangerous than the other trails, adventurers ignored the possibility of Indian attacks and limited watering holes. All three parts of the trail—north, south and middle—all ended up in the area of Denver.

A tidal wave of men made their way up the valleys of the Platte and Arkansas Rivers and across the plains between the rivers. Some walked while others took the stage or hitched a ride on a mule train. A trip from Omaha took six to seven weeks. Most were ill prepared for the trip, having no idea how long it would take them to get to the new territory. Many fell by the wayside with broken-down wagons, or their horses ran off with the wild herds. Those who completed the trip were shocked with what they found, which was no gold. Crude tents and rough-hewn log cabins marked the banks of Cherry Creek at Russellville. Others never made it past Garden of the Gods in present-day Colorado Springs. The rush lasted from 1859 to 1860.

Disheartened by the lack of gold, some gold seekers departed, but others stayed to make this area their new home. The '59ers who stayed laid the foundation for Colorado's greatness, becoming farmers, cattle ranchers and dairymen.[57]

5

BIRTH OF THE CENTENNIAL STATE

by Tania Urenda

The enticement of gold may have lured white settlers to the West, but it was Colorado's untamed potential that carved the pioneer trails into history forever. The dream of creating a new life from the savage land lured farsighted men and women after the gold rush. The reality meant surviving Colorado's frigid winters, arid summers and Indian attacks.

By late 1850s, pioneers began to flow into Colorado. The roaming buffalo that inhabited the rich grazing lands were diminishing, even though they had been there for thousands of years. Adventure seekers, political reformers and lawbreakers replaced them. Instead of gold strikes, people staked their claim to fresh beginnings, new leadership and tall tales.

Whole families arrived, adapting their tried-and-true eastern practices to the harsh land. Some had few skills, being gentlefolk from the citified East or from overseas. Many failed and many died, but the hardiest of pioneers stayed to welcome the birth of the state.

Of course, mere survival would not be enough. A new era was coming, with the ultimate goals of developing the land, forming local governments and establishing law. Some settlers chose Douglas County, with its tabletop mesas, scattered pine forests and meadows, as the place to put down roots.

Being far from civilization, people felt the need for rules and justice. Isolated in a remote wilderness, they realized the resounding issues to be communication, guidance and resources from the East. In November of 1858, delegates from Auraria, an early settlement west of Denver, reached Washington with a petition to establish the "Territory of Jefferson."[58]

The Twenty Mile House of Parker, twenty miles from Denver, provided meals, lodging and provisions to weary travelers along the Smoky Hill and Cherokee Trails. *1992.011.002.0023. Douglas County History Research Center.*

The delegation failed, but the people surged ahead. In September 1859, a constitution for the "State of Jefferson" was voted on and dismissed. However, a "provisional government" with an adopted constitution was established and a territorial governor, R.W. Steele, chosen. This proved to be confusing since Kansas's law technically governed the eastern portion of the territory.

The people's court solved matters on the Plains, while the mountains utilized the miners' court. M.L. Whittaker describes these courts that sprang up in *Pathbreakers and Pioneers of the Pueblo Region*:

> *The penalties of these "courts" were few in number but were inflicted without mercy. For serious crimes, such as horse stealing or highway robbery, the penalty was death, while for crimes of a less serious nature the culprit was often banished from the settlement and forbidden to return on pain of death.*[59]

This crude yet protective form of government was maintained from 1858 to 1861.[60]

The end of the people's court coincided with two historical events in history. Most devastating was the beginning of the Civil War. The second was the signing of the Colorado bill by President Buchanan that established Colorado as a territory on February 28, 1861.[61] Four days later, Abraham Lincoln became president of the United States.

President Lincoln nominated William Gilpin as governor for the new territory, an easy choice since Gilpin was no stranger to Colorado. In 1843, a much younger Gilpin had traveled along the Santa Fe Trail in search of adventure. He met up with renowned explorer General Frémont and famous mountain man and fur trapper Kit Carson. Gilpin had held a great love for Colorado ever since.[62]

Gilpin was first to suggest the name "Colorado." In Spanish, *colorado* means "colored red," like the striking rock formations found at Roxborough State Park in Douglas County. However, the governor chose the name from the land's principal river, already named the Colorado River. The state name was much envied, with Senator Gwin of California suggesting the name go to the area now known as Arizona, also in the process of claiming territorial rights.[63]

The governor wasted no time getting reacquainted by doing a census to find a population of 25,329, of which over 20,000 were men.[64] He reached out to the president's appointed officers, held an election for federal delegates, enacted a full code of laws and divided the territory into seventeen counties with Colorado City, the future Colorado Springs, as the capital. Douglas County proudly became one of the first Colorado counties, being founded on November 1, 1861, and named after Stephen A. Douglas, U.S. senator of Illinois who had died five months earlier.

The new county's western border was near the South Platte River, flowing near the foothills of the Colorado Rockies, and its eastern border spanned all the way to the Kansas state line.[65] Frankstown, later shortened to Franktown and named after James Frank Gardner, was proclaimed county seat.

Gardner was elected county clerk. He had come to Colorado in search of gold in 1859, after hearing the embellished stories of explorations by the Russell brothers—William Green, Levi and Oliver. These men had founded Russellville, southeast of Franktown.[66] Their party's discovery of gold dust led to a thunderous, yet short-lived, influx of gold-seekers. Mrs. Agnes Harris, courthouse employee in the 1960s, reported that "although not plentiful enough to sustain fortune-seekers, [Russellville] gold was particularly fine and had a special rose hue that distinguished local wedding rings! Up to the 1940's some citizens [even] paid taxes in Russellville gold dust."[67]

Like others, Gardner did not find fortune along the shallow creeks of Douglas County. Contracting typhoid fever, he gave up his dreams of striking gold.[68] Just before Colorado was granted its territorial rights in 1861, Gardner established a small settlement from his squatter's claim along Cherry Creek, four miles north of present-day Franktown. County and

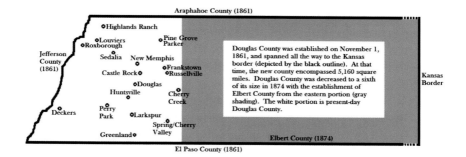

Araphahoe County (1861)

Highlands Ranch

Louviers
Roxborough

Pine Grove
Parker

Jefferson
County
(1861)

Sedalia New Memphis

Castle Rock

Frankstown
Russellville

Douglas

Huntsville

Cherry
Creek

Deckers

Perry
Park Larkspur

Spring/Cherry
Greenland Valley

Kansas
Border

Elbert County (1874)

El Paso County (1861)

Douglas County was established on November 1, 1861, and spanned all the way to the Kansas border (depicted by the black outline). At that time, the new county encompassed 5,160 square miles. Douglas County was decreased to a sixth of its size in 1874 with the establishment of Elbert County from the eastern portion (gray shading). The white portion is present-day Douglas County.

This map shows the early towns and settlements of Douglas County, which used to include what today is known as Elbert County. *Tania Urenda Collection.*

post office business took place within Gardner's one-room log cabin, as the Frankstown post office had been transferred from Russellville in 1862.

Just northwest of Russellville, Charles F. Parkhurst constructed the California Ranch Hotel and a stagecoach station. In 1862, Parkhurst sold the California Ranch property and 155 acres to Gardner in order to move to Denver and build the Tremont House Hotel.

Previously, Gardner had transferred the town title and county seat to California Ranch, after selling his squatter's claim.[69] His son James Frank Jr. reported in a 1946 *Record-Journal* article that his father "called it California Ranch, but it soon came to be called 'Frank's Town' in his honor."[70]

Others were instrumental in Douglas County's climb to popularity. By 1859, the town of Huntsville had been laid out by Sarah Coberly, the first white woman in the Pike's Peak area, when she opened the Coberly Half Way House Hotel. The hotel was halfway between Denver and Colorado Springs.[71] The town was the site of the earliest post office in Colorado in 1860, while still part of Kansas Territory.

Major D.C. Oakes, a prominent figure in Douglas County development, became the county's first postmaster in 1861.[72] He established the first Colorado sawmill in Huntsville in 1859 and also built Fort Lincoln in 1864.[73] Thirty families sought refuge in this "people's fort" for six months after the Hungate massacre near Elizabeth. Huntsville was eventually moved to the Lower Lake Gulch Road area and renamed "Larkspur" in 1871.

Major Oakes's second lumber mill at the location of present-day Daniel's Park supplied lumber to Denver City. This one-thousand-acre mountain park between Sedalia and Highlands Ranch has a memorial dedicated to

Oakes's friend and adventure seeker Kit Carson, who in 1868 was traveling back home to New Mexico to die. The two made their "last campfire" and ate their noon meal.[74]

Another homesteader named Rufus H. "Dad" Clark settled in today's Highland Ranch Golf Club area. He claimed 160 acres, trying his hand at potato farming. His first crop was so successful that he became Colorado royalty, being forever known as the "potato king of Colorado." Like other historical figures, he is remembered in namesakes—in his case, "Dad Clark Drive" and "Dad Clark Park" in Highlands Ranch.

Colorado's path to becoming a state would be rife with obstacles at every turn. The Civil War and Indian Wars threatened to derail government involvement from the East. Territorial issues were secondary in the minds of people in eastern states while the Civil War raged—during a single clash at the Battle of Antietam, over twenty-two thousand soldiers were either wounded or killed in an "awful tornado of battle."[75] Loyal Colorado boosters, such as *Rocky Mountain News* editor William N. Byers, took full advantage of these horrors and social upheavals by promoting "no better 'Land of Promise' than Colorado."[76]

Colorado was divided. Byers, a strong anti-Confederate man, printed "we take our stand ON THE SIDE OF THE UNION!" in his April 1861 publication of the *Rocky Mountain News*.[77] The same article referenced Douglas County's namesake: "That great Statesman and true patriot, STEPHEN A. DOUGLAS, has already spoken out in favor of the Union." On the other side, many Southerners departed Colorado to protect families and homes at the commencement of war, but clusters of Confederates remained, especially along the mountain mines. A Confederate flag, hung shortly after the war's beginning, was torn down with threats of bloodshed if it were not removed.[78] Those who uttered disloyal statements were arrested or shunned in public.[79]

During the second year of the Civil War, the territory of Colorado also heralded its second governor, John Evans, on May 16, 1862. Physician, politician, businessman and lifelong humanitarian against slavery, Evans set to work promoting railroad development, moving the territorial capital from picturesque yet remote Colorado City to the economic and political center of the territory—Golden City, later Golden. He appointed Reverend John Chivington as colonel of the Colorado Volunteers militia.

Many Indians would soon die in Colorado. As tribe after tribe of Ute, Cheyenne and Arapahoe Indians found themselves constrained to parcels of land a fraction of the size of their traditional hunting ground, tensions escalated. The Indians were told to farm the land, but they were given little guidance.

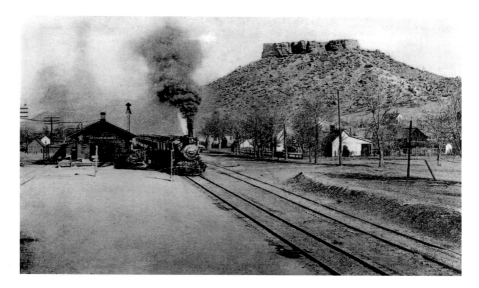

Denver and Rio Grande Railroad Depot, Castle Rock was built in 1875 from local lava stone. Now on Elbert Street, it houses the Castle Rock Museum. *1992.001.0687.0031. Douglas County History Research Center.*

The government promised to periodically supply the reservations with blankets, provisions and other trinkets as per one treaty or another. By winter, the people were cold and hungry. They were bitter over broken promises, their anger flaring. The dog warriors, the strongest and bravest of the Indian fighters, lashed out against the white invaders, attacking stagecoach routes and raiding homesteads. Sometimes, they even murdered, scalped and raped their victims.

One such atrocity occurred on June 11, 1864, when Douglas County's borders stretched to include the area around the town of Elizabeth. Nathan (Ward) Hungate, a hired hand of the Van Wormer ranch, noticed smoke rising from the main house. Worried about his family, Hungate rushed back while another man fled to seek help. Four Arapahoe warriors, bent on revenge, brutally murdered Hungate, his two young daughters and his wife, whom they also raped. The perpetrators made off with a good number of livestock. The family's mutilated bodies were brought back to Denver and publically displayed, becoming Governor Evans's proof that the Indians thirsted for war. Rage ensued.[80] Cries for protection lead to a horrific backlash, the Sand Creek Massacre.

On November 29, 1864, Colonel Chivington, backed by Governor Evans, ordered retaliation on a peaceful Cheyenne and Arapahoe

encampment outside Fort Lyon, about 150 miles southeast of Douglas County. The camp, led by Chief Black Kettle, housed about two hundred Indians. Most were women, children and the elderly. The braves had left earlier to hunt buffalo. An American flag, as well as white flags of peace, flew high above the camp.

Only two officers, Captain Silas Soule and Lieutenant Joseph Cramer, refused to obey the order. Both condemned Colonel Chivington's actions, describing unimaginable atrocities in letters to their former commander, Major Wynkoop.[81] The territory's inhabitants first cheered at news of the slaughter. Then Washington condemned the attack, launching an investigation. John S. Smith, U.S. Indian interpreter and agent, recounts his observations of the massacre during his congressional testimony: "I think I saw altogether some seventy dead bodies lying there; the greater portion women and children."[82] Accounts of the number of dead and wounded vary greatly, but none dispute the horror of the mutilated dead.

A month after the assassination of President Lincoln on April 15, 1865, good news announcing that the Civil War had ended reached territorial ears. Republicans, centered in Denver, cheered for they had seen the war as a shroud over aspirations for statehood. They soon realized other obstacles lay in the way.

The spring before the Sand Creek Massacre, the territorial legislature had petitioned Congress to pass an enabling act to admit Colorado as a state. This first step to statehood was granted, and Colorado drafted its first constitution, which the people of Colorado rejected.[83] Different visions from various factions slowed progress to statehood, with Republicans aspiring to move the capital to Denver and Democrats pushing to remain a territory and retain their power in Golden.

After Lincoln's death, Vice President Andrew Johnson assumed the presidency. No match for the work at hand, he found himself threatened with impeachment by Congress. This did not bode well for Colorado. Not wishing to aid Congress by adding two more senators and one more representative to potentially impeach him, he declined Colorado's admission.

Congress passed another enabling act for Colorado on May 3, 1866, which was promptly vetoed. The president's reasons included the Sand Creek Massacre, the doubtful legality of the proposed constitution and the dwindling population in Colorado. The territory's population had decreased to less than 30,000 while 127,000 voters were required for one representative. Faltering gold mines and the Civil War had made their impact. As Mrs. C.E. Simms recounted in the *Fort Collins Courier*: "Men in the territories were

Left: Miriam and Hubert Fonder homesteaded the Parker area in 1865. Miriam's many hardships included disfigurement, loss, blizzards and grasshopper plagues. Hardships were typical of life in the West. *1998.045.019. Douglas County History Research Center.*

Below: Silas Madge discovered and mined a pinkish gray volcanic stone on his property south of Castle Rock. Early builders used this rhyolite stone for homes and businesses until cement became available. The stone was shipped to Denver and other cities. *1997.011.0004. Douglas County History Research Center.*

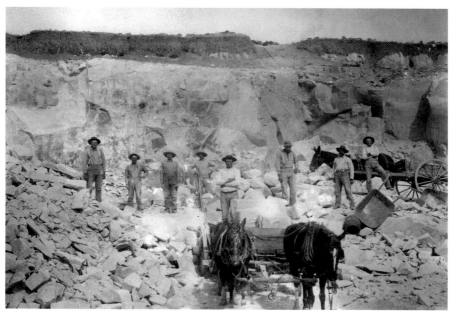

exempt from the draft law during the Civil War, and the larger vote in 1861 is thus accounted for."[84]

President Johnson vetoed one more attempt in 1867.[85] The push for statehood stopped for eight long years afterward.

Meanwhile, news of Douglas County's potential traveled. The Homestead Act of 1862, entitling settlers to 160 acres at little or no cost, benefited the county greatly. Benjamin Quick, a very early settler of Upper West Plum Creek, built Fort Washington to fence in his house and barn and provide shelter for others. Constructed with double rows of logs eight feet tall with earth packed in between the rows, the fort became a godsend when Indians raided. Neighbors ran behind its walls for safety.[86]

Other homesteaders committed themselves to the creation of new towns in Douglas County. On April 7, 1874, Jeremiah M. Gould established the town of Castle Rock by donating 120 acres of his 160-acre homestead, located south of "the rock," that he'd acquired in 1868.[87] John H. Craig bought and invested in Castle Rock property. In 1874, the county seat was moved to Castle Rock and the eastern portion of the county became Elbert County.[88]

On August 1, 1876, the state of Colorado was born when President Ulysses S. Grant admitted Colorado as the thirty-eighth state of the Union. One hundred years earlier, the nation's founding fathers had signed the Declaration of Independence of the United States of America. The nation celebrated along with the inhabitants of the new state. Colorado now had the right to vote for its governor. Governor Routt, a successful silver miner in Leadville, became the last appointed territorial governor and the first elected state governor of Colorado.[89]

The state, aptly nicknamed the "centennial state," was finally born. The hardened men, women and children of Colorado lived and died by the state's motto—*Nil Sine Numine*, which means "nothing without God." This seemed appropriate, for the land would often test those who sought to civilize it. The people had to survive famine and illness. They had to contend with floods, droughts, fires and winter storms. Coloradans earned their right to live on the diverse terrain, growing to have spines as hard as the rocks beneath their feet. Gold may have brought men to Colorado, but it was Colorado's struggles that ultimately refined the proud men and women of the state.

CLOSING OF THE FRONTIER

by Jean Jacobsen

While Colorado was busy becoming a territory and then a state, the area that became Douglas County had growing pains of its own. Examining them requires a closer look at the years 1858 to 1876 before moving on to the years leading up to 1900. These years focus on some of the pioneer families and towns that are the foundation of Douglas County today.

Tuberculosis was a worldwide problem by the 1860s. Physicians in the eastern United States recommended sunny Colorado for the health of their asthmatic or tubercular patients. The state population grew alarmingly with these ill people. By the year 1900, "one-third of Colorado's population was residents of the state because of tuberculosis."[90]

Advances in other areas ensued. Ferdinand V. Hayden first surveyed Perry Park, known at that time as Pleasant Park, in 1869 as he was preparing the first atlas of Colorado.[91]

General Bela Hughes, president of the Central Overland and Pike's Peak Express stage line, arrived here from Kansas. Hughes played a big role in the state's transportation system by connecting Denver and Colorado to the East. This was accomplished by a joint agreement with John D. Perry, president of a rail line chartered by the territory of Kansas, to build a railroad across Kansas to Denver. Railroad service started September 1, 1870. The railroads became an integral part of the state and county business life.

The two men became business partners and formed the Red Stone Town, Land and Mining Company. They started on plans to build a resort community at Perry Park that was far enough away from Denver to be out of

Above: At Pleasant Park, later called Perry Park, F.V. Hayden conducted a triangulation survey for the first atlas of Colorado, which was released in 1874. *Ed and Nancy Bathke Collection.*

Opposite: Perry Park, a picturesque area, enticed visitors from Denver to enjoy an afternoon away from the city. Pictured are the "twin rocks." *Ed and Nancy Bathke Collection.*

the brown cloud of dirty air that exists to this day. The area was a pleasant destination for those needing a diversion from city life. C.W. Perry and his brother also built one of the finest cattle and horse ranches in the county, raising shorthorn cattle.[92]

Three notable grocery markets in the area of Perry Park and Larkspur were Saare Grocery, Pearmans Grocery and Allen Grocery.

Other pioneer families of the area included but are not limited to George and Sarah Nickson and their seven children; Benjamin and Mary Quick, who ranched in Perry Park; and Isaac Jergirtha "I.J." Noe and Jennie (Cain) Noe, who purchased ranchland near Greenland and named it Eagle Mountain Ranch. Carr and Ann Lamb, along with their six children, ran their dairy ranch; he served concurrently as county commissioner. The McClure family grew alfalfa and clover for stock feed. Gus Nelson worked his Indian Creek Ranch at Sedalia. The Keystone Ranch, founded by Christian "Chris" and Sarah Manhart, was run by the couple with their eight children. George W.,

one of the Manharts' sons, operated a grocery store in Sedalia, which was two floors and a basement built from stone.

Issac C. van Wormer, known for his fine horses, operated a ranch on Plum Creek, becoming the first rancher to brand his cattle.[93] At that time, all cattle were run on the open range; later, it became necessary to fence one's property.

Pine Grove, later named Parker, was home to some of the county's early pioneers. Elizabeth Pennock, orphaned, moved to Colorado in 1864 to join her sister Mary Foster and brother-in-law H.M. Foster. John and Elizabeth (Pennock) Tallman were married in Russellville one year later. Tallman and Foster owned one of the three sawmills operating in the Russellville area and made shingles there for the first shingled house in Denver.[94] Their wives often helped out by taking a wagon to Denver for supplies for the mill. The sisters were the first guests to stay at the Twenty Mile House one rainy night, before it was even finished. The Longs welcomed them to the house—a good place to stop when traveling from Russellville with loads of lumber for the construction in Denver.[95] The stopover, twenty miles from Denver, was also at the junction of Smoky Hill Trail and Santa Fe stage lines.

Farms and ranches were separated by miles, not blocks, meaning that neighborly visits required riding on horseback or using a horse and wagon. The creeks and rivers had no bridges. Several rutted trails existed for the wagons to travel on. In areas where heavy clay was prevalent, it was common for a wagon to become stuck during a rainstorm. Families relied on a shovel and axe usually stored in the wagon bed. The only road was the Territorial Road, which ran from Colorado Springs to Denver by way of present-day Daniel's Park area.[96]

School for the children was held in settlers' homes until attendance was large enough to warrant the building of schoolhouses. Franktown established the first school district. The Sedalia School District, then called the "Pioneer District," was established in 1865, making the Sedalia School one of the earliest in the county.[97] Taxes to support the schools were suspended because of Indians from 1865 to 1867. The district paid teachers twenty-five dollars a month, with free room and board being furnished by the families, who took turns hosting the teacher two weeks at a time.[98] Another of the oldest schools in the county was Allison School, housed in a frame building on the east side of Cherry Creek. It was replaced in 1879 by a brick building near what would become the Allison Ranch.[99] Twin houses on the Allison Ranch, used as a tuberculosis sanitarium, had mineral spring waters piped into the houses, making this a popular resort after the sanitarium was no longer needed.

Early homestead houses were generally constructed of logs. If a man used lumber to build his home, he was generally thought to be "putting on style." In Denver, however, the story was different. Residents there tended to order lumber from Douglas County's established sawmills. A few men, like James Frank Gardner, for whom Franktown was named, found it more lucrative to haul lumber to Denver than work in the mills. Gardner had a second wagon that was used to haul logs to the mills.[100]

Early pioneer settlers in the north end of the county were the Schweiger family from Austria. Three brothers, John, Joseph and Jacob, accumulated an estimated four thousand acres at the height of their ranching days. They successfully farmed corn, rye, wheat, alfalfa, oats, apples and potatoes. In addition, they raised cattle for a dairy operation and other farm animals.[101]

A one-room schoolhouse was built in 1880, on land donated by John, forming the Happy Canyon School, District No. 28. John married Anna Scheider in 1885. They hold the distinction of being the fifty-third marriage recorded in Douglas County.

In 1874, Douglas County was divided into two counties, creating Elbert County on the eastern half. This caused controversy. A heated debate developed between the county residents, with the towns of Castle Rock, Franktown, Douglas, New Memphis, Glade and Sedalia all vying for the honor of being the new county seat. They all knew that whichever town was designated as the county seat would garner wealth and prosperity. The town of Castle Rock received the most votes, ending the debate.

Jeremiah Gould and John Craig platted the town of Castle Rock with six streets named Elbert, Jerry, Wilcox, Perry, Castle and Front Streets. They then defined the courthouse square and laid out seventy-seven lots, each 50 by 112 feet, which were auctioned off for a total profit of $3,400.[102] The Castle Rock ditch system was dug to provide irrigation water for the town. Lot owners were encouraged to plant trees along the streets for the beautification of the area, with the town selling trees for $1.50 each and providing the water.[103]

Businesses began to move in, and a railroad siding was added to the line.[104] Reluctant at first, the Denver and Rio Grande Western Railroad eventually built a station next to the tracks in the shadow of "the rock." That building was moved to Elbert Street in the 1970s, and it now houses the Castle Rock Museum.[105]

Three newspapers were published in Douglas County in the pioneer days. Among them were the *Independent*; the *Castle Rock Journal*, which is an ancestor of the *Douglas County News Press*; and the *Douglas County News*.[106]

This scenic view of Main Street in Castle Rock shows mature trees connecting overhead. The street was later renamed Wilcox Street. *Ed and Nancy Bathke Collection.*

With the admittance of Colorado into the United States in 1876, John L. Routt became the first Colorado state governor. A very popular man, he won the governor's seat without making a single public speech, and he also served as Colorado's seventh governor from 1891 to 1893. Women in the state supported him because of his strong stance on women's right to vote, especially after he personally escorted Susan B. Anthony around the state. In Colorado history, his wife, Eliza, holds the distinction of being the first woman to register to vote and then vote in the general election of 1894.[107] Routt is an ancestor of President George H.W. Bush and President George W. Bush through the Routt, Bay and Walker families.

Carrie Holly, Clara Cressingham and Frances Klock, three women of note, were elected to the Colorado General Assembly in 1894. They were the first women elected to a state legislature in the United States. Theodosia Ammons, from a Douglas County family, is famous in her own right as president of the Colorado Women's Suffrage Association.

Denver became a great crossroad for world travelers who came to see Colorado's majestic mountains and open spaces. Within the blink of an eye, an appearance of western grandness appealed to visitors. Horace Tabor, with money he made mining silver, built the Tabor Opera House. The house "was said to be the most opulent building and the best equipped theater between Chicago and San Francisco at its opening."[108] Electric

lights and the telegraph arrived in Denver along with electric trolley cars and telephone service.

Life in Douglas County moved at a much slower pace. Gold seekers came and went. Cattle ranching, farming and dairy ranching—where milk and cheese were produced—became the new way of life and remained so for nearly one hundred years. With few exceptions, a new school, post office or church was opened every year from 1877 to 1899.

The City Hotel moved from New Memphis to nearby Castle Rock in 1874, and another early Castle Rock hotel, the Owens House, opened in 1879. Many guests at the hotels came from the East for the pure air, thought to be helpful for those with tuberculosis and other lung ailments. County commissioners used the hotels for social gatherings and business meetings.

Charles Woodhouse, a transplanted brick maker from England, found clay deposits in the Castle Rock area to be perfect for his profession. He and his brother James, from the Sedalia area, started the Woodhouse Brick Makers Company to supply bricks for the many chimneys in the houses being constructed.

From another walk of life, William Dillon was a prominent man whose life intersected with Douglas County several times. Born in New York as an American citizen in an Irish family, Dillon returned to Ireland with his family where he was raised and educated. As a young adult, Dillon worked in London for two years before being admitted to the Irish Bar in 1874. He practiced law for five years in Dublin.

Poor health led Dillon to move to Douglas County to recuperate and regain his strength. He paid room and board to live on the George Ratcliff Ranch, later known as the T-Ranch, where he learned the ways of cattle ranching. When his brother John and his uncle Charles Henry Hart visited him, the uncle noticed there was no Catholic church in the county seat. Hart returned to Ireland and, with William's mother, raised money for a church, only asking that the church be named after St. Francis of Assisi in honor of William and John's brother who had joined the priesthood. In 1888, the church was built with the funds from Ireland and from the locals.

Dillon and George Ratcliff agreed to partner in the Crull Ranch, later known as the Meadows Ranch. Dillon lived in a log cabin on the ranch. Within two years, he inherited money from an Irish relative, enabling him to acquire half interest in the expanded ranch. He married the rancher's daughter, Elizabeth Ratcliff, in 1885. They lived in Chicago and raised their family there and in Castle Rock, still maintaining their connection to the ranch.

Charles Richard "Dick" Dillon, son of attorney and rancher William Dillon, relaxes on the Dillon family property. *Susan Cheney Joyce Collection.*

Dillon was an attorney in Dublin, Chicago and then Castle Rock. He was the first dean of the Loyola University School of Law. When national dignitaries attended his funeral in Castle Rock in 1935 or wired condolences, local residents were surprised to find out how famous he was.[109]

For a period of more than twenty years, Castle Rock was a thriving quarrying town. However, it was rhyolite, not gold, that ultimately led to the settlement of Castle Rock.[110] The rhyolite quarries produced tons of rock a year. In 1887, there were orders for 350 train cars of rock that were shipped from the Madge and O'Brien quarries alone.[111] Many Swedish immigrants arrived in the area to work in the quarries. Rhyolite, ranging in color from pink to gray, was used in the construction of many notable buildings such as the Douglas Masonic Lodge No. 153 and the former St. Francis of Assisi Church in downtown Castle Rock. Colorado College in Colorado Springs is built with rhyolite, as well as many buildings in downtown Denver, including Trinity Methodist Church and the Kittredge Building at Sixteenth and Glenarm Streets.[112] Many of the exterior walls of Union Station are also built of the volcanic lava stone.

Dawson Butte, a landmark in central Douglas County, was named in honor of Thomas Dawson, who began ranching on the South Platte River along with Elias Ammons. Ammons became governor in 1886.

Douglas County organized the first county fair in 1892, with county residents displaying garden vegetables, orchard fruits, cattle and horses. The Douglas County Fair continues to this day at the Douglas County Events Center and Fair Grounds in Castle Rock, held yearly in early August.

About 3,120 people called Douglas County home in 1900.[113] The chapter on the frontier days of pioneer wagons and Indian attacks came to a close as life grew more settled and more sophisticated. The people looked forward to a new chapter in a new century, one bringing in modern ideas and conveniences.

THE TWENTIETH-CENTURY ADVENTURE

by Alice Aldridge–Dennis

B y the beginning of the twentieth century, exploration and expansion had segued into settled communities and a unified nation. The United States of America had grown into a prominent world power, strengthened at home by excellence in agriculture, a coast-to-coast rail system and industry in oil fields and steel refineries. At world fairs—such as the Pan-American Exposition in 1901 in Buffalo, New York, and the Louisiana Purchase Exposition in 1904 in St. Louis—Americans celebrated technologies like baby incubators and electric lights. They learned about cultures from around the world, including the American West. This period in American history was an exciting time due to stability in the country but also because of the innovations and discoveries.[114]

> *By 1900, telephones were in wide use. Cities were being electrified. The "moving pictures" were a curiosity. Guglielmo Marconi was conducting experiments that would lead to the development of the radio, and the Wright brothers were at work on a heavier-than-air flying machine.*[115]

That same year, Kodak introduced the Brownie camera. Also, Max Planck came up with quantum theory, and Sigmund Freud released his book *The Interpretation of Dreams*. By 1903, the baseball world embarked on its first World Series, and the first film, *The Great Train Robbery*, played to audiences. By 1907, the electric washing machine debuted, and the next year, Ford Motor Company introduced the famous Model T Ford.[116]

Politics also changed in the new century. Republican William McKinley was reelected in 1900, one of six presidents from Ohio, illustrating that the power base of the nation was no longer the East Coast. When McKinley was assassinated in 1901 and Vice President Teddy Roosevelt assumed office, a Progressive movement was taking hold. Women's suffrage, work standards and wage rates and the need for primary elections were issues the next presidents would support, trying to balance the great wealth of businesses and the poverty of the workers.[117]

Ironically, while the nation grew politically and financially sophisticated, a former Army scout and buffalo hunter named William F. Cody, also known as "Buffalo Bill," took an indoor stage show to the outdoors with real animals and reenactments of scenes from the old West. His "Buffalo Bill's Wild West Show" featured American Indians from various tribes, cowboys doing rope tricks and women such as Annie Oakley demonstrating feats of marksmanship. He might have continued on longer, but local rodeos followed his example, creating their own fan bases. In 1913, Cody closed his show after thirty years.[118]

Meanwhile, back at the ranches and towns of Douglas County, Colorado, life was quieter, with a population of over three thousand people. As time passed, the farmers and ranchers diversified operations to supplement their incomes and update their equipment. The open range was now closed, due to the prominence of barbed wire. Branded cattle, which once roamed freely up and down the Front Range and required a cattle roundup that lasted many weeks, now grazed closer to home. Town governments worked on amenities and standards, and families built homes and businesses.

Castle Rock, the county seat, became a place where people valued government and education.[119] The town had already built the rhyolite two-story Cantril School in 1897 atop a hill looking down toward town, and the county built the rhyolite Douglas County courthouse, creating an admirable town square for the new century. In 1901, the two-story Keystone Hotel at Wilcox and Fourth Streets went up to provide hotel lodging, a saloon and a restaurant, making it a gathering place for locals and visitors. In 1904, Castle Rock Bank, the first bank in the county, received a new name and a new building. Renamed the First National Bank of Douglas County, the rhyolite showpiece in Romanesque Revival style graced the corner of Wilcox and Third Streets. These two structures would carry the distinction of being placed on the National Register of Historic Places in the 1990s.[120]

Parker's Tallman-Newlin House is on the Colorado State Register of Historic Homes. The home was first a log cabin built in 1866 by John and

The Rhode Island Hotel in Parker was an elegant hotel for its time. Only a portion of the hotel still stands today. *Alice Aldridge-Dennis Collection.*

Elizabeth Tallman. However, in the early 1900s, William Gilpin Newlin and his wife, Elizabeth, applied wood siding to the home, upgrading it to newer standards in home construction. Today, the home is located on Callaway Road, having been moved to save it from being torn down.[121]

Mainstreet in Parker was the center of activity. Legend has it that the street name is spelled as one word because the first street sign listed it that way, probably because the piece of wood was not long enough to allow for a space. A famous building on Mainstreet was the Rhode Island Hotel. Martin Henry Goddard and his wife, Nellie, ran the hotel, serving visitors and the local people. From the back of the hotel, guests could walk to the railroad tracks.[122] The accommodations and meals were considered first class:

> *The hotel was modern for the times, with acetylene gas lighting, hot and cold running water on both floors, steam heat; there were even indoor sanitary facilities. The hotel's water was supplied by a windmill until 1911, when a gasoline engine was installed to power the pump.*[123]

Goddard put a telephone system into the hotel, first connecting guests with the outside world through the Sullivan Exchange. The system grew to become the Cherry Creek Telephone Company. By 1913, the Goddards left the hotel business, with Goddard pursuing his telephone business and other ventures, while his wife wrote about Parker for the *Castle Rock Record-Journal*.[124]

The Ruth Memorial Chapel of Parker still stands on the south side of Mainstreet. It is on the National Register of Historic Places. The original name was Ruth Memorial Methodist Episcopal Church, and it was dedicated in 1913 in memory of Dr. Walter Heath's daughter Ruth, who died young. In 1915, the Parker schoolhouse to the east of the chapel replaced the original school in Pine Grove, as Parker was first known. The first school was located at the corner of Parker Road and Mainstreet. All grades from one through twelve attended the school until 1956. The chapel and the schoolhouse belong to the Town of Parker today.[125]

With the land being arid and the weather unpredictable, some farmers in the Parker area turned to endeavors besides ranching and farming. E.R. Parson proved that fruit trees could be profitable. By 1907, his orchards had grown to "one thousand cherry trees, five hundred plum trees, two hundred apple trees and 1,500 currant bushes."

Creameries were another successful business. Initially, farmers and ranchers who were diversifying their ranch businesses sent dairy products by rail to the Littleton Creamery. In 1908, Will Duray started the Parker Creamery in the former blacksmith shop owned by Rich Hawkey. The creamery was a transfer station, but eventually, Duray bought a separator and a pasteurizer in order to process his own milk.

With thriving businesses, Parker needed its own bank where people could bank locally. Parker State Bank incorporated in 1911 and was housed in a brick building on Mainstreet. The bank served the area until 1922, when it merged with the Castle Rock Bank.[126]

In 1913, the Colorado Traveling Library Commission at the statehouse in Denver announced that 150 traveling libraries had been put together for the use of schools, churches and other organizations. The libraries included "books of history, travel, fiction, reference, juvenile, agricultural, and scientific collections." The sets could be checked out for six months, and the postage was covered.[127]

In the northwest portion of the county, the area now known as Highlands Ranch consisted of individual farms and ranches, which were bought up by John W. Springer. From this, Springer built the John W. Springer Cross Country Horse and Cattle Ranch, making it one of the best in the nation, with

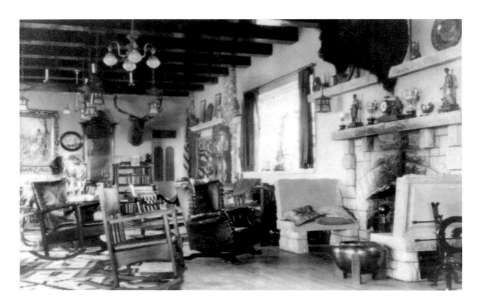

John W. Springer built Springer's Castle on his extensive cattle and horse ranch in northern Douglas County. The lodge-like interior made a perfect place for cowboys to unwind. *2011.007.007. Douglas County History Research Center.*

Oldenburg stallions and imported German mares. The ranch specialized in the German coach horse. A reservoir enabled Springer to grow two hundred acres of alfalfa, oats and hay for cattle, as well as wheat, rye and grasses for the horses. Springer built "Springer's Castle," a large home resembling a hunting lodge.[128] Today, the building, which was modernized with each new owner, is known as the Highlands Ranch Mansion, and the Highlands Ranch Metro District owns it.

Matthew Plews, a gifted horticulturist who ran a truck garden on his Fly'n B Ranch, built his Fly'n B House in 1906. He also worked for Senator Edward Wolcott at Blakeland at County Line and Santa Fe Roads. Over the years, the property changed hands several times, with the route for C-470 cutting through the middle. The home and the Fly'n B Park are under the jurisdiction of the Highlands Ranch Metro District.[129]

The secluded town of Louviers off Highway 85 takes its name from Louviers, France, home of the DuPont family, and from Louviers, Delaware, home of a DuPont textiles factory. Realizing the need for explosives in the western U.S., the company decided to diversify—to manufacture dynamite as well as woolens. The first step was to find a location in the Denver area.

In 1906, the E.I. du Pont de Nemours and Company started Louviers Works along the banks of the Plum Creek north of Sedalia, where access to the nearby railroad on Jonathan Kelly's land was possible. The company built a town for workers and management, renting the houses to its employees and providing electricity and coal. In 1908, the company built the Louviers Clubhouse for recreation, enlarging it in 1917. In 1912, the company erected a hotel that housed single workers for eighteen years. Today, the factory is gone, and the residents own their homes in this picturesque town. The town was placed on the National Register of Historic Places in 1999.[130]

On the rail line from Denver to Colorado City, Sedalia was still a small town by 1900, but a busy one. The Denver and Rio Grande Western Railroad ran through town, as did the Atchison, Topeka and Santa Fe Railroad, making Sedalia a trade center for shipments of coal, milk and cheese, cider and apple butter, quarried stone and lumber and railroad ties from the sawmills. The supplies for the three grocery stores also came by rail. In addition, Sedalia was a perfect distance for bicyclists and, later on, motorists to get out of Denver.[131]

Some of the homes built around the turn of the century and before World War I were the Lambert Home (1909) on the Lambert Ranch west of Sedalia in the Indian Creek Valley, the Rohner-Nitz Homestead first house (1909), the Claude Home (1907), the Friendly-Beeman House with carriage house (1910–11), Charles Hier Ranch (1902) along Indian Creek and the Manhart Home/Gabriel's Restaurant (in 1908).

Sedalia School ran independently for many years, as most county schools did, with its own school board. The schoolchildren were honored to have Teddy Roosevelt visit Sedalia via train; school was let out so the children could see him at the nearby depot.[132]

A 140,000-gallon steel water tank, built in 1906 by the Santa Fe Railroad, still stands in Sedalia. "Around 1900, railroads began using steel tanks to replace the elevated wood tanks that provided water for coal-fired steam locomotives." The tank is listed on the National Register.[133]

One of the first post offices in Kansas Territory was at Huntsville, later renamed Larkspur. In the new century, with access to pine forests, the local sawmills cut and shipped lumber to Denver and other places via the railroads. In 1902, the Frink Creamery opened to purchase and process the milk from the many nearby dairy farms blessed with plentiful grasses. The creamery employed local people, who turned eight hundred pounds of milk into Black Canyon cheese every day.

Between 1913 and 1914, the Frink House was built in a modified foursquare style, with a square shape and two stories. The owners, Clarence and Ellen

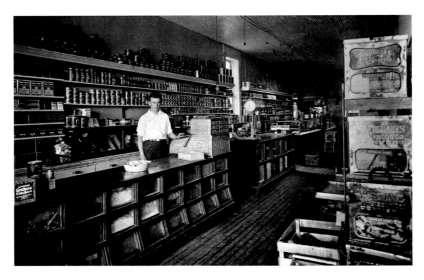

George Manhart built Manhart's General Merchandise and Grocery Store in Sedalia, which evolved into a community meeting place. The store was a prosperous business, stocking popular goods that appealed to all ages. *1992.001.0687.0545. Douglas County History Research Center.*

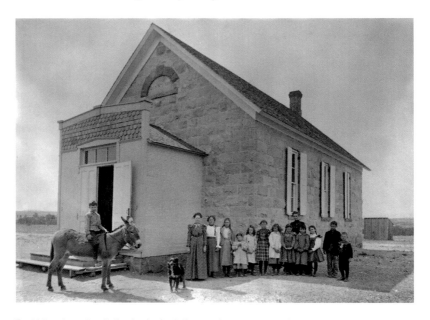

In 1865, the school district in Sedalia was formed, one of seven school districts in the county with a total enrollment of seventy students. A stone building, shown above, replaced the original frame Sedalia Schoolhouse in 1891. *1992.001.0687.0561. Douglas County History Research Center.*

Frink, were part owners of the creamery, which was later destroyed in the flood of 1965. The house still stands in 2014, and it is listed on the Douglas County Historic Register (2009).[134]

The wood-frame Glen Grove School opened in 1910, serving local children for three generations. Located at 7300 Perry Park Road, the school is on the National Register.[135]

By 1900, gold seekers no longer traveled into the area, and the county seat was no longer in Franktown. However, ranchers and farmers in the Franktown area found success in producing crops due to the water of Cherry Creek.[136] In 1909, Pike's Peak Grange No. 163 was built as a place for the community to congregate. This grange is still an active one, proudly on the National Register of Historic Places since 1990.[137]

Castlewood Dam, built in 1890 to provide more irrigation to the area, had problems by 1897 with small breaks and damage to nearby areas. In the early 1900s, the dam changed hands four times before becoming organized by the Cherry Creek Mutual Irrigation Company. The dam held for another thirty years before bursting and overflowing downstream into Denver. What remains of the dam is on the Colorado State Register of Historic Places.[138]

Historic Douglas County, Inc., presented the program "Breeds, Brands, and Ranches of Early Douglas County" on March 11, 2014, at the Parker Historical Society. This program was planned for several locations in the area, with Parker being the first. Kicking off the series in Parker was apropos since the Parker area was the first place to have a beef cattle herd in 1865. Larry Schlupp led the audience through the development of ranches and the origin of the types of cattle that came here from Texas, England and Scotland. Some of the breeds brought to Colorado were the longhorn, the shorthorn, the Hereford, the Angus and the Santa Gertrudis. Schlupp pointed out that weather and predators, such as wolves and coyotes, challenged ranchers, as did the management of water and grasses. Douglas County still has sixty-one working ranches and farms, with 6,500 beef and dairy cattle.[139]

Bill Noe and Bev Higginson Noe, Douglas County High School classes of 1954 and 1957, both grew up on ranches near Larkspur. Today, they live on a parcel of land that was once part of the land homesteaded in 1877 by Bill Noe's great-grandfather I.J. Noe. He developed it into Eagle Mountain Ranch, and his son Fred Noe took over the ranching as I.J. grew older. Not all the great-grandchildren went into ranching; Bill's and Bev's careers were at Lockheed Martin and Rose Hospital, and Bill was the first Douglas County planner from 1973 to 1979.

Richard William "Bill" Noe and Beverly (Higginson) Noe, pictured above, treasure the piano that originally belonged to Bev's grandmother Margaret Louise Grout Stewart, circa 1910. The Stewarts owned and ran West View Ranch, near Jackson Creek Road and Perry Park Road (Highway 105). *Alice Aldridge-Dennis Collection.*

Bev's family also has roots in early Douglas County. Her great-grandfather, English-born Jonathan Higginson graduated from Oxford Law School and then emigrated and homesteaded near Deckers. In 1907, son Harold Higginson and his wife, Essie Voorhees Higginson, founded Higginson Ranch, where they raised beef and dairy cattle and farmed oats and rye. They raised five children, among them Bev's father.

The Noes pointed out that the first wave of ranchers struggled with the high elevation and a short growing season. The second wave stayed, buying up small farms and raising hay and crops to get them through the winters. Much land was needed, as it took thirty acres to keep one calf for one year. With steam sawmills and wells, a golden era of ranching was ushered in, lasting until the 1920s. The railroads used wood for their engines' fuel, later switching to coal. At Eagle Mountain Ranch, horses pulled the trees off the mountain, and lumbermen made them into railroad ties. The railroad companies bought them for thirty-four cents each.[140]

Harold Higginson bought and founded the Higginson Ranch in February 1907 and married Essie Voorhees in March 1907. Both were from Deckers. They raised beef and dairy cattle, and they farmed oats and rye. *Bill and Beverly Noe Collection.*

Alexander Scott homesteaded east of Castle Rock, creating the XS Ranch, which stayed in the Scott and Marr families for five generations. *Laurie Marr Wasmund Collection.*

Another ranching family was the Scotts. Alexander Scott Sr. and Jane Morton Scott, originally from Arbroath, Scotland, homesteaded on 160 acres six miles from Castle Rock along a gulch connected to Cherry Creek. The ranch was named XS Ranch, possibly because Alexander's initials, A.S., might have been used on another ranch's name. The family began ranching while Alexander still worked for the Denver and Rio Grande Western Railroad and commuted home on weekends. Later, his daughter and son-in-law, Georgina and Earl Andrews, bought the ranch. By the early 1900s, Georgina's brother Alexander Scott Jr. and his wife, Martha Wilson Scott, used homestead rights to purchase nearby acreage, first 146 acres and then 160 acres, followed by another 160 acres, permissible due to certain laws that passed. The ranch stayed in the family until 1981, and for many years, the ranchers oversaw a dairy herd and raised crops, using horses and later tractors.[141]

The new century brought energy to Douglas County, as businesses from sawmills to creameries to grocery stores sprung up to help people support their families and improve their lives. Cattle ranchers adapted to the closed range, expanding into dairy farming and other endeavors.

FROM WORLD WAR I INTO THE ROARING TWENTIES

by Susan Rocco-McKeel

On November 2, 1918, Douglas County soldier Walter Scott wrote from France: "Those who have never been over here do not know what war is."[142] The United States reluctantly entered World War I in the spring of 1917,[143] over two years after its inception, changing the balance of the war for the exhausted Allies, primarily Great Britain, France and Italy against the Central powers led by Germany and the Austro-Hungarian Empire. This was the first full-scale war using modern weapons such as U-boats, mines, artillery, machine guns and poison gas. It is estimated that over twenty million died from all sides in the war.[144] Soldiers suffered horrifically from being gassed, bombed, shot and racked with disease.[145]

Colorado congressman Eaton wrote in 1929: "In not another state did the youth of the land respond more readily to the call of arms. And few states suffered as severely in numbers making the supreme sacrifice."[146] Colorado contributed 43,000 volunteers and draftees, of which 1,009 died in the service, 1,759 were wounded and 326 died in battle.[147] In 1917, John Marshall, provost marshal of Colorado, and his board of mathematicians estimated the net quota of Douglas County men to be drafted into the first national Army to be 30 out of a population of 3,670.[148]

However, from the Larkspur, Greenland, Cherry Valley and Spring Valley areas alone, about 124 young men were drafted and one enlisted for the War. With Larkspur's 1910 census population at 201, this number was a significant loss of manpower and talent for small communities.[149] Other communities suffered a similar loss. For example, from Louviers went

farmer Charlie Cecil Campbell to field artillery, civil engineer Leslie Gore to the signal corps, and college student Frank Alwar Cantril to participate in the sinking of submarines while in the Navy.[150] Immigrants joined the war as well, such as Fred W. Kugler, a farm worker from Sedalia, who was born in Frickendofen Wirtenberg, Germany in 1886 and entered the war on July 24, 1918.[151]

Those on the homefront bought war bonds, paid higher taxes, planted gardens and fields and joined in meatless, heatless and lightless days and nights. Coloradans worried about the possibility of sabotage to exposed reservoirs and tunnels.

The Colorado National Guard became nationalized in August 1917 and was tasked with protecting these resources. By May 1918, all but four Colorado counties had formed councils of defense; one of the counties with a council was Douglas County. Following Governor Julius Gunter's recommendation, the Douglas County commissioners and the Castle Rock Town Council authorized Sheriff George Nickson to organize a local home guard posse. With the organized militia called into service for the war, the governor wrote that reliance would be upon local initiatives to safeguard persons, property and order.[152]

Governor Gunter divided defense work for the state into the War Council, which was composed of men, and the Women's Advisory Council, which was said to be given equal power to initiate and forward their plans.[153] The Douglas County Women's Council distributed flyers to encourage more food production.[154]

Other roles were not so equitable. The U.S. War Department asked the American Library Association to provide reading material for soldiers. The Colorado Library Association and the Colorado Library Commission met in September 1917, with representatives from the War Department. Interested citizens were urged to attend, and any could represent "his" town. The plan was to have a central library in each cantonment "managed by library men of experience. Women will not be used for this work."[155]

The government encouraged citizens to donate magazines and books to the soldiers. Magazines could be mailed for one cent. Current event magazines could not be older than two months. "Good" books were sent to the cantonments, defined as the books one would reread or recommend but not give away when cleaning.[156]

At the time, World War I was thought to be the "war to end all wars," but World War II would occur in another twenty years. The aftermath of World War I changed boundaries; produced new treaties; created new nations,

such as Czechoslovakia out of the Austria-Hungary Empire; and saw the beginning of the revolution that resulted in the Soviet Union, thus sowing the seeds for future conflict.

Before the armistice was signed on November 11, 1918, the influenza pandemic or "Spanish flu" of 1918 attacked. The crowded conditions of the military camps and trenches on the western front in Europe fostered the spread of influenza among the traveling soldiers. Influenza crossed the ocean with them back to the United States. During the war, influenza killed more men than did the enemy weapons.[157]

In over ten months, 7,783 Coloradans died from influenza.[158] Colorado had one of the highest mortality rates in the nation, possibly due to a large population with compromised lung function associated with mining.[159] Douglas County residents were urged to avoid crowds and contact with those who might have the "germ," especially those who were coughing or spitting; to eat well; to exercise; and, if sick, to stay in bed until the symptoms passed.[160] The largest building of its kind at the time in Douglas County, the Louviers Village Club assembly hall, served as a temporary hospital ward.[161] Although science did not understand influenza as a virus at the time, it correctly identified the connection between crowded conditions and the disease's proliferation. This recognition laid the foundation for further study of the disease, which benefits populations today.

Like the rest of the country, Colorado reacted with relief to the end of its sacrifice for the war effort and moved into a more prosperous era of the Roaring Twenties. This generation had unprecedented money and leisure time.[162] People were aware of the current fads through newspapers, magazines and the radio. While the prosperity was not evenly experienced, generally in 1929, even a family with a modest income could afford to buy items such as toys. A large steel truck was $1.70 in the Sears catalogue; an electric train with four cars was $2.98; and a sleeping, crying doll was $0.99 cents.[163]

In the 1920s, a Ford automobile could be purchased for $290. For those who could afford an automobile, life in rural Douglas County became less isolated.[164] The automobile also encouraged the growth of the tourist industry in Colorado and the development of regional water compacts, while leading to a decline in railroads. Another consequence was accidents. The *Record-Journal* reported in 1924, that there was an increasing frequency of cars striking the sides of trains at railroad crossings.[165] Douglas County reflected the experience of small towns where even those with a population of three hundred had a bustling main street for trade and entertainment.[166]

The Higginsons, a well-dressed Douglas County family of the time, posed for a family portrait in 1928. *Top, left to right*: Russell (in a Douglas County High School letter sweater), Robert (also in DCHS letter sweater), Esther (daughter) and Albert (youngest son); *bottom, left to right*: Harold, Essie (Voorhees) and Janet. At that time, DCHS was the only high school in the county. *Bill and Beverly Noe Collection.*

An ominous ramification loomed for the nation, including Colorado. The increased agricultural production that served the Allies and benefited farmers during the war declined between 1919 and 1920, setting the stage for a decade of surplus food with declining prices and debt due to expansion for farmers and ranchers. Some lost their land.[167] The crime rate increased, and law enforcement was lax. Fear of communism spread. The search for scapegoats led to the rise of the Ku Klux Klan in 1921, on an anti-foreign, anti-Catholic and anti-Semitic platform and hiding beneath patriotic rhetoric as a service club.[168]

In 1924, every Colorado county had a Klan presence, and members held high offices, including Colorado governor Clarence Morley and Secretary of State Carl Milliken, though he later renounced this affiliation.[169] Douglas County followed the Klan's movement through local publications.

The KKK met at the Douglas County Courthouse in 1925. The local paper printed a sympathetic report, describing its speaker as "eloquent," his words adhering to the U.S. Constitution, and comparing the ideology of the Klan to Catholic and Jewish religious organizations whose memberships were exclusive to their religion, such as the Knights of Columbus.[170]

In 1923, the *Alamosa Journal* (reprinted in the *Littleton Independent*) predicted that the KKK could not survive. The paper described it as an un-American organization, issuing masked edicts while denying the right of a jury trial.[171]

The Klan declined around 1925, as opposition intensified, newspapers attacked it,[172] the state legislature turned against it, membership became disillusioned, and its Colorado leader, John G. Locke, was imprisoned for failure to pay federal income taxes.[173] In 1925, the *Record-Journal* printed: "Colorado klansmen are charging that the Pope bribed Doc Locke to wreck the klan. They probably knew him better than we do, and whether or not he would take a bribe. If the report is true, we would like to learn how much more than fifty cents was paid to the [unintelligible] ex-dragon."[174]

The Eighteenth Amendment to the U.S. Constitution grew out of a reform movement to reduce drinking by eliminating the businesses that made and sold alcohol. The Volstead Act followed, authorizing federal enforcement of the amendment and defining intoxicating beverages as those containing 0.5 percent of alcohol or more.[175] Previously, Colorado had one of the nation's strongest temperance campaigns, outlawing the production of alcohol five years before national Prohibition.[176] With Protestant churches as a driving force, the genesis of the movement began in the 1830s when it was estimated that the average American male over age fifteen was consuming about seven gallons of pure alcohol a year.[177]

Despite its prior temperance movement and the Eighteenth Amendment, Colorado had an active bootlegging underground. Douglas County was no

exception. People made liquor out of a variety of available products such as raisins, apples or potatoes. Those who did not make their own could get it from bootleggers engaged in moonshine productions.[178]

According to local legends in Douglas County, after the Spring Valley Cheese Factory closed, dances were held on the second floor of the barn. Booze was retrieved from its hiding place in West Cherry Creek and brought to the dances. Numerous newspaper articles chronicled the widespread nature of bootlegging—for example, "Pouppirts [were] Nabbed on Booze Charges." Near Parker, the authorities found "a half gallon of moonshine booze, seventy-two jugs and three quarts of wine" and seventeen buried kegs. Sheriff McKissack confiscated a three-hundred-gallon-capacity still for a trial in Castle Rock. The sheriff captured a still near Devil's Head, and his officers destroyed a "big booze plant" near Larkspur. Proprietors of a Douglas County resort, Parker pool hall operators and garage owners were arrested.[179]

In 1922, after investigating the Cave Hotel in Parker, the sheriff and his deputies went to Sedalia for another investigation of rumors that "the town barber J.A. Mosner was catering to the thirst of his customers, as well as attending to care for their personal appearance."[180]

After fleeing a Chicago gang war, Diamond Jack Alterie ended up in Douglas County, where he owned a ranch in Jarre Canyon. Newspapers reported what followed as a muddled series of events. While the *Chicago Daily News* detailed Sheriff McKissack's hunt for Diamond Jack as having received a warrant that he "pocketed," the *Record-Journal* of Douglas County reported that McKissack was investigating but had not received a warrant. Further, it said that McKissack visited the Jarre Canyon Ranch but could not locate Alterie.[181] Then, a few days later, it stated that the Chicago police did not want Diamond Jack and there would be no warrant.[182] Within a month, the *Record-Journal* announced that Diamond Jack gave McKissack a sheriff's star set with diamonds and a .38 Smith and Wesson revolver for his "square treatment."[183] In 1926, when Diamond Jack recorded a quitclaim deed for the last of the property he owned in Douglas County, originally planned for a summer resort, the paper reported that "[h]is departure was not accompanied by any great demonstration of sorrow on the part of our people."[184]

Before the Twenty-first Amendment repealed Prohibition on December 5, 1933, the nation experienced many unintended consequences such as lost revenue; the elimination of jobs for barrel makers, truckers, waiters and related trades; the high cost of enforcement; and increased crime as bootlegging occurred, some sponsored by organized crime.[185]

Besides bootlegging, Douglas County had some rare but alarming criminal incidents. In 1921, three armed, unmasked bandits robbed the Parker Bank of about $3,000 in cash and almost $4,000 in Liberty Bonds. One bandit pointed a gun at assistant cashier Elizabeth Schultz's head. The bandits warned her that she would be shot if she cried out. Then they locked her in the vault. She tried to set the burglar alarm, but it was too dark to do so.[186]

In 1913, Simon Solie was robbed of fifteen dollars at gunpoint. "This was about the boldest hold-up that has ever occurred in these parts."[187] Sheriff Nickson caught both of those robbers.

Douglas County is rich in historic landmarks. Three of this era's landmarks that are remarkable for their legacy are the Hilltop Historic School House, Cherokee Castle and the American Federation for Human Rights headquarters.

Hilltop Historic School House, built in 1897, is located in an area once known as Bellevue, at the junction of Hilltop and Flintwood Roads. March 26, 1921, saw the inauguration of the Hilltop Social Club, which took over the maintenance of the school building and agreed to work on fundraising to help with the salary of the minister who held services in the school every other Sunday. The dues were ten cents per person per meeting. In the minutes from 1923, the ladies decided to buy a "graphanolo which had 50 records with it, and it took quite a number of entertainments…to pay for it."[188] Under the current club president, Louise West, the social club continues its mission to care for the schoolhouse and for community service, such as adopting a senior for the holidays in 2013, although the dues have increased to ten dollars per year and classes have not been held since 1954.[189]

Built during the period of 1924 to 1926 by Charles Alfred Johnson, the fifteenth century–style Charlford Castle was constructed of petrified wood and the native stones rhyolite and quartzite.[190] The original castle and its outbuildings still stand south of Sedalia and southwest of Daniels Park, thanks to Mildred "Tweet" Kimball. Ms. Kimball bought the castle and its ranch of about 2,500 acres in 1954, renaming it Cherokee Castle. She increased the property size and introduced the Santa Gertrudis cattle from Texas to Colorado.[191]

In 1996, she began a process to protect her ranch. She established a private foundation, the Cherokee Ranch and Castle Foundation, putting about three thousand acres under a conservation easement to ensure its continuation.[192] Douglas County Open Space purchased the conservation easement, protecting the natural setting of grasslands, mesas, shrublands, ponderosa pines, juniper and Douglas firs that provide habitat for wildlife such as bluebirds, elk, bears, bobcats and foxes.[193] The Cherokee Castle is continually used for cultural events and weddings.

Hilltop Social Club, 2013. *From left*: Elaine Cain, Eileen Cantrell, Romona Welcomer, Lillian Preston, Lorelie Linwood, Barbara Hintz, Louise West, Ellen Kaihara, Be Dent, Jan Porteous and Susy Cushman. *Susan Rocco-McKeel Collection.*

The Cherokee Castle and Ranch Foundation runs the Cherokee Castle in Sedalia, presenting fundraising events open to the community. The land is a protected habitat. *Susan Rocco-McKeel Collection.*

The land for the American Federation of Human Rights headquarters in Larkspur was purchased in 1916. The building is on the National Registry of Historic Landmarks. *Susan Rocco-McKeel Collection.*

The American Federation of Human Rights, the corporate arm of the Co-Masonry fraternal order, finished construction of its headquarters building in Larkspur in 1923. Active in promoting equality for women and better working conditions, it also served as a home for coal miners with lung disease.[194] Rosario Menocal, its energetic and devoted president for almost twenty years, continues the federation's work.[195] The striking blue-and-white building emerges from the forest off South Douglas Boulevard. It is on the National Register of Historic Places.[196]

Events related to World War I and the 1920s reverberate to the present. World War I and the resulting geopolitics contributed to the Second World War twenty years later, with repercussions for decades to come. The rise and fall of the KKK provided cautions on the danger of fear and bigotry. Increased medical knowledge resulted from the influenza pandemic of 1918. While alcohol abuse is still a problem, Prohibition proved not to be the solution. Douglas County citizens and visitors enjoy the heritage of many local treasures with functioning landmarks such as the Hilltop Historic School with its social club, Cherokee Castle and its nature habitat and the American Federation of Human Rights continuing its operation.

1930s: SEEDS FOR TOMORROW

by Susan Rocco-McKeel

Jackrabbit stew. Coyote hunting for a five-dollar bounty.[197] Attempted gold mining at the abandoned Muldoon Mine in the Parker area.[198] For many, hardship and sacrifice became the new reality after the relative prosperity of the 1920s. The Great Depression exacerbated the struggle already challenging ranchers and farmers reeling from the deflated prices and debt accrued during a period of overproduction for World War I. This affected the price of produce and land with credit being withdrawn, loans called in and foreclosures on property.[199] Signaled by the stock market crash of 1929, severe unemployment and disasters plagued the next decade, such as the Dust Bowl that ravaged agricultural areas, including Colorado's eastern plains, by blowing topsoil miles away. The experimental legislation and programs initiated during this time to ameliorate the toll on people and their livelihoods left a notable legacy.

Livestock prices dropped further during the Depression. For example, hogs selling for $12.10 in 1929 sold for a maximum of $3.10 in 1933. Potatoes selling at $1.40 a bushel dropped to $0.24 cents a bushel in 1932. The cost of harvesting often left crops rotting on the ground.[200]

The flight of some to cities and the loss of property to foreclosure for others paved the way for absentee owners and tenant farmers.[201] Tenant farmers accounted for 23 percent of the total number of farmers employed in Colorado in 1920. By 1930, this number had increased to almost 35 percent.[202] One-fourth of Coloradans who were employed in the 1930s were working in agriculture, but by 1940, this decreased to one-fifth.[203]

While agriculture supplanted ranching overall in Colorado in the 1930s, Douglas County was mostly ranchland with crops and dairy used to supplement incomes.[204] Those ranchers who owned their land and were not in debt could feed their families during the Depression, a tenuous prospect for those dependent on wages.[205]

Colorado State University (CSU) helped farmers by developing drought-resistant varieties of wheat, corn and other crops.[206] Bill Noe of Larkspur, whose grandfather Isaac "I.J." Noe owned the Eagle Mountain Ranch, recalls accounts of ranches lost due to foreclosure. Bill Noe learned about CSU experimenting at Eastonville, roughly between Larkspur and Monument, to determine what crops, such as winter wheat, would grow in an area once dominated by turnips and later by potatoes. CSU and the farmers tried grains since the horses did better on these than on plain grass.[207]

With 66 of Colorado's 237 banks failing, Douglas County banks suffered as well.[208] For example, in 1932, the Castle Rock State Bank closed its doors due to market conditions.[209] Eventually, the federal government closed all banks for a period of time in order to decide which banks had enough money to continue, creating the Federal Deposit Insurance Corporation (FDIC) to insure deposits.[210]

Elected in 1932, President Franklin D. Roosevelt (FDR) launched the New Deal, an experimental succession of programs and legislation aimed at relieving the suffering from poverty and unemployment afflicting so many in the nation. These programs addressed a wide range of issues including banking, child labor, employment, conservation and agriculture.[211] For example, the Agricultural Adjustment Act of 1933 paid farmers to decrease the production of crops and animals.[212] The Social Security Act was signed in 1935.[213]

Another New Deal program, the Works Progress Administration (WPA), employed more than 8.5 million people building bridges, roads, public buildings, parks and airports.[214] In Douglas County, the WPA enlisted men from county relief rolls to build bridges in response to flooding as well as employing Douglas County women for sewing projects.[215] WPA workers also installed curb and gutters on Wilcox Street in Castle Rock, with the town providing equipment and tools, and "they [made] a mighty fine job of it."[216]

In per-capita expenditures by New Deal agencies, Colorado ranked tenth out of forty-eight states during 1933 to 1939, but when the Depression began Colorado lacked a sales or income tax for revenue.[217] The federal government would not continue funding relief without state contributions. As a result, in 1933, Colorado appropriated funds to buy cattle to feed those

The Castle Rock Star, erected during the Great Depression as a hopeful means of enticing travelers into town, has remained a treasured holiday symbol. *Ed and Nancy Bathke Collection.*

in need and instituted a 2 percent sales tax to raise relief money.[218] Colorado amended its constitution in 1936 to provide pensions for elderly citizens in need, using money from sales, liquor taxes and liquor licenses.[219] The same year saw the state's first tax on individual and corporate income with the initial proceeds going to public education.[220]

Notwithstanding the decade's trials, Douglas County people enjoyed themselves. They "made their own entertainment," playing cards, engaging in turkey shoots and attending box socials. Louise Beeman Hier and Florence Campbell Beeman recalled "canned music" from a record player brought to the Grange Hall on Saturday nights for dances charging about fifty cents.[221] In April 1938 alone, the *Record-Journal* reported various activities: Douglas County schools held a track meet and organized a county music festival, the American Legion sponsored a dance at Franktown, the Hilltop Social Club decided to hold a mother-daughter tea and the Douglas County Woman's Club was raising funds to reduce cancer mortality.[222]

Looking for a way to bring hope and income to a struggling economy, the town of Castle Rock installed and lit its famous beacon star in 1936 to attract travelers. Volunteer firemen carried 40-foot steel rods up the 290-foot rock and welded them together. For a token amount, George P. Stewart gave Castle Rock's prominent rock and surrounding land to the town.[223]

According to Laurie Marr Wasmund, in the 1930s her mother, Wilma (Scott) Marr, who still lives in the area "and Willard Monk were eighth graders, and they were the first to sing at the Castle Rock Starlighting Service."[224] Decades later, visitors enjoy Rock Park and the winter-holiday lighting ceremony.

According to the *Record-Journal* in 1933, businesses in Castle Rock committed to making a success of the National Recovery Act, a complicated legislative act aimed at fair competition through an alliance of industries, with mixed results.[225] Castle Rock businesses that agreed to change their hours in accordance with the new legislation were Arapahoe Food Store, Kroll's Grocery, Woltzen's Community Cash Store, Castle Rock Meat Market and Eichling's Dry Goods.[226]

Douglas County continued a commitment to education amid the tough economy. Reporting as early as 1904, the *Record-Journal* republished information from *World's Work* stating that a high school education increased the chances for success for a common schoolchild by eighty-seven times.[227] Even in 1923, the newspaper highlighted citizen concern that the number of schools in Douglas County was insufficient to serve the increasing number of students.[228] Despite the Depression, county taxpayers voted to issue bonds, matched with federal dollars to improve the Douglas County High School building, the only high school at the time with an average graduating class between twenty and thirty-three students.[229]

In the early 1930s, 54 percent of young men between the ages of seventeen and twenty-five were out of work or employed in unsteady, low-paying jobs. The Civilian Conservation Corps (CCC), nicknamed "Roosevelt's Tree Army," was born from pairing "wasted" land with languishing youth who lacked job skills and experience, an effort to save both the land and the youth. Perhaps the most popular program of the New Deal, the CCC aimed to provide sufficient employment to take care of the men and their families.[230] Unlike the WPA, which gave work to those hired locally, the federal government hired and supervised the CCC men.[231] This ambitious and innovative program required the coordination of the Department of Labor for recruitment, the War Department for training and the Department of Agriculture to organize the work.[232]

Camp 1845, originally a drought-relief camp under the Forest Service, changed to a CCC camp under the U.S. Army. Camp 1845 was located in McMurdo Gulch. Initially, young men lived in tents, but construction for a permanent camp occurred later resulting in five barracks, a recreation hall, a mess hall, a headquarters building and a latrine and washroom.[233] Little is left to mark where the camp stood, but a few remains can be seen east of Founders Parkway on Castle Oaks Drive in Castle Rock.

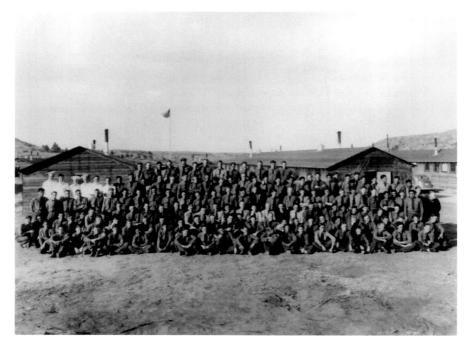

Young men of the Civilian Conservation Corp Camp 1845 (earlier known as Camp SCS-7-C) gathered for a group photograph in March 1938. The CCC camp was located in McMurdo Gulch near present-day Castle Rock. *1998.027. Douglas County History Research Center.*

Men were moved from cities and other states to work in the CCC. The railroad delivered them from Massachusetts and Vermont, but according to Camp 1845's early roster, many men were from Colorado and its rural areas.[234] For their work in the program, the men received clothing and housing plus thirty dollars a month with twenty-five dollars of that money sent to their families.[235]

McMurdo Gulch was named after the great-grandfather of John Berry of Castle Rock who homesteaded the area. Berry's father, Tom Berry, went into the CCC as a teen and then into the U.S. Navy. Berry recalls his dad showing him some check dams that he built during his time with the CCC.[236]

In Douglas County, the young CCC men worked on various projects: dams, diversion ditches, contours, terraces, pipe lines, fences, levies, dykes, jetties, bank slopes, excavations, quarries, seed collections, surveys, rodent control and emergency work at Franktown during the 1935 flood.[237] After noticing work being done by CCC, the Douglas County Martin family asked

Above: This Castlewood Canyon Dam photo, circa 1910, shows a terraced wall on one side of the dam. *1993.005.0027.002. Douglas County History Research Center, Helen Oltmans Collection.*

Left: Ruins of the Castlewood Canyon Dam are visible from the hiking trails in the Castlewood Canyon State Park are shown in this 2014 photo. *Susan Rocco-McKeel Collection.*

for assistance with soil erosion from hard rains, and the CCC reached an agreement to help.[238]

Citizenship improvement and job skill development became an added focus for the CCC. Nationally, 90 percent of the men took classes offered in the evening such as literature or welding. In a span of nine years, the CCC taught forty thousand illiterate men to read.[239]

Throughout the nation, CCC men participated in planting three billion trees between 1933 and 1942, renewing the nation's forests, which had decreased from 800 million acres of virgin forest to only 100 million acres.[240] Locally, the CCC aided efforts for Douglas and Elbert Counties' grasshopper plague of 1936 to 1938 and for emergency help during Castlewood Canyon Dam break.[241]

In 1891, the *Castle Rock Journal* wrote that expert engineers were examining the Castlewood Canyon Dam, located southeast of Castle Rock, planning its strength to "not only hold water but be absolutely safe beyond a possibility of doubt and thus forever silence the howls of those…who have tried to obstruct the progress."[242] Of the dam built by horse, mule and man in 1897, the *Journal* reported that "the floods this week have caused rumors of great danger to Castlewood Dam, but the *Journal* is now safe in saying that the danger is past."[243] In 1900, the dam's engineer wrote a letter to the *Times*, stating, "the Castlewood dam will never, in the life of any person now living, or in generations to come, break to an extent that will do any great damage either to itself or others from the volume of water impounded."[244] However, by 1933, the *Journal* was reporting that heavy rains had washed out the dam.[245] The floodwaters reached Denver, killing two people and an uncounted number of animals and causing over $1 million dollars in damages, the equivalent to $18 million today. It was estimated that 1.7 billion gallons of water were released.[246] Since the dam's conception, controversy had hounded the dam project with issues related to financing and safety, as well as multiple changes in ownership.[247]

Nettie Driskill Harth was earning ten dollars a month plus room and board at the Parker telephone exchange when the dam broke. Witnessing the water and debris flowing to Denver, she warned people to leave and move their livestock.[248]

Besides serving as an important source of water for agriculture during its use, the dam had provided a scenic recreational area for others in Colorado and beyond. In the 1930s, Harvey B. Cochran of Denver explored the dam area before it broke. Driving in a friend's obsolete Model T, which only sold for about twenty-five dollars at this point, and scrounging gas money when

Young men of the CCC Camp SCS-7-C built this dam, which still stands. It is located off Upper Lake Gulch Road near Caslte Rock. *Susan Rocco-McKeel Collection.*

it was fifteen cents a gallon, Cochran and his friend would go to Castlewood Canyon, shooting and walking across the dam.[249]

Mickey Gates Maker witnessed the flooding that reached the Denver area when he was nine. "Dirty brown water was raging down the creek in great waves piling on each other and carrying whole trees and houses with it."[250]

Although the dam and the water are gone, visitors continue to experience Castlewood Canyon's rugged beauty through its thirteen miles of hiking trails and established picnic areas.[251]

In 1935, FDR authorized the expansion of the CCC's Veterans' Contingent, with selection of men from veterans permanently residing in Colorado. The pay was thirty dollars per month with maintenance and clothing. Preference was given to new enrollees and those who would give three-fourths of their pay to their dependents.[252] Although the emergency conservation legislation had broad public support, Congress did not create a permanent agency to continue the work.[253] The CCC was never abolished, but funding ceased in 1941 due to factors such as decreasing enrollment and an emphasis on defense for World War II.[254]

While the federal government provided significant programs to help the nation recover from the Great Depression, the nation did not rebound until World War II, when workers made weapons and supplies for the United States and its allies, as well as raising cattle and sheep to feed them.[255] The

dire circumstances of the Depression generated experimental endeavors, some of which are institutions today, such as Social Security and the FDIC.

Succeeding generations have benefitted from the labor of the Works Progress Administration on national parks and the Civilian Conservation Corps' efforts planting trees and building dams that shaped the Douglas County landscape. The spirit of the CCC, as the steward of natural resources through training youth workers, is ongoing today. The Southwest Conservation Corps is built on the CCC model, providing young men and women with service and educational opportunities through natural resource stewardship.[256]

The Veterans-Youth Conservation Corps Partnership brings youth and veterans together for employment and job training while working to restore Colorado's public lands.[257] John Evans, Parker attorney and former Douglas County state senator, continues the legacy of utilizing veterans' experiences. Evans is the executive director and a founder of School Leaders For Colorado. The organization takes leadership skills gained from military service and combines them with instruction and mentoring for eventual school principalship.[258]

Douglas County has derived a rich heritage from a decade of difficult economic challenges. That heritage has defined parks, refined the landscape and developed programs for youth, seniors and veterans with an entrepreneurial spirit that is evident today.

10

WORLD WAR II: DOUGLAS COUNTY SERVES THE COUNTRY

by Mark A. Cohen

World War II changed the lives of Americans, including those living in Douglas County. In the week before the Pearl Harbor attack, the front page of the December 5, 1941 issue of the *Record-Journal* discussed farmers' meetings, weddings, class plays and shoring up the Navy. President Roosevelt asked Congress for more military appropriations and a partial repeal of the "Neutrality Act."[259]

Within a week, the *Record-Journal* published war bond ads and cartoons supporting the U.S. war effort. Ads against the Axis powers appeared, imploring all citizens to make sacrifices. Children could earn money by collecting junk. Citizens were asked to place 10 percent of their earnings into war bonds and war stamps. Boys younger than draft age, which was eighteen years old, were expected to join the armed forces when old enough.[260]

One ad titled "Whose Boy Will Die Because YOU Failed?" urged the public to turn in scrap metal "NOW!" In January 1943, the *Record-Journal* featured a front-page story on a new "Victory Tax." Every worker earning more than twelve dollars a week was required to pay 5 percent of his gross income over twelve dollars. The Colorado government erected a massive scoreboard on the state capitol grounds in Denver to keep track of each county's war contributions. By 1944, the war had taken over the front page of the local newspaper, filling it week after week with patriotic images and articles.[261]

The population of Douglas County remained steady around 3,500 people from 1920 until 1960, when the census recorded 4,816 residents. Viewed another way, the total number of high school graduates in the entire county in 1949 numbered 38. A scant 316 people from Douglas County enlisted in the armed forces during World War II.[262]

SEDALIA RESIDENT BILL BRUNGER SERVES IN THE INFANTRY

Bill Brunger, born Wilbur H. Brunger in 1923 in Denver, had completed his first year in engineering at the Colorado School of Mines when duty called. He attended basic training at Fort Belvoir, Virginia, and then became an instructor of new recruits for a year. Selected to fly the P-38, the first fighter to exceed four hundred miles per hour, Bill only required ten more hours of flight training to prepare for his first solo.

Then the Army changed plans, announcing that all servicemen with previous infantry training would be shipped overseas. Brunger joined the Seventy-fifth Division at Camp Breckinridge, Kentucky, with orders to serve as a platoon sergeant. Brunger became one of about four thousand troops who traveled to England at the end of 1944, sailing on the cruise ship *Franconia* as part of a sixty-five-ship convoy escorted by two destroyers.

Brunger's first action occurred on the night of December 27 in a thick fog. He shot his Garand rifle at the sound of rustling or gunfire. He could hear the enemy screaming, taunting the American soldiers with the names of baseball players, actress Mae West and President Roosevelt. His battalion of eight hundred ignored the verbal abuse, concentrating on battle and killing about five hundred enemy soldiers. As dawn broke, the soldiers realized the enemy had been very close: they could reach out and touch dead soldiers. They learned that the deceased were German SS elite, not regular troops.

Due to the intensity of the fighting, soldiers found it impossible to stop for every wounded man. Once, a man next to him was drowning in his own blood from a shot in the throat. Brunger and a fellow soldier performed a tracheotomy with a fountain pen before moving on. They later heard the man survived.

Bill Brunger never received an injury, although two watches were shot off his wrist. His company entered the Battle of the Bulge with 186 men and

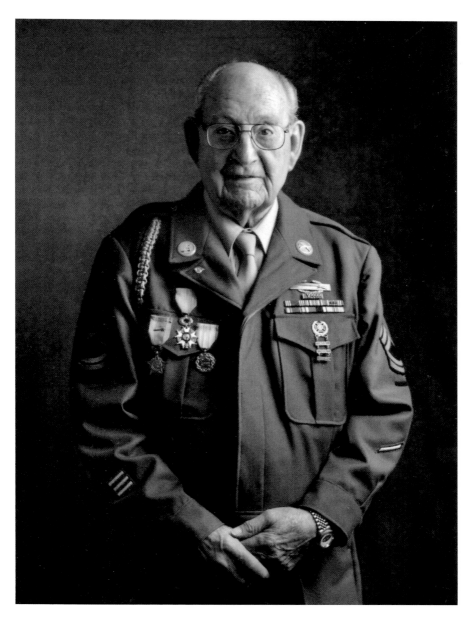

Sergeant Bill Brunger, pictured in his U.S. Army uniform from World War II, received the French Legion of Honor Award in 2013 in Denver. *Adam Williams Photography.*

left with 20. He credits his survival of the war years to his mother, who sent him a letter through V-mail that contained a verse from a hymn: "Anywhere with Jesus, I can safely go, / Anywhere he leads me in this world below, / Anywhere without him dearest joys would fade. / Anywhere with Jesus, I am not afraid." Brunger carried this message with him throughout the war, and he framed it for his war display in his basement.

"Being scared and being afraid are different to me. Everybody's scared in combat when bullets are coming at you and artillery is firing. But I was not afraid. I knew from my belief in God that what was going to happen was going to happen. I could be a better soldier because of my belief," said Brunger.

Brunger fought in the Battle of the Bulge in Belgium. He then served in the American Seventh Army under the French First Army at Alsace-Lorraine. His outfit later relieved the British Second Army in Holland. Next, his unit was assigned to the American Ninth Army on the other side of the Maas River. His unit crossed the Rhine River into Germany to fight until the war's end.

After World War II, Brunger and his father started Arapahoe Plumbing and Heating, serving businesses and families. In retirement, he and his wife, Janet Brunger, have traveled to many of the places where he fought in Europe. The couple has also worked with the Greatest Generation Foundation in Denver, which sends veterans on three-day trips to the World War II Memorial in Washington, D.C. These trips allow World War II vets to bond with one another and heal emotionally from the traumas suffered during the war. Mr. Brunger also started speaking in schools about his war experiences three years ago.

The United States awarded Brunger with five Bronze Stars and one Valor Award. The fifth Bronze Star, awarded in 2013, was for action that occurred seven days into combat. This seventy-year delay occurred because of a fire at the St. Louis Records Center that destroyed many records. The French recognized him for service in the Colmar Pocket and, in 2012, bestowed on him the French Legion of Honor, the highest honor the French can give to a citizen of another country.[263]

The Van Lopik and Curtis Stories

Justin van Lopik (1924–1997) served in the Pacific Theater in World War II. After the war, Justin became a deacon and later a pharmacist. He was the

son of J.A. van Lopik, mayor of Castle Rock in 1941. Justin's brother-in-law, Bernard Curtis, born and raised in Sedalia, joined the Navy on October 11, 1940. Curtis married the mayor's daughter, Mary Elizabeth van Lopik (1918–1988), in Reno, Nevada, while on leave from duty in California. The Curtises were married for only six months. Lieutenant Curtis was "killed in enemy action" on November 13, 1942, at the age of twenty-four, near the Solomon Islands in the Pacific, according to the *Record-Journal*.[264]

Mrs. Curtis received a telegram informing her of her husband's death. The message, signed by Rear Admiral Randall Jacobs, chief of Naval Personnel, extended sympathy for her loss and asked her not to "divulge the name of his ship or station."

Curtis's funeral service was held on January 3, 1943, in Castle Rock. The military posthumously awarded Lieutenant Curtis, a survivor of the Pearl Harbor attack, the Purple Heart. The medal is awarded in the name of the president of the United States to those wounded or killed in service.

Mrs. Curtis never remarried. She moved to Chicago and became a buyer for Spiegel, sending frequent photos of her adventures to her family in Castle Rock. She died in 1988 in Hawaii at the age of seventy.[265]

GEORGE SALVADOR SERVES WITH AN ARMY AIR CORPS SQUADRON

As a part of the Remember Our Veterans (ROV) Project, supported by Douglas County Libraries, George Salvador and other veterans speak regularly at Douglas County High School to help educate our youth about America's involvement in World War II and other wars.

George Salvador—born in Trinidad, Colorado, and brought up in Spain—fought against Spain's fascist dictator Francisco Franco as a member of the Spanish Republican army.

"Franco won the [Spanish Civil] War," Salvador said, explaining that he lived in a French refugee camp after fleeing Spain. The war claimed thousands of lives, including a brother-in-law and many of Salvador's friends and schoolmates.

Salvador said the refugee camp was "more like a concentration camp" than any of the kinder, softer descriptions. Despite the fact that the camp housed over 100,000 "refugees," he recalled receiving a stunning phone call one day from the American Consul.

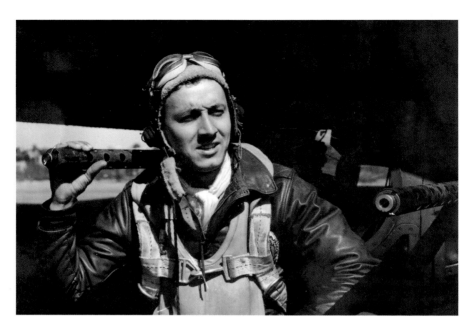

George Salvador, age twenty-four, posed for a photograph on June 6, 1944 (D-day) at Great Ashfield, England, after his twenty-sixth and final mission. *George Salvador Collection.*

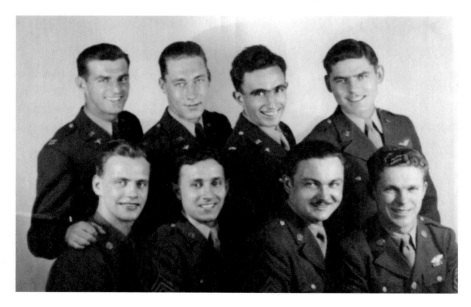

Crew members, *top, left to right*: Frederick Heiser, Bob James, John F. Hills and Carlyle Hanson; *bottom, left to right*: Richard Schultheis, George Salvador, A.J. (Tony) Aidjinski and John A. Dougherty. *George Salvador Collection.*

"Your name is George Salvador. You were born in Colorado. Do you have a birth certificate?" asked the caller. Salvador did have his birth certificate and, a month later, received an American passport.

"I was on my way to America," Salvador said. He departed, leaving behind his father and other relatives in the camp in France. His father survived the war.

Back in Colorado, Salvador lived with an uncle and worked in the coal mines. After the Japanese attack on Pearl Harbor when he was twenty-two, he enlisted in the U.S. Army and was assigned to the Air Corps. The Army needed pilots, but he doubted his abilities. Despite his fluency in four languages, he found English the most difficult. He gave credit to his wife of sixty years, Alice, for teaching him.

"He was a terrible student," she said. Alice chuckled about it, and George—with a detectable accent—insisted he is still learning.

Assigned to the Motor Pool after basic training, George became a driver for the squadron commander. Motivated by hatred for Franco and a desire to liberate his family in German-occupied France, he asked the general if he could fly. George received permission to take an assignment on the B-17 bomber. Due to poor English, he became a ball-turret gunner, not a navigator. On one mission, his plane was hit.

"They shot my ball-turret gun, and I lost my heating system. It was twenty degrees below zero, and I felt pain in my legs," Salvador said. The crew pulled him out of the plane and wrapped him in a wool blanket. Temporarily paralyzed from the hips down, Salvador was lucky. The doctor told him that if he had been in the plane for five more minutes, he'd have died. Although Salvador qualified for the Purple Heart, he refused the honor.[266]

Another time, his squadron lost seven planes. Flying back from a mission over Berlin, Salvador's plane lost two engines, one on each side. One choice was to bail out over France, where his family was held captive. The pilot said, "I think we have enough gas to make it to the Channel, and we're going to ditch." However, the Polish tail gunner protested in broken English: "Please no bail out us at the sea? I don't know how to swim."

The captain laughed and said, "Well, let's see if we can make it to England." They threw some of their heavy items into the Channel to lighten the load, and the crews made it back to England. After landing, the men counted 322 bullet holes in their damaged plane.

"After twenty-five missions you were allowed to go home," George said, but his twenty-sixth mission coincided with the morning of D-day. Due to the need for the mission, he had volunteered, while knowing he could legally opt out. On June 6, 1944, the D-day invasion on Normandy's beaches, Salvador flew overhead.

"We saw hundreds of ships and lots of air traffic. The beaches were full of people lying down. I didn't know if they were dead or just lying down, and then the Germans running, running, running, you know, and shooting. When we got back, the whole crew was crying—it was so terrible," he recalled. Salvador is one of the few remaining B-17 crew members left to tell the story firsthand.

After the war, Salvador earned his engineering degree, brushing elbows with many famous people while working with NASA for Rockwell International. He shared that he participated in the selection of the original Mercury astronauts and worked on the Apollo program with Werner Von Braun. Today, George and Alice live at Bonaventure Senior Living in Castle Rock.

LOU ZOGHBY OF CASTLE ROCK SERVES WITH AN AIR CORPS GLIDER DIVISION

Louis Zoghby (pronounced "zo-bee"), an eighteen-year-old eager to attend college, was drafted in March 1943. Instead of protesting like some did, Zoghby felt a duty to contribute. The military moved him into the Army Specialist Training Program (ASTP), assigning him to attend classes at Harvard University.

At Harvard, a captain's secretary with the Women's Army Corps invited Lou to accompany her to a presentation. The tickets were usually reserved for officers, but by happenstance, a WAC and an enlisted man found themselves sitting next to colonels and generals. Zoghby noticed that "everybody in the place was wearing all the brass there ever was."

A colonel leaned over and asked Zoghby what the hell he was doing there, to which Zoghby replied that he had been invited. He then listened to British prime minister Winston Churchill speak for an hour.

Some 200,000 young men, ages eighteen to twenty-two, were enrolled in the ASTP program in 1944. Then, the students heard a rumor that the Army was going to disband the group of potential pilots and send the participants to the infantry. A bunch of them "went down to Boston to what was called the First Service Command of the Army." Zoghby volunteered for the Army Air Corps on the spot.

The Army Air Corps assigned him to the Seventeenth Airborne Glider Division in March 1944. Zoghby felt terrified because gliders, also known as "flying coffins," were hard to control. His squadron missed the June D-day mission, arriving in England in August 1944.[267]

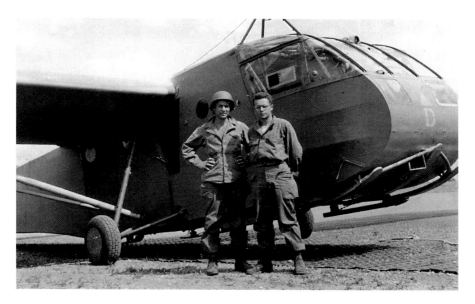

Lou Zoghby (left) and a fellow soldier stand next to a glider used to deliver troops from the United Kingdom to Europe during World War II. *Lou Zoghby Collection.*

The squadron's first duty was to dig foxholes to sleep in. Due to the cold temperatures, the men's shovels would not penetrate deeper than four inches. They perspired while digging. Zoghby hung up his overcoat on a branch in order to nap; but while he slept, the coat froze solid. As his unit moved out, he carried his outer garment as if it were a body. Other soldiers made fun of the coat's manlike shape, asking, "Who's your friend?"

Zoghby did not shoot directly at German troops, nor did he find himself in line of fire; however, he did get within one thousand feet of enemy soldiers. He received a single wound from a mortar shell—a scratch on his hand. He could have accepted the Purple Heart and returned home. He refused. At times, he wondered why he had been spared when others lost limbs or their lives.

"I was very lucky—in the right spot at the right time," he said. He fought in the Battle of the Bulge from December. 16, 1944, through January 25, 1945. The term "bulge" came from the shape of Hitler's forces on a map of Belgium.

Back with his glider squadron, he prepared for the First Allied Airborne Army's "Operation Varsity" in March 1945. The Air Corps tried a new approach regarding glider operations by attaching two Waco CG4A gliders to one tow plane.

"Well, that was a disaster, because as you can imagine, two gliders were on three-hundred-foot lengths of rope, and the wings were practically touching," said Zoghby. The unarmed gliders each housed one pilot and fifteen men, in rows of seven and eight facing one another, knees almost touching. After flying through the safety of Allied-controlled air space, the gliders soared over enemy territory for nine minutes.

"Nine minutes doesn't sound like much, but nine minutes over enemies when they're shooting at you with handguns and rifles…" Zoghby shook his head, remembering. Then he continued the story. "One soldier suddenly said, 'I'm hit.'" Then the man turned white. The bullet had entered his thigh, right up through the glider. Bullets came through the wings.

The planes released hundreds of gliders, and as they came down, some crashed. "You know, it's not like a plane, where you can maneuver," Zoghby said. He felt lucky just to have survived the landings.

The men scrambled through the countryside for several days, trying to catch up with their units because the gliders had missed their planned landing points.[268]

As many who survived war, Zoghby had several close calls. On one occasion, a mortar made an unmistakable whizzing, whistling sound above his head. He instinctively listened for the explosion, but instead heard a dull thud. When he peeked out from under his helmet, he saw the unexploded shell two feet from his head.[269]

GOLD STAR BOYS

"Gold Star Boys" was a designation given to American soldiers who died in World War II. Fourteen men from Douglas County died in the war: Frederick L. Angel, Eduard Lee Armeni, Dorsey Cain, Thomas P. Chrisman, Bernard John Curtis, Walter D. Edwards, Keith Melvin Gordon, Byron Higgins, Donald Robert Nelson, Jack Charles Nipho, Tony Perez, Edson Monroe Raymond, Raymond J. Woodbury and Alton L. Wyatt.[270]

News anchor and author Tom Brokaw called the men and women who served in World War II "the greatest generation" in his book of the same name. Those who did not serve think of these veterans as the brave heroes who saved the United States and its allies from tyranny. Those who did serve see it differently: they see themselves as lucky survivors who simply did their duty.

THE HEROES RETURN HOME

by Kimberlee Gard

The year 1945 brought change to the nation. The war was over, and heroes came home. Like many, John K. Emerson found himself on a final train ride across Europe and boarded a Liberty ship home.

"I felt the exhilaration of being alive in anticipation of coming home," Emerson said. Traveling across the ocean, he remembers hit tunes like "I'm Beginning to See the Light" playing all the way to Boston Harbor. After the men processed through Camp Miles Standish, the crowds welcomed the men home with applause and band music, celebrating the victory of the country and the men who returned. On a troop train to Colorado, John Emerson witnessed people lined up along the tracks cheering and waving flags. At every station, local people served all types of refreshments. After arriving home, Emerson was so elated that the war was over he ripped the dog tags from around his neck and threw them as far as he could.

Virginia Nielsen, a high school student during the war years, loved to dance. With so many young men away serving in the war, school dances were often a lonely event. That changed in 1945 when the young men came home. That year, Virginia met Jack Muse, who was recovering at Fitzsimons Army Hospital after being injured in the war. A retired World War I Army captain often drove the service men around, and during one of those outings, Jack was introduced to Virginia. Later, Jack accompanied Virginia to her senior year dance.

Virginia and Jack Muse, longtime Douglas County residents, pose for a photo before a high school dance after Jack returned from World War II. *Kimberlee Gard Collection.*

Jack and Virginia dated all summer, often making the trip to historic Elitch Gardens in northwest Denver to dance and hear the bands play. After these romantic evenings, Jack always caught the last bus back to the base at Fitzsimons. One night however, he was late, and he rounded the corner to see the bus driver waiting for him. "It was a time when people looked out for one another," he said. Jack and Virginia were later married, and like many others, they turned a new chapter in their lives and started a family. After living in Denver for many years, Jack and Virginia moved to Parker and became well known in the community for raising champion Morgan horses.[271]

GROWTH IN DOUGLAS COUNTY

Situated between Denver and Colorado Springs, Douglas County and its towns experienced economic growth from the postwar boom. In the 1940s and '50s, the county was still primarily rural, dominated by dairy and cattle farms and working ranches of hundreds or thousands of acres. Family homesteads throughout the county—the ones that had endured the Depression and the war that took the young men across the sea—began to grow and diversify. Many families added operations such as dairy work, hay cultivation and farming corn or other new crops.

Local residents who lived on the ranches remembered the diversification. Elizabeth Saunders, who operated the Denver and Rio Grande Western depot during World War II because the few able-bodied men in Douglas County were involved in the war effort, said her family raised feeder cattle and dairy cows, corn, alfalfa hay, pigs and potatoes on a ranch southeast of Castle Rock.[272]

For many ranchers, the years after the war brought promise. Before the war, Douglas County rancher Lawrence Phipps Jr. bought the Diamond K ranch. In 1943, he added to his land by purchasing the failing Welte farm property along Big Dry Creek. Later, with other land purchases, the consolidated property brought the new ranch size to twenty-two thousand acres—making Diamond K one of the largest ranches in the county. Lawrence Phipps Jr. changed the name to "Highlands Ranch," reclaiming an earlier name and adding an *s*. Highlands Ranch, with its bluffs and rolling hills, survived and prospered as a cattle ranch, sheep ranch and headquarters for the Arapahoe Hunt Club.[273]

For many Douglas County ranchers and farmers, determination and strength saw them through hard times. Residents fought hardships of summer droughts and winter blizzards, including a record thirty-eight inches in the

winter of 1946. Families living on Douglas County homesteads were isolated for days, as were the citizens who lived in town.

Saunders remembers the blizzard of 1946 paralyzed the town of Castle Rock. "The only way to travel was on foot because vehicles could not get through the snow," she said. The blizzard came right at election time, and for many like Elizabeth Saunders, the only way to vote was to wade through the snow to the courthouse.[274]

Another assault of nature hit homesteads in the summer of 1958, going down in history as "the year of the grasshopper plague." The creatures numbered twenty-five or more per square yard in most areas, and they ate everything in sight chewing holes in door screens and window frames. Farmers would bury their shovels and pitchforks in haystacks when they left the fields in the evenings to keep the grasshoppers from eating the handles. Despite such challenging events, people said that the hardships formed a unity among neighbors. Local resident Doris Johnston said, "Neighbors helped each other and relied on each other."[275]

THE B AND B CAFÉ

The favorite Castle Rock establishment and the local hot spot for town gossip made history one fateful winter day in 1946 when a shootout shocked the town. Three days before Valentine's Day, eighteen-year-old Manuel Perez shot and wounded two Denver police officers. The fugitive eluded authorities, hiding in the gulches around Castle Rock until hunger lead him into the B and B Café on February 14, 1946. While dining, other restaurant patrons recognized Manuel Perez. Town marshal Ray Lewis, the only law enforcement officer in town that day, was summoned. When Sheriff Lewis arrived and questioned Manuel Perez, Perez pulled a revolver from his coat and fatally shot Marshal Lewis.

B and B Café patrons jumped in. Armed only with a flowerpot and hunting knife, several people tackled Manuel Perez and subdued him. While no one else was killed, several shots were fired during the struggle leaving bullet holes in the pressed-tin ceiling that can still be seen to this day.

Although residents inside the B and B Café suggested hanging Manuel Perez from a tree in Courthouse Square, Perez was held until the undersheriff, Duncan Lowell, arrived to make the arrest. Manuel Perez was sentenced to life in prison and later killed in a prison knife fight.

News of the shooting circled the community as the town of Castle Rock grieved for one of its own. In 1953, the Castle Rock Town Council approved the change of name from Main Street to Lewis Street in honor of town marshal Ray Lewis.[276]

BUILDING COMMUNITY

With the hardships of World War II now in the past, the decade gave birth to the suburban dream. The years following the war brought a revival to the nation, and Douglas County was no exception.

The grange movement started in earlier times but became prominent after the war. Among the first in the county were Pike's Peak Grange No. 163 and Sedalia's Sunflower Grange No. 162. They, like granges across the nation, became the "voices of America." The granges offered social events, educational lectures and legislative programs. And that was not all—the grange social clubs held monthly meetings, and people often gathered for bowling, games of horseshoes, potlucks and summer picnics.

In 1958, Douglas County schools were consolidated, marking the beginning of the end of the various one-room schoolhouses spread all over the county.[277]

Stores in the area shelved the iconic toys of the day. Radio Flyer wagons, bicycles, hula hoops, Frisbees, Slinkies and Barbie and Davy Crocket figurines were among the favorite possessions of the youngest generation. Teens frequented shops like the Van Lopik Drugstore, sitting and socializing over shakes and malts at the soda fountain. The 1950s brought rock 'n' roll, drive-in movies and school sock hops to Douglas County youths looking for fun.

The Parker Community Center was opened in 1951, creating a space for community meetings, dances and basketball events. The Parker High School basketball team, which, prior to the Community Center, had practiced and held games in a railroad shed, played ball in the new facility. The players expressed enthusiastic appreciation for a building in which they no longer had to pull splinters from their shoes and hands.[278]

In another part of the county, residents of Louviers frequented the Louviers Village Club—home to bowling leagues, nightly card games, dances and first-run movies offered every Friday night. The Louviers Village Club still houses the oldest bowling alley in the state.

Local granges, like the Pikes Peak Grange No. 163 in Franktown, hosted many community events. Grange No. 163 is still in use today. *Jean Jacobsen Collection.*

Many teens and children in the rural areas of Douglas County made their own fun. Fishing was a popular pastime for boys and girls alike, as was splashing in swimming holes along the Plum Creek and Cherry Creek. In the wintertime, youths ice-skated on the frozen creek beds.

The 4-H program grew in popularity during the 1950s, and the Douglas County Fair was known to be one of the finest in the state. Residents John Lowell, Charlie Sherlock and John Paulk pioneered the 4-H livestock sale, which would grow to be one of the most successful in the state, helping Douglas County youngsters raise money for college.[279]

The Douglas County Fair held the promise of opportunity for many children and young adults who often prepared for months to show their livestock there. The fair was held in the late weeks of summer, when schools were closed and students could participate.

For local families, the Douglas County Fair was the highlight of the summer, providing a livestock show, parade, dances, auctions, rides, competitions and games. This yearly event brought the community together. Cost of admission was $1.20, and attendance promised hours of fun.

For Douglas County, patriotism soared in the years after World War II. With people's newfound love and loyalty to the nation, the time after the war was a time of prosperity. The 1950s brought a sense of stability and contentment, and America found itself in a state of celebration. After overcoming the hardships of World War II, people across America showed a united sense of pride, and Douglas County joined the rest of the nation in a pledge of patriotism.

THE PURCHASE OF PERRY PARK

The once well-known guest ranch of Perry Park was sold in 1951 to Boyd E. Cousins, who desired the seclusion and privacy of a vacation retreat. The Cousinses quickly called the place "home." The property had been privately owned for the previous seventy-nine years, with the general public from the Front Range welcome to use the property as a favorite picnic spot. However, with littering and damage to the property, occasional shooting of livestock and unauthorized motor boating on the lake, Boyd Cousins eventually locked all gates and forbid entry to the property.[280]

The Cousins family owned Perry Park for the next decade and a half, spending many summers and holidays there. Late one summer night, the family dog alerted them to an intruder of sorts. Boyd Cousins woke to the barking dog and went out to investigate the noises. He was astonished to find a bear on the children's new trampoline, jumping back and forth from the trampoline to the higher leveled ground at the side until it was ruined.[281]

AN EXPLOSIVE PAST AND PROMISING FUTURE

The 1950s brought economic growth to the town of Louviers. Four-plus decades before, DuPont Company built the Louviers factory to meet regional needs and ship dynamite across the growing western region. Explosives were in demand for railroad and road construction as well as mining operations.

During the war, DuPont continued building explosives but did not contribute any to the war effort. Planes were banned from the airspace over

the DuPont operations all throughout World War II. Men on horseback patrolled the plant property. In the evenings, patrolmen rode the streets to make sure shades were drawn and lights were out because blackouts were required so the enemy could not locate Louviers.[282]

Louviers, located north of Castle Rock and Sedalia on Highway 85, had a reputation as a family town and a favorable place to live. This company town was self-contained with the exception of the Meadow Gold milk truck that brought fresh milk to the community. DuPont provided housing, medical care and a good salary. In 1950, the population was 350 people. Few occurrences disturbed the peaceful town, although in 1954, a heavy rainfall along Plum Creek swept away one of the bridges. In June 1958, DuPont Company employees and their families celebrated the company's fiftieth anniversary.[283]

Throughout the early decades of the twentieth century, the town played an essential part in the construction of Pike's Peak Highway, Moffat Tunnel, Glen Canyon Dam and major mining operations and activities.

MONSTER SIGHTED ALONG PLUM CREEK

Sedalia made headlines in 1954 when an article in the *Littleton Independent* claimed, "Curiosity on Plum Creek Bears Human and Animal Traits: Three Local Men Describe Antics of 'Ape-like' Man with Green Face." The article went on to say the men, three hunters from Colorado Springs, witnessed a hairy "monster" with perilous jaws and a green face tarrying along Plum Creek. The claim alarmed Plum Creek residents who demanded a posse be organized to find the monster.[284]

Within days, two thousand people swarmed to the area of the sighting hoping to see a glimpse of the monster and the thirteen-inch footprints it left behind.

A week later, hysteria ran though the community again when a woman reportedly saw the creature in her headlights, while traveling along Plum Creek Road.

Rumors flew among the townspeople, stating that the monster might be a prisoner released from a Littleton jail. Others thought the sighting could be a prank played out by the co-owner of a local radio station who rented a gorilla costume during that time. Later, local resident and school board member Mary Wilkinson admitted that she had been playing a joke on a

friend. Officials dropped the case. Local TV station Channel 8 produced a program on the hoax.[285]

HUNTING IN DOUGLAS COUNTY

Douglas County was once known as a "hunter's paradise," and the area remained popular with hunters into the 1950s. Many traveled from various places along the Front Range to camp and roam through the picturesque rolling prairies and ponderosa forests in pursuit of the hunt. The ghost town of Nighthawk and its neighboring town of Deckers brought many huntsman, fishermen and outdoorsmen to the county.

Ranchers and farmers throughout Douglas County trapped and sold muskrat and coyote pelts for profit while others, like Larkspur locals, Frank and Tom Garcilaso, held bear hunts. Many towns offered turkey shoots. Residents from all over the county gathered for the events, such as the Championship Turkey Shoot at Plum Creek in 1954. The Arapahoe Hunt at Highlands Ranch gave the wealthy of the region an opportunity to ride with the hounds in pursuit of coyotes—for the fun of the chase, but not

A group of hunters and fishermen gather outside the entrance to Twin Cedar Lodge, owned by Don and Jane Simeth. *1994.051.0001. Douglas County History Research Center.*

to kill a coyote. Equestrians throughout the county and the Front Range enjoyed the twenty-five-mile cross-country ride on horseback.[286]

For Douglas County, the time after the war was a time for family, and the booming prosperity of the 1950s helped to create a widespread sense of stability and contentment. The era created a wonderful sense of place for generations to come.

THE AGE OF AQUARIUS
AND 4-H

by Alice Aldridge-Dennis

The youth in Douglas County in the 1960s and 1970s lived in a place where everyone knew everyone else. They went to drive-in movies on hot summer evenings and sledded down closed-off streets on snowy winter days. The "ranch kids" rode the bus in to Douglas County High School, visited their "town" friends and rode horseback during free time. If town kids were lucky, their ranch friends had an extra horse or two—and they, too, could experience the thrill of open fields and the wind in their faces.

The United States faced major societal changes, with the '60s and '70s becoming a time of civil unrest—with women's rights, Vietnam War protests, the sexual revolution and more. The baby boomers, born into postwar prosperity, stepped into the spotlight, danced to the Beach Boys and embraced the messages of the Beatles. They were empowered by enlightened ideas and a celebrated youth culture.[287]

Photos from high school yearbooks in the Douglas County History Research Center show students who resemble their counterparts in other areas. In the '50s and '60s, rolled jeans and white T-shirts for the boys were in, with sweater sets, skirts and saddle shoes with Bobby socks for the girls. By the '70s, bell-bottom pants for both sexes and peasant tops and prairie skirts for the girls replaced the more wholesome '60s look. The boys grew long hair, and both sexes sported round, wire-rim glasses.[288]

The question is whether life in Douglas County changed as drastically as it did on the two coasts. Local baby boomers knew about the unrest, but life mostly went on as usual. First, farm and ranch life required hard work,

leaving little extra time; and the teens were supported by close-knit families and community ties built over generations.

In 1958, Douglas County School District was consolidated, closing one-room schoolhouses around the county and closing Parker High School, whose students joined their peers at Douglas County High School. Now students from all over the county traveled to Castle Rock by bus and by car.

Leeds Lacy, math teacher and coach, taught at Douglas County High School during the late '50s and early '60s. Douglas County was considered "country," but it was close enough to Denver and the mountains to excite people about two new opportunities. In 1960, Denver owned its first major-league sports team, the Broncos, and Vail opened the nation's largest ski resort.[289]

Lacy and his wife, Jan Lacy, who taught second grade at Castle Rock Elementary, deemed the county seat a friendly place to live and work. They spoke fondly of Superintendent Lowell Baumunk and their teaching colleagues.[290]

The first class at Douglas County High School to have its senior year in the new building on High School Road was the class of 1963. This was not an easy time because the Vietnam War had started, and the class lost several classmates.

High school sweethearts George and Joyce (Jensma) Hier of Sedalia married young, living in Castle Rock. Later, their small children liked to watch their parents play in softball games at Parker, Elizabeth and Franktown, since most towns had a team. The women's team would play first, and then the men's would follow.

"We kids would run around like hooligans or pilfer a bat and ball and play ourselves," said Robbie (Hier) Person. She and her brother Bruce liked bicycling to the Douglas County Fairgrounds, as well as going to the drive-in near "the rock," just off Highway 86 and not too far from their home. Their mother popped Jiffy Pop popcorn, put the children in their pajamas and piled them into the car.

By 1969, the young family had moved to Sedalia to have more connection with their extended family. The grandchildren remember their grandmother Harriett Beeman, age seventy, going up in a hot-air balloon on Sedalia Day.

In 1971, the Curtis branch of the family celebrated one hundred years of living on and working the Curtis Ranch. Cousins flew in from all over the country, staying with local family members. Children, including the Hiers and the Marrs, loved the games and activities. The gathering featured a greased-pig contest, pie eating, a dance, round and square dancing and period costumes.[291]

New people soon trickled into the area, joining the families of homesteaders and early settlers.

Betty Meyer, retired from Douglas County School District, left the panhandle of Texas after high school to study at Colorado Women's College in Denver. Later, she and her husband, Herb Meyer, an aerospace engineer at Martin Marietta, drew a circle on a map to find land partway between their two jobs. Then they waited for a piece of land to go on the market at a good price. The Meyers moved to one hundred acres west of Castle Rock in 1962.

"When we moved to Castle Rock, there was one stoplight in the county, at Fifth Street and Wilcox. We were all so proud, until Parker then got three. Wolfensberger Road, named after one of the old-timers, was just a gravel road," said Meyer.

With two boys and two girls, the family participated in 4-H, raising cattle on leased ground and filling their own ranch with horses, cats and dogs. Meyer taught, later earning a master's degree, certification in learning disabilities, and an EdS in school psychology. By 1968, she was district psychologist.

Meyer respected many of her colleagues, but she especially revered Bob Hier, who taught Latin at the high school and spoke five languages. "He was a remarkable guy, very well-read. He would help his former students who phoned him from college, including my own kids!" said Meyer.[292]

Not everyone moving south sought large acreage and ranch life. Once I-25 opened in 1952, some searched for a quieter life than Denver afforded. At the same time, some farm families became empty nesters with no one to take over the ranch work. Selling off land was a way to have retirement money. Part of the original Happy Canyon Ranch owned by the Schweiger family, was sold to the Happy Canyon and Surrey Ridge developments. According to the *Surrey Ridge Sentinel* newsletter (1998–2000), Surrey Ridge Units 1 and 2 were platted in 1966. "Developers envisioned a strong market for these two-acre lots if they could create a distinctive horse community. In nearby Happy Canyon, residents were required to keep horses in community barns. The SR developers hoped a unique horse community, with individual barns on private lots, would attract buyers," wrote Amy Flanagan in the October 1999 issue.

The first year in Surrey Ridge brought Henry and Helen Wells, their children and their horses. By the late '60s, the Wellses, Gensches, Davilas and Jensens built the first horse arena in the area. After that, holidays featured rodeos with contests for the residents.

By 1973, Surrey Ridge had forty-four homes on roads that were still unpaved. Residents often rode horses to Daniel's Park and other areas.

This unofficial history of Surrey Ridge was researched and written by Amy Flanagan of Surrey Ridge Estates. It was originally published in the Surrey Sentinel edited by Amy and her husband, Dave, in eight installments between October, 1998 and May, 2000.

Surrey Sentinel

Published Occasionally for the Loan Owners of Surrey Ridge & Surrey Ridge Estates by Amy & Dave Flanagan.

Way Back When - Part I
from the Oct 1998 Surrey Sentinel Vol. 5 Issue 6

And now for something completely different...some history of Surrey Ridge and the surrounding countryside. Amy has been busy gathering information from old newspaper articles, books, deeds, the Douglas County Historical Society, local realtors, an occasional bartender, and our neighbors that have been living here since the beginning of Surrey Ridge

In this installment we learn why Exit 191 is the Schweiger Exit and how Happy Canyon was named...

Happy Canyon Ranch Sign at Exit 190

The first documented, non-native, settlers of Surrey Ridge were John H. Craig, Jack Johnson and Charles Holmes who settled in the pine hills 10 miles north of Castle Rock in 1859. They raised cattle and mined for gold and silver. After a particularly hard winter that year they left the area. John Craig went to Oakes sawmill in Riley Gulch (south of Daniels Park) and later became owner of what is now Sedalia and a founder of Castle Rock.

In the 1860s, the first permanent settlers in our area were the Schweiger brothers (John Sr., Joseph, and Jacob) and their mother. They lived in a small two-room house on the eastern side of I-25 near exit 191.

From Mrs. Rose Tuggle, 94 year old daughter of John Schweiger, Jr. (The Express—March 5, 1980) comes the story of how this area was named Happy Cañon (the original Spanish for Canyon).

| Way Back When by Amy Flanagan | Page 1 | Surrey Sentinel 1998-2000 |

Amy and Dave Flanagan researched the Schweiger family and Happy Canyon Ranch. They published the information in the *Surrey Ridge Sentinel*, their neighborhood's newsletter. *Amy and Dave Flanagan Collection.*

The use of horses came in especially handy on the weekend of May 5–6 of that year. Heavy rains caused Happy Canyon Creek to flood, covering the frontage road with water. Stranded homeowners left their cars on high ground at the highway exit and were ferried by neighbors on horseback across the water.[293]

Debbie Buboltz, DCHS class of 1968 and author of *Philip Simon Miller: Butcher, Bankers, and Benefactor; His Life and Legacy in Douglas County, Colorado*, saw life as calm in the '60s. "All the changes going on elsewhere didn't have an impact here. We didn't have rallies or riots. Maybe the '70s were a bit wilder. If you went to CSU or Boulder, maybe some people burned bras there. Castle Rock was safe and secure, in that we did not have to lock our doors or take our keys out of the car ignitions," said Buboltz.

Buboltz recollected trick or treating at every house in town from Elbert Street on the west and Anderson Street on the east. She said that everyone went to school together and to the various churches, so the teens knew all the other kids in town and their parents, too. She lived in a house in town, but she rode horses with her friends on their ranches.

Buboltz's father, Willis Buboltz, worked as a bank vice-president for Philip S. Miller for forty years, so Buboltz grew up knowing Miller personally. With no children to inherit his wealth, Miller left $30 million in a perpetual trust for seven different entities. Buboltz wrote her book about him to keep his legacy alive.[294]

Bob and Carol Terwilleger moved to Douglas County in 1968 to teach—English at the high school for Bob and sixth grade at Northeast Elementary for Carol. They felt lucky to live next door to local writer and historian Josephine Marr on Lewis Street, sharing a love of local history. They also felt fortunate to later move into the historic Dillon Home in Castle Rock. Bob preserved and worked on local records discarded by former owner Karl Scholz. This work contributed to establishing the historical preservation archives at Douglas Public Libraries.[295]

Steve Ramsour, DCHS class of 1969, grew up on Anderson Street. His parents, Glen and Ollie (Olive Pinkston) Ramsour, had arrived in Castle Rock in 1946. Ollie had two sons from a previous marriage, Bill and Bruce Blakeslee, and she and Glen had two more children, Steve and Bob.

"Castle Rock was like Mayberry. We had probably 1,100 people in the high school," said Ramsour. "By our twentieth high school reunion, most of my friends had gravitated back to Castle Rock. You ask them, and they will tell you they loved their childhood in Castle Rock." Ramsour mentioned that old cottonwood trees touched overhead and framed Wilcox Street, making a trip down Castle Rock's "Main Street" a scenic event.

Gay (Finney) Ramsour, originally from Tennessee, arrived in Castle Rock in the late '60s and worked for a veterinarian. After living other places, she returned to Castle Rock to work for a friend at the Old Stone Church Restaurant, the former St. Francis of Assisi Catholic Church. She planned to save for veterinary school but decided she preferred running a restaurant. She has never regretted her decision.

She especially liked the people: "They accepted you. The Old Stone Church was the only formal restaurant in town, and many people congregated at the Chaplain's Bar to visit. It was the place to be." She deemed the town to be a perfect "country town" in the West, with a dry climate and only thirty minutes out of Denver.

Ramsour's father, Glen, and his two uncles—Fred and Don—ran the award-winning Ramsour Brothers, Inc., building concrete walls in Castle Rock at first and moving on to build bridges. The company built bridges from Limon to the state line on Interstate 70 when it was new. Steve attended college, and he worked in the bridge business until the older generation sold the business in 1983. He then studied design and opened a sign shop called Signdesign in Castle Rock.

In 1965, the South Platte River flooded, and the destruction was massive, with retaining walls collapsing and bridges washing out. The bridge over I-25 at Wolfensberger Road, which led out past Cedar Hill Cemetery and to Highway 105, was gone. With hundreds of bridges to be rebuilt, the family business boomed.

"The flood was an amazing event because it had not happened before," said Ramsour.[296]

John Berry, retired Highlands Ranch High School history teacher and DCHS class of 1963 member, also witnessed the devastation: "Seven-foot waves poured over the bridge at Wolfensberger Road. Cops turned people away at Happy Canyon, if they were heading south." Berry worked as a DuPont employee at the time.[297]

Laurie Marr Wasmund, novelist and English instructor at Arapahoe Community College, equates childhood with her family's XS Ranch off Crowfoot Valley Road, as well as the 4-H program. Her oldest sister, Carol, excelled in showing beef cattle and dairy, and her sister Patsy succeeded in dairy, sheep and then clothing. Their brother showed pigs, and Laurie worked with sheep, pigs and sewing. Their mother, Wilma (Scott) Marr, was the leader for the Scissor Snappers 4-H, where girls learned to make their own clothes.

"Our mother and our grandmother Kate Scott taught us all to sew. Our mother became a 4-H judge for sewing, first in Colorado and later in

Ollie and Glen Ramsour (on the right) and Susie and Don Ramsour attended the annual Convention of Colorado Contractors. Glen was president in 1976. *Steve and Gay Ramsour Collection.*

Idaho," said Marr Wasmund. The 4-H program was for adults, too. Her parents participated in the Young Farmers and Homemakers program, running a concession stand at the Douglas County Fair. Each year, the group would host the Young Farmers from Gunnison to judge the various divisions at the fair, and the following October, they would return the favor by judging in Gunnison.

Wilma Marr also directed the junior choir for grades one through eight and coordinated the summer Bible school at the First United Methodist Church of Castle Rock.

High school in the early to mid-'70s was a wonderful time, according to Marr Wasmund, with well-attended football games, a dynamic choir and an ambitious drama program. Football games were a time to be with friends. Larry Johnson, the new choir director, challenged his students with difficult

The South Platte River flooded in 1965, taking out many bridges. This photo shows the bridge at Wolfensberger Road, looking back west. *1995.006.0015. Douglas County History Research Center.*

pieces, culminating in a performance with the Denver Symphony. The drama teacher, Wally Larsen, was "legendary, bringing Douglas County to a higher level by producing controversial plays, not always rural-audience friendly," said Marr Wasmund. Students also had a chance to be in first-rate musicals, such as *Man of La Mancha.*

During the summer of 1975, Marr Wasmund served as a "People to People" ambassador, touring thirteen countries in six weeks. After high school, she studied English at the University of Denver, no surprise since she comes from a family of storytellers and writers. "My mother is still the best editor ever. She instilled a love of reading in me, too."[298]

Curt Cummings, son of Idella and Russel Cummings, was born in 1957, so he was too young to remember his father as the mayor of Castle Rock from 1960 to 1962. The Cummings youth all graduated from DCHS—Rita in 1961, Steve in 1965 and Curt in 1976. Curt worked after school at his father's John Deere dealership, but on weekend nights, he cruised Main Street with friends, honking at others they knew. "Kids had hotrods, and there might be only one policeman in town. While he was busy at one end of town, we could drag race at the other end of town," said Cummings. On

Friday and Saturday nights, teens parked and talked at the old courthouse. If they wanted more excitement, they could cruise Broadway in Denver with kids from other schools or meet at the bridge south of Franktown to swing on the big swing or make a bonfire. Sometimes the police checked in on the teens, who knew all the deputies. If someone was inebriated, that person was driven home but not arrested.[299]

Joe and Mary Ellen Howard, leaders in a Christian organization called Young Life, moved their sons Joe Jr. (Chip), Greg and Steve from Burbank, California, to one hundred acres in northern Douglas County in 1970 and later to Sedalia.[300] The parents came to the area to teach. Looking more like "surfer dudes" than ranch hands, the boys soon adjusted, becoming both cowboys and jocks. They had been to Colorado during summers when their dad brought Young Life teens to experience dude ranches.[301]

"We loved the snow, the horses, the open spaces—the area was a boy's delight," said Greg Howard. Greg said when Parker was deluged with an influx of new people, good athletes moved in, and by 1975, the "jocks" were the dominant group at DCHS. They got along fine with the cowboys. During summers, Joe and the sons custom-cut hay and ran a combine where SkyRidge Medical Center is today and also behind Hier Drilling in Castle Rock.

Kaye and Mick Marsh moved from Denver in 1973 to nine and a half miles southeast of Parker. Their five-acre plot was part of the original farm of George and Belle Smith, near present-day Legend High School. They wanted their children, Erik (age five) and Taryn (age three) to grow up in a smaller community than Denver. Mick commuted to Jefferson County to teach and coach, and Kay raised the children and substitute taught at times. She works presently as the receptionist for Douglas County School District at the district offices on Wilcox Street.

"The gas station on Parker Road had a dirt floor. For a long time, we had two gas stations that both closed at 5:00 p.m., and neither was open on Sunday," said Marsh. "In those days there wasn't much traffic in Parker." Hilltop Road, which runs east from Parker Road and curves south, was a dirt road, with blacktop only to the crest of the hill.

The children rode in a horse-drawn carriage at Christmastime, a Parker tradition. On the Fourth of July, families took wagon rides at an old farm between the Pinery subdivision and Ponderosa High School. The picnic celebrations were closer to the actual town of Parker.

The parents in their area started a soccer league, with the children first playing at Hidden Village and later at Richlawn Turf Farm, a large, well-

Joe and Mary Ellen Howard bought the Hill House at Santa Fe and Daniel's Park Road after living on one hundred acres in northern Douglas County. *Mary Ellen Howard Collection.*

The showpiece of the county—the Douglas County courthouse—burned in 1978, when a teenager tried to cause a diversion and spring her boyfriend from jail. *1993.018.0003. Douglas County History Research Center.*

known company that grew turf for housing developments. As their children got older, Kaye and Mick drove Taryn to Littleton for gymnastics and Erik to Cherry Creek for competitive soccer.

In the early '70s, two brothers purchased much of downtown Parker with a vision of creating a Victorian village. They tore down original buildings, but they were unable to do more than build one impressive building of Victorian-style architecture. They declared bankruptcy, departing and leaving Parker without some of its historical buildings.[302]

In the late '70s and early '80s, Ann Milam was the school principal at the Griffith Center, a residential treatment center for forty teenage boys, ages thirteen through eighteen. The camp-like setting in Larkspur off Highway 105 was a location that offered an opportunity for troubled teens to backpack, ride horses, go on canoe trips and do rope courses. Later, Milam worked as education director for the Colorado Division of Youth Corrections.

Milam remembers two restaurants in town at that time, Mr. Manners and Village Inn. The road on the east side of the Meadows/Founders exit was dirt, all the way out to Highway 86, the road that leads east to Franktown.[303]

In 1978, an unfortunate event broke the hearts of local residents: the architectural centerpiece of Douglas County burned down. The Douglas County courthouse, built in 1890 of rhyolite stone, had taken a year to build, and community events often took place on the grass in front of the courthouse. In 1976, the building had been placed on the National Register of Historic Places. Two years later, it was gone.[304]

"In an unsuccessful attempt to spring her boyfriend from jail, a teenage girl set fire to the Douglas County Courthouse on March 11, 1978," wrote Ryan Boldrey in a June 2013 *Douglas County News-Press* article. The county restored some damaged maps and other documents in 2013, making them available for public viewing.[305]

In 1981, James L. Marr, county assessor for eight years and treasurer for twenty-six years, sold the XS Ranch, which had been in the family for five generations. First, the courthouse where he had worked all his life burned down. Then other factors, such as people partying on his property and cutting fences that let the cows out, contributed to his and his wife's decision to move to Idaho.[306]

People in Douglas County did not escape the challenges of the 1960s and 1970s, and societal change could be painful. According to the U.S. Census Bureau, the population was 4,816 in 1960, and by 1980, it was 25,153.[307] Numbers alone would have changed the various communities.

Even so, compared to other turbulent places in the United States, "family" and "fun" were still key words describing life in Douglas County. The descendants of homesteaders and ranchers, with their deep roots and sense of community, carried on their traditions and ways despite the changes around them.

<center>*13*</center>

THE ME GENERATION

by John Longman

Political and social analysts labeled the people of the 1980s and 1990s as the "me generation." Due to economic woes, or maybe because of them, adults focused on achieving, sometimes at any cost. Yesterday's hippies morphed into bankers and CPAs, with goals of success and personal comfort. Even with economic uncertainty hanging over the end of the twentieth century, people in Douglas County retained their well-being and sense of community.

SETTING THE STAGE NATIONALLY

The 1980s started with a national stagflation. Bank prime interest rates peaked at 21.5 percent per annum on December 19, 1980, and choked off much of the growth in the United States. Oil prices went up dramatically in 1980 then dropped from $37.42 per barrel to $14.44 per barrel in 1986. The oil and gas industry moved out of Colorado in the middle to late 1980s.[308]

The Cold War between the international superpowers waged on, until the Berlin Wall fell in 1989, sending the Cold War away in a whimper. The fall of the former Soviet Union in 1991 brought only a small dividend regarding world peace—the former Iron Curtain countries did offer cheap labor, as did China and India. Companies with foresight, such as Walmart and later Apple, saw these sources of cheap labor as the sources of cheaper

goods for American consumers. The world became much smaller as the Internet was introduced.[309]

Issues with the Middle East escalated, as U.S. Embassy hostages were taken in Iran after Islamic fundamentalists overthrew the shah. The United States led a coalition of countries to defeat Iraq's aggression in Kuwait, one of the world's major oil-producing sources.[310]

The Savings and Loans were deregulated in the early 1980s, leading to a building boom not seen since the 1920s. Changes to national tax law resulted in overbuilding of commercial real estate. Denver had more than its share of these projects. At the end of the 1980s, whole buildings sat vacant, the Republic Building being the largest in Denver.

In the later 1980s, real estate values declined, and many Savings and Loans went bankrupt. Silverado Savings and Loan was perhaps the largest failure in the Denver area. Denver countered the downward spiral in the early 1900s and built one of the most modern airports in the world, Denver International Airport. This project turned around the Denver-area economy.[311]

The last two decades of the twentieth century were a period of transformation. Personal computers replaced typewriters. The worldwide web, a novelty at first, transformed the way people communicated and did business. Banking changed from weekdays from 9:00 a.m. to 3:00 p.m. to extended hours on weekdays and Saturdays. Banking became accessible twenty-four hours a day on the Internet.

Productivity, which had been declining through much of the 1980s, suddenly accelerated. Dot-coms were the rage on Wall Street, even though few turned a profit. Amazon, a company that had not made a dime in profit, took over very profitable Time Warner.

The War on Drugs lingered, but consumers of illegal drugs continued buying. This drove a dramatic increase in the United States' prison population, requiring many new prisons. No politician in his right mind wanted to be seen as "soft" on crime.[312]

SETTING THE STAGE LOCALLY

The 1980s and 1990s in the county was a time of expansion and fun. In its last year as the only high school in the county, Douglas County High School marching band performed in the Rose Bowl Parade in Pasadena, California.[313]

In 1981, the Douglas County High School marching band performed in the Rose Bowl Parade in Pasadena, California. *Mary Ellen Howard Collection.*

The Colorado Renaissance Festival in Larkspur held its fifth summer festival.[314] While the Continental Divide Raceway had reopened briefly in 1981, the celebrated raceway closed, leaving memories of racing greats who competed there over the previous two decades.[315]

The county seat of Castle Rock celebrated its 100th year, over the July 4 weekend in 1981. The locals hauled in dirt to make Perry Street a dirt road once again, and they built faux fronts on buildings to reinvent the western look of the early years. The celebration included families in pioneer and Indian costumes, a firemen's contest with the locals competing, hot-air balloon rides, a dunk tank, a Lion's Club Star Saloon and ice cream cones sold by the American Cancer Society. Governor Dick Lamm, then forty-six years old, ran among the seven hundred runners in the Centennial Run. Four contenders in wheelchairs all finished the race before Governor Lamm. A spirit of fun pervaded the events.[316] "Governor Dick Lamm was hauled off to a faux jail and sentenced by Judge Roy Beam, portrayed by Bob Foster, for 'failure to have a bonnet button, beard, and most dastardly of all, being a Democrat in a Republican town.'"[317]

Weather played a role in the lives of people living in Douglas County throughout the years. During the summer of 1985, a tornado blew through

The Continental Divide Raceway, located about four miles south of Castle Rock, became a favorite with many famous racecar drivers during the 1960s and 1970s. The land was sold to developers in 1983. *2009.033.0001. Douglas County History Research Center Collection.*

the area one month after Amy and Dave Flanagan moved into Surrey Ridge Estates. They recall the commotion and fear, as well as the insurance agents who arrived that evening to assess the situation.[318] According to George Durkop, Douglas County emergency coordinator, ten homes in the 9000 block of Corral Road and Juan Way were damaged.[319]

The Flanagans shared that the residents of Surrey Ridge and Surrey Ridge Estates enjoyed the land, whether it was for Fourth of July get-togethers on the bluffs or biking over the hills into what would become the Lone Tree area. Parents would often pick up their kids on the way home from work when they had biked up to County Line Road to swim. The area was an

active horse community, with barrel racing and other events for teens and young adults.

"The kids had a great time biking and paint-balling in the summer, and playing video games in the winter," said Amy Flanagan. She described the dam the Flanagan, Slaby, Murray and Braddock youths made at the nearby creek. Sometimes the Crandall kids from the Charter Oaks neighborhood to the south joined them.[320]

Steve and Gay Ramsour of Castle Rock changed directions in the early '80s, starting a signage business and having a baby. After a positive experience with an enriched preschool program, the Ramsours made the decision to homeschool their daughter, Stevie. At the time, the public school system was puzzled about what to do about homeschoolers, since the movement was fairly new in the area. The Ramsours took to heart the Montessori method of "following the child." One of Stevie's choices was to study music at Swallow Hill School in Denver.

In her late teens, Stevie moved to Louisiana to experience gospel music at Jimmy Swaggart Ministries, where she first met her future husband, Damien Nelson. She then decided to study at Christopher Newport University in Newport News, Virginia. Without a formal high school diploma, Stevie needed to prove she was capable of college work. The school district agreed to take Stevie's standardized test results and send a report on her scores. She was admitted, and she earned a bachelor's in philosophy. Today, the couple lives in Castle Rock. He commutes into Denver to study theology at Iliff School of Theology, and she runs an online antique business while finishing up a master's in humanities.[321]

Still expanding, Douglas County offered residents new shopping experiences in the form of the Outlets at Castle Rock and, later, Park Meadows Mall—a mall with the ambiance of a ski resort. Recreational activities included golf on a multitude of courses and access to hiking at Roxborough Park, Chatfield Reservoir and Castlewood Canyon. The schools offered reasonable class sizes and a calm environment. These life amenities added up to a prescription for the fastest-growing county in the United States.

Castle Pines hosted the International Golf Tournament starting in 1985, putting the area on the national radar. In the meantime, *National Geographic* magazine featured Highlands Ranch in 1994, making it an example of master-planned communities across the country.[322]

In 1981, one of the first residents of the new Highlands Ranch was Kenneth A. Miller. Miller was distinct because of his ambition and intelligence but

also because of his African American heritage. He found neighbors who helped one another and opportunities beyond his imagining. He became part of a group hosting an African trade mission at the World Trade Center in Denver. He worked for a number of companies, but Richard P. Arber and Associates, an environmental engineering concern, set him on his path. Kenneth later formed his own environmental company called Intelligent Earth with offices in Atlanta and New York City. Miller found that in Denver and Douglas County, people judged others by their integrity and results rather than their family heritage, affluence or position of power.[323]

When newlyweds Helen and Joseph Lenda moved to Highlands Ranch in 1982, they both worked at Lockheed Martin. Their new house was the first house in the second phase of the Bayfield series, with Broadway being the only paved road nearby. The hilly County Line Road held bumper-to-bumper traffic, because C-470 had not been built yet. For access into their home, the Lendas had to take a temporary road put in across from Wilmore Nursery.

"All that was around us was tumbleweed and coyotes. As other houses started going up, we experienced dust storms because of the construction," said Helen Lenda. Their lot was the only green in the midst of a construction zone. The project was so new, even UPS and FedEx did not know how to access the Lendas' home: wedding gifts were returned to the senders with a note saying the address did not exist.

In the summer of 1986, Mission Viejo, the company that owned the ranchland, announced it was going to sell a parcel to Elitch Gardens. The community took action, doing a door-to-door survey, encouraging a traffic study and convening meetings. The citizens were concerned that the amusement park noise would add to the noise of trains on Santa Fe. These well-educated, bright people took on a big corporation and won.

Nearby, Northridge Recreation Center grew from two small exercise rooms and an outdoor pool to a community center that celebrated the Fourth of July with bike parades, a carnival and fireworks in Northridge Park. Fire trucks would put out the resulting small fires in the gulch. At Christmas time, Santa had a hut on Broadway for all the children to visit. The Lendas' son and daughter are now grown, successful in their respective careers in aerospace engineering and molecular biology and forensics. Both attended Northridge Elementary and Ranch View Middle School, graduating from Thunder Ridge High School in 2003 and 2005.[324]

When Douglas County residents Libby and Dennis Smith married, the plan was for the wedding party to climb the fourteen-thousand-foot Grey's Peak to the ceremony at the summit. This was a two-hour trek both ways,

but when a wedding party member exhibited signs of exhaustion, plans changed. A beautiful mountain meadow loaded with flowers, hummingbirds and filtered sunlight became the perfect place. The couple married in the splendor of that setting, ringed by mountain peaks, with Dennis's two sons and their friends and family in attendance.

Libby and Dennis have lived southeast of Franktown on eight acres on the edge of Russellville. Near the Smiths' driveway and an old conifer is a dynamite hole where a gold prospector tried to find a placer deposit in the nineteenth century. The couple drives past the area where, in the early 1860s, both Union and Confederate sympathizers tried to convince westerners to take a side. The Confederates recruited and trained soldiers and then passed out Sharps rifles to the graduated recruits out of Denver.

Dennis and Libby have worked together at Dennis's CPA business, which supported two sons through college, who now both plan to become CPAs. Living in the area allowed the family to have an appreciation for the land. Early in the marriage, Dennis brought home a motorcycle, much to Libby's chagrin due to an unfavorable early experience on a motorcycle. However, after a switch to a heavier, more comfortable bike, they were hooked on traveling by motorcycle. They enjoy being able to explore the local area and places from South Dakota to Wyoming to the Pacific Northwest to New Mexico.[325]

Carol and Chris Doubek, and their sons Charlie and Mike, relocated in 1988 from Acres Green in northern Douglas County to a new home in the Meadows, west of the Outlets at Castle Rock. Carol wrote about their experiences in a creative writing magazine compiled in 2013 by the Castle Rock Senior Center. She wrote, "As the tenth house built in the new area, our home provided us with blue skies, billowing clouds, and pink and orange sunsets. A big windmill blew in a constant stream of energy, but life was still peaceful." Carol also pointed out in her essay that seniors are the fastest-growing population in Douglas County, with seniors moving to be close to grown children and grandchildren.[326]

The population of Denver declined in the late 1980s and then rebounded, but Douglas County grew through this entire period. As large ranches were sold for subdivisions, development boomed in unincorporated Douglas County. Neighborhoods in Highlands Ranch, the Lone Tree area and Castle Rock offered amenities such as neighborhood associations and recreation centers, and churches dotted the landscape. Two small Presbyterian churches in Sedalia and Louviers closed in order to form a new congregation in Castle Rock, where projected growth was expected.

Above: Dennis and Libby Smith, who reside in Russellville, enjoy riding motorcycles through rural Douglas County, as well as to out-of-state locations. *Dennis and Libby Smith Collection.*

Left: The Doubek family moved to The Meadows in Castle Rock in 1988. Pictured are (top, left to right) Chris, Charlie and Mike; (bottom, left to right) Carol's mother, Ellen Rettig, and Carol. *Chris and Carol Doubek Collection.*

Sedalia Community Presbyterian Church and Louviers Community Presbyterian Church both closed, and the two congregations formed New Hope Presbyterian Church in Castle Rock. Groundbreaking was in 1990. *Jean Jacobsen Collection.*

So what made Douglas County so desirable? People moved into the area looking for open space, clean air and tranquility. Residents found all the advantages of a big city without the problems of traffic and pollution. Douglas County afforded people access to jobs, lower housing costs than the city and lower levels of crime.

Growing pains also affected the Castle Pines area, mainly in the form of the Rueter-Hess Reservoir project. During the environmental impact study for the project in 1999, the archaeological team headed by Gordon C. Tucker, PhD, saw what it thought were animal bones sticking out from the side of a water-cut bank. Upon further investigation, they were found to be

the skeletal remains of two humans, a fifteen- to nineteen-year-old female and a five- to nine-year-old juvenile of American Indian descent. This may have been a reburial of the bones, which had been dried, possibly on a scaffold. The bones showed no evidence of fracturing or similar injuries. The burial pit also held bird-bone beads, probably a necklace, and a shell pendant. The team phoned the sheriff and then the coroner and the state archaeologist. Based on charcoal in the pit, the remains were originally dated as two thousand years old, but later carbon dating revealed an estimated one-thousand-year-old dating. No tribe claimed the bones, and after several years, the bones were interned in a grave near Golden, Colorado.[327]

Archaeologists are detectives solving age-old puzzles left behind by older inhabitants. It is painstaking work, necessary to preserve accurate records of an area's habitation by earlier humans. Projects such as the Rueter-Hess Reservoir provide historical information, in addition to new resources, enabling the county to grow and prosper.

The descendants of the original settlers and miners have adapted to massive change, as new people have arrived from both coasts, as well as Denver. Many new arrivals are transplanted Californians and Texans. The landscape of the northern county has transformed into a more suburban place, but the growth has also provided jobs and new energy from the people who have joined the community. Once again, cultures collide and then cope as people get to know one another and begin to forge new memories.

14

LOOKING INTO THE TWENTY-FIRST CENTURY

by Mark A. Cohen

As the year 2000 approached, some debated whether the third millennium would register when their clock ticked past December 31, 1999. This discussion seemed an overblown concern after January 1, but political pundits and broadcasters took it seriously during the build-up to the new century

Businesses used the trendy term "Y2K" to address new-century concerns with computer programs. Most computers contained a programming shortcut of defining the year with two digits instead of four. Yet people feared a deluge of minor annoyances, such as malfunctioning clocks and timers, as well as massive problems with the national infrastructure, such as the shutting down of power plants or traffic control systems. The possibility of human casualties due to winter temperatures with no heat caused genuine concern.

Much like the rest of the world, Douglas County experienced the Y2K computer programming glitch as a nonissue. No one died from digital errors. Douglas County undersheriff Tony Spurlock pointed out that on New Year's Eve 1999, the county experienced fewer law enforcement incidents than in other years.[328] Sheriff Dave Weaver agreed with that assessment.[329]

The twenty-first century brought some unusual incidents and weather phenomena. One event that affected the nation was the tragedy of September 11, 2011. Americans remember the personal details about where they were at the time of the attacks on the World Trade Center. Other events affected the lives of residents. When the Columbine High School shootings happened toward the end of the 1990s, Douglas County School District

schools went on lockdown, unsure of the full details of the threat. Into the new century, local cities and towns and the school district reevaluated safety issues and procedures.

Mother Nature played an unpredictable role in Douglas County and neighboring counties in the new century. Fires in the state, such as the 2002 Hayman fire, inspired Douglas County volunteers to assist as well as donate clothing and food. Weather events, such as the snowstorms of 2003 and 2007, led people to bond and help each other. In addition, eleven tornadoes touched down in the county in the 2000–12 period.[330]

The county experienced its largest population growth spurt in the new century, growing by over 100,000 people from 2000 to 2010.[331] David Casiano, the fifth mayor of the town of Parker, said that the town boomed through the previous decade and into the twenty-first century despite its lack of infrastructure. Multiple municipalities and county personnel worked at managing this explosive growth.[332]

David Weaver, current Douglas County sheriff, and Mike Acree, Douglas County sheriff from 2003 to 2005, served on a team that brought the Robert A. Christensen Justice Center to Castle Rock in 1998.[333] Designed for the new century, this modern facility replaced the overcrowded jails by almost tripling the capacity. It brought multiple services together under one roof, providing offices, a lunchroom, the jail and fourteen courtrooms. "The justice center is for the people," Acree stated. He stressed that everyone feels safe there, including workers, visitors and the inmates.

During the late 1990s, Acree made over 230 presentations to promote building the justice center. He pointed out positive aspects, such as boosting the local economy, not imposing a burden on the community and not being an eyesore when viewed from Interstate 25. The planning group allowed for future expansion and funded the center with a penny sales tax.

Mike Acree began his law enforcement career in 1976 by educating residents of the new Highlands Ranch community. "They thought they were in Littleton," he said. He had to let them know that their county seat was in Castle Rock, even though they crossed County Line Road to shop in Littleton. Acree served for twenty years as a police commander.

In 2005, Governor Bill Owens asked Acree to serve the state as deputy executive director of the Colorado Department of Public Safety. Born in Douglas County and with a deep love of the area, Acree asked the governor, "Why would I leave?"[334] Governor Owens replied, "We need you." He wanted Sheriff Acree to bring the state together as he had done successfully in Douglas County. Acree accepted the position.[335]

The front entrance of Douglas County's Robert A. Christensen Justice Center welcomes those who work there and those who visit for legal services or issues. *Mark A. Cohen Collection.*

Sheriff Dave Weaver at his desk in 2014 encourages citizens to do their part in keeping their families safe by locking up and being aware. *Mark A. Cohen Collection.*

Weaver assumed the role of sheriff in 2005, and he was reelected twice. In a survey completed in 2011, 85 percent of residents rated the effectiveness of the sheriff's office as favorable.[336]

Weaver said that he feels "fortunate to have maintained a low crime rate" through his time in office, with "the lowest number of officers per capita in the metro area." He said that crime is not a police problem; it's a community issue. He stressed the importance of partnering with neighboring municipalities to keep towns and rural areas safe.

Sheriff Weaver stated that he wants citizens to be vigilant, pointing out that people travel here to commit crimes. He said that over 65 percent of those incarcerated in the county do not live in Douglas County.

Weaver gave advice on community safety, such as "If you see your neighbors' garage door open, call him" and "look out for suspicious behavior." He suggested that in questionable situations, people jot down a license plate number and then call the sheriff's office. Douglas County public servants have a human side.[337] Acree said former inmates thanked him personally for helping them to turn their lives around.[338]

The Douglas County coroner's mission statement says, "Compassion for families with accountability to the taxpayer."[339] The coroner's office helps families deal with the death of loved ones, whether by murder or suicide. The coroner meets with relatives of victims, in order to help them through hard times. The coroner must also deal with the societal problem of suicides, which increased in the county from 2012 to 2013. Coroner Lora Thomas found that risk factors for taking one's life include alcohol, drug abuse, DUI arrest and domestic situations and consequent tensions.[340]

Increased public transportation has helped the county to blossom. RTD, the Regional Transportation District, serves eight counties with bus service and light rail in the Denver metro area. Construction was completed in 2006, twenty-two months ahead of schedule. This project earned worldwide recognition for the cooperation of intergovernmental agencies.[341]

In September 2003, the Philip S. Miller Library, named after the Douglas County businessman and philanthropist, relocated to a remodeled former Safeway store on Wilcox Street in Castle Rock. To achieve the monumental task of getting the books from the old library to the new facility, the Burlington Northern & Santa Fe Railroad arranged a train to take the books to a nearby siding.[342]

Railroad conductor David Rhodus reminisced, "It was a beautiful day, with lots of sunshine. I was on the scheduling board for pusher conductors, and we were sent down to Castle Rock to talk with Jamie LaRue, director of

CASTLE ROCK
NEWS-PRESS

Volume 2 Issue 34 Free

Photo by Evan Lewis

Jamie LaRue, the director of Douglas County Libraries, hands a box of books to Burlington Northern & Santa Fe Railroad conductor Dave Rhodus. The train moved books in commemoration of the new Philip S. Miller Library, which opens Sept. 27 in Castle Rock.

New library opens Sept. 27

Steve Patterson with Burlington Northern & Santa Fe Railroad carries a box of books

Youth parade among activities to celebrate completion

The new Philip S. Miller Library will open Sept. 27 at 100 S. Wilcox St. in downtown Castle Rock. The grand opening celebration will be from 10 a.m. to 10 p.m.

The library will open at noon, following a Mason cornerstone ceremony at 10 a.m., a youth parade from the former library at 961 S. Plum Creek Blvd. to the new library at 10:30 a.m. and a ribbon cutting ceremony at 11:30 a.m.

The emcee for the ribbon cutting will be Dom Testa from Mix 100.3 FM, and the keynote speaker will be former Denver Broncos running back Reggie Rivers.

A community and neighbor expo and food alley will be open from noon to 3 p.m., and live music and family programs will be offered from noon to 4 p.m.

The library will close at 5 p.m., but that doesn't mean an end to the celebration. A community dance with local bluegrass favorite Southern Exposure will be from 7-10 p.m. in the parking lot.

Mascot Dougie P.L. Dog, the Little Flowers Dancers, and Philip S. Miller Library storytime families.

The community expo will feature local businesses and organizations, including the Dumb Friends League, Wells Fargo Bank, First National Bank of Castle Rock, Douglas County Senior Services, Douglas County Open Space, Castle Rock Players, the Town of Castle Rock, the Women's Crisis Center, Metro Denver Bright Beginnings, the Colorado State Extension Service, the Castle Rock Economic Development Council, the Castle Rock Merchants and Shop the Rock, several neighboring businesses and many more.

Douglas County Libraries and the U.S. Postal Service will provide a special postal cancellation commemorating the opening. Postal cancellations will be available for purchase from noon to 4 p.m.

The cancellation centers around the grand opening theme, "A Moving History" and features a fine drawing of

Douglas County Libraries director Jamie LaRue handed books to engineer Dave Rhodus when books were transferred by rail from the old library to the new library. Castle Rock News-Press *front page, Douglas County History Research Center.*

the library, and Steve Patterson, Santa Fe engineer. It was quite an experience." Moving books by train symbolized the connection between the contributions of the railroad to the development of the area and the importance of education and literacy to the people of the county.[343]

Douglas County Libraries began in 1966, with Douglas County Board of Commissioners appropriating $5,000. Philip S. and Jerry Miller donated $25,000 for library construction that following spring. Later, the Parker Book Depository became a part of the Douglas County Public Library System. Today, seven libraries serve the county in Castle Rock, Castle Pines, Highlands Ranch, Lone Tree, Louviers, Parker and Roxborough. Under the direction of James LaRue for many years, the district programs grew to include "Talking Books," "Bark for Books," "Cuddle Up and Read," citizenship classes and e-publishing. The district also developed an Adult Learning Center.[344]

In August 2013, the Douglas County Veterans Monument Foundation dedicated a stunning monument commemorating the service of veterans of the Army, Navy, Marine Corps, Air Force, Coast Guard and Merchant Marines. The monument is erected on the corner of Fourth and Wilcox Streets on the same ground on which the historic Douglas County courthouse once stood.[345]

"The statue *Freedom's Keeper* is our symbol honoring those many keepers of our freedom who have served in the military, are serving now, and will serve in the future," said Henry Bohne, CEO and chairman of the board of the Douglas County Veterans Monument Foundation.[346]

Douglas County is recognized on some impressive lists. The county made *CNN Money*'s top-ten "growing U.S. counties" list in 2010.[347] *CNN Money* showed a house in Castle Rock as an example of good home value. The county is listed on Wikipedia's list of highest-income U.S. counties in 2011 and 2012, where it ranked ninth both times. The *Washington Post* concurred with the 2011 ranking. *CNN Money* ranks the county twentieth in the nation in job growth at 9.1 percent.[348]

Fracking, the practice of fracturing rock layers by forcing pressurized liquid into the ground to discover oil or natural gas, will be an issue going forward, according to Commissioner Jack Hilbert and others. The Niobrara Basin, which includes Douglas County, contains oil shale and natural gas, and energy companies are eager to explore. One online map revealed 214 fracking permits for the county in 2010, which pales in comparison to other state counties.[349]

Douglas County commissioners worked to bring private companies to the county. Cabela's opened in Lone Tree in August 2013, and Charles

The Douglas County Veterans Monument Foundation erected the *Freedom's Keeper* sculpture in the square in Castle Rock to honor all military veterans—past, present and future. *Douglas County Veterans Monument Foundation Collection.*

This construction site in the city of Lone Tree is near Sky Ridge Medical Center, visible from Interstate 25. *Mark A. Cohen Collection.*

Schwab plans to open its doors in 2014. Kaiser Permanente, Polystrand and WildBlue plan to start their operations here soon. Douglas County's leaders think about the future, knowing that increased business means more employment, but it also brings a higher population and associated problems, such as increased water needs and transportation growth.[350]

First conceived in 1985, the four-year construction project for the Rueter-Hess Reservoir east of I-25 on Hess Road was completed in 2012. The reservoir collects rainwater, sometimes by the millions of gallons, reaching 10 percent full in November 2013. The capacity is estimated to be twenty-three and a half trillion gallons of water.[351] Another project, Chambers Reservoir on E-470 and Chambers Road, is finished except for road paving. Built primarily for neighboring Arapahoe County, it will also serve northern Douglas County.[352]

The county's leaders have planned for future transportation needs. Three "transportation plans" for 2010, 2020 and 2030 are available on the Douglas County website. The plans explain how the county is positioned

for population growth and how those who govern propose to deal with it. In addition to expanding the road system, plans call for connecting the bicycle paths, many of which are not contiguous.[353]

Douglas County officials streamlined many processes. The narrator of a short video on the county website, www.douglas.co.us/business, stated, "Red tape has never hired a single employee, written a paycheck or celebrated a banner year."

"It's still one of the fastest-growing counties in the country," the narrator said. In 2010, the county recorded 285,465 residents, according to census. gov. The 2030 Transportation Plan estimates the population at 383,500 by the year 2020 and 490,300 people by 2030.

County commissioner Hilbert believes we must remain mindful of the needs of future residents. He thinks that as a result of the current lifestyles of younger people, more condos and apartment complexes will be built instead of houses. "They like to stay active and do activities," he said.[354]

All of the officials interviewed believe the area will thrive if county leaders continue to address water, electricity, transportation and education requirements. They believe future leaders will continue to look ahead and plan accordingly.

Sheriff Weaver said, "We've seen more technology in the last thirty years than in the history of mankind," and he foresees even more. He wonders what the area will be like in thirty more years, predicting that RTD's light rail will one day push its way to Castle Rock and then to Colorado Springs.[355]

Douglas County School District, with its motto "Learn today, lead tomorrow," provides education for sixty-seven thousand students in the district through forty-seven neighborhood schools, twelve charter schools, nine middle schools, nine high schools and an alternative high school. DCSD is the third-largest district in the state and the fifty-ninth largest in the nation.[356]

An area in the north part of the county incorporated in 1998 to become the city of Lone Tree. In 2008, the city of Castle Pines North incorporated, two years later changing its name to the city of Castle Pines. Parker built the Parker Arts, Culture, and Events (PACE) Center, and Lone Tree constructed the Lone Tree Arts Center, both state-of-the-art facilities, bringing quality theater and music to the area.[357]

Today, some descendants of the early settlers in Douglas County have moved on to other places and adventures. Susan Cheney Joyce grew up in Park Hill and lives in Arvada, and she is a great-granddaughter of William Dillon, acclaimed attorney in Dublin, Chicago and Castle Rock. Joyce keeps up with family history and family members.

Those who stayed in Douglas County over the generations often stay in touch with relatives, whether they are first, second or third cousins. They have adjusted to a vastly different way of life than the ones their grandparents, great-grandparents and great-great-grandparents lived.[358]

Charlie Hier's descendants still live on land he homesteaded and in family homes in Sedalia. Hier Drilling Co., started by Archie Hier, was passed on to son George Hier and now is run by his children Bruce Hier and Robbie (Hier) Person. Kevin Person, Robbie and Donald Person's son, recently joined the company as a pump technician, making a fourth generation. Daughters Jill Coe and Kendra Jackson now live in the Sedalia area with their families. The connection to the land and one another is real.[359]

The Cummings family roots only go back to 1954, but they go deep, as well. Former Castle Rock mayor Russel Cummings and his wife, Idella, took pride in their son Curt's successful Conoco gas station in Franktown. He now teaches motorcycle safety to Marine and Navy personnel, commuting to San Diego when needed. Curt and Lori Cummings celebrate the achievements of sons Cory and Craig, who recently opened Firehouse Subs franchises in Castle Rock, Parker and Aurora. The love of the area is in their blood, as evidenced by the mural Curt commissioned to show the family ties to Castle Rock.[360]

Red and Jackie Friesen also put down roots in the county, moving here from Denver in 1978. Red was a Denver auctioneer, and Jackie ran antique shops. In 1980, they started Titan RV Storage at the corner of Titan Road and Santa Fe. Their daughter and son-in-law Pat and John Salazar made the move from Northglenn in 1990 in time for son Chris to attend DCHS and join in 4-H and the horse program for youth called Little Britches. Today, he and his family live in Gill, Colorado. Older brother Alex works as a traffic technician for the Douglas County Traffic Division, and he and his family help out with the storage business with Red and John being deceased.

The Douglas County Fair is a big part of all their lives. Pat is superintendent of the Open Division, which covers quilts and arts and crafts. Jackie is a talented artist, who often wins top prizes at the fair. Jackie's grandmother taught Jackie to sew and quilt, and Jackie taught Pat. Mother and daughter quilt every Wednesday at the Piecemakers group, part of New Hope Presbyterian Women at their church. The two Salazar boys are prize-winning team ropers, competing in the Professional Rodeo Cowboy Association all over the region.

Pat points out that when her parents moved to Titan Road in the late '70s, one could see the lights of the city. Highlands Ranch Parkway was a dirt road, and Santa Fe was a two-lane road all the way to Castle Rock.

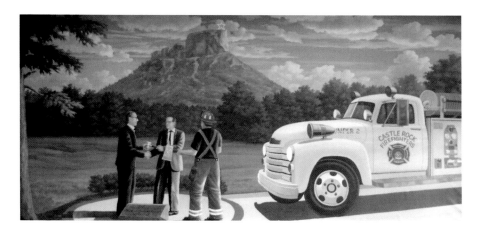

A wall-sized mural inside the Firehouse Subs restaurant in Castle Rock brings to life the 1960 swearing in of Mayor Russel Cummings, the grandfather of the restaurant owner. *Alice Aldridge-Dennis Collection.*

"I like being where there is open land. Our property is backed up to a creek. This is a family-oriented community here, still struggling to stay rural, and yet we have accessibility to the mountains, Colorado Springs and Denver. The County Fair people and the people at New Hope make this a nice community," said Salazar.[361]

Businesses continue to open in Douglas County, and new residents choose to begin chapters of their lives here. They come for affordable homes, schools, parks, inviting landscapes and incredible sunsets over the towering Rockies. The modern-day arrivals bring with them optimism and a willingness to work hard, not unlike the first settlers. The future looks bright for Douglas County, Colorado.

NOTES

CHAPTER 1

1. Dickinson, *Universe and Beyond*, 1–10.
2. Kirk and Raynolds, *Ancient Denvers*, 10.
3. Sudell, *Illustrated Encyclopedia of Dinosaurs*, 12–13.
4. Kirk and Raynolds, *Ancient Denvers*, 1.
5. Ibid., 1.
6. Ibid., 8.
7. Ibid., 17–26.
8. Sudell, *Illustrated Encyclopedia of Dinosaurs*, 6.
9. Ibid., 1.
10. Ibid., 6.
11. Ibid., 10.
12. Ibid., 12.
13. Ibid., 14.
14. Ibid., 16.
15. Ibid., 20.
16. Ibid., 18.
17. Ibid., 22.
18. Ibid., 24.
19. Ibid., 26.
20. Ibid., 28.

21. Ibid., 30.
22. Trumble, lecture.
23. Castlewood Canyon State Park, archaeological review.

Chapter 2

24. Ask.com, "Paleo-Indians."
25. Indians.org, "Paleo-Indians."
26. Turner, Nichol and Scott, "Scoring Procedures," 13–31.
27. U.S. Department of Commerce, National Oceanic and Atmosphere and Administration, "Summary of 100,000 Years."
28. Fisher, "Observations," 51–81.
29. Douglas County History Repository, "Prehistoric Occupations."
30. Wikipedia, "National Register of Historic Places Listings in Douglas County Colorado."
31. Ibid., "Franktown Cave."
32. Tucker, presentation; Gordon C. Tucker Jr., PhD, interview with John Longman, February 22, 2014.
33. David Creed, interviews with John Longman, December 15, 2003; January 20, 2004; and February 18, 2004.
34. Pettit, "UTES," 25–30; Wroth, *Ute Indian Arts & Culture*, 4–9.

Chapter 3

35. Colorado State Archives, "CO History Chronology."
36. Ute Indian, "Tribal History."
37. Crow Canyon Archaeological Center, "Peoples of the Mesa Verde Region."
38. Hewitt Institute, *Doing History/Keeping the Past*.
39. Ute Indian, "Tribal History."
40. Parsons, *Making of Colorado*, 51.
41. Shaun Boyd, archivist, Douglas County, Colorado History Resource Center, interview with Jean Jacobsen.
42. Ibid.
43. Parsons, *Making of Colorado*, 70.
44. Benson, *Introduction to the Stephen Long Expedition of 1820*.

45. Cleland, *This Reckless Breed of Men*.
46. Wikipedia, "Mountain Men and the Fur Trade."
47. Cleland, *This Reckless Breed of Men*.

CHAPTER 4

48. Heapes and Havey, *Stephen Long Expedition*.
49. McNamara, "19 Century History."
50. Parsons, *Making of Colorado*, 89, 92, 96, 98, 100, 104, 106.
51. Roberts, *Newer World*.
52. Parsons, *Making of Colorado*, 96.
53. Wikipedia, "John Williams Gunnison."
54. Parsons, *Making of Colorado*, 117, 119.
55. Hayes, "D.C. Oakes, Early Colorado Booster."
56. Holmes, *Covered Wagon Women*, 25–30.
57. Parsons, *Making of Colorado*, 130–31, 133–35.

CHAPTER 5

58. Chapman, *Story of Colorado*, 126, 130.
59. Whittaker, *Pathbreakers and Pioneers*, 145.
60. Chapman, *Story of Colorado*, 134.
61. Ibid.
62. Civil War Trust, "Saving America's Battlefields."
63. Chapman, *Story of Colorado*, 133–35.
64. Ibid., 137.
65. Kirby, *Castle Rock, Douglas County*, 2.
66. Appleby, *Fading Past*, 20, 45, 135; "Franktown."
67. "Franktown."
68. Gardner, "James Frank Gardner and Franktown," 1–5.
69. Appleby, *Fading Past*, 48.
70. Gardner, "James Frank Gardner and Franktown," 1–5.
71. Yogi Bear's Jellystone Camp Resort.
72. Ibid.
73. Stone, *History of Colorado*, 614–16.

74. Denver's Mountain Parks, "Daniel's Park."

75. Smith, *Birth of Colorado*, 104.

76. Ibid., 108.

77. Byers, "Our Colors Flying," 2; Smith, *Birth of Colorado*, 11.

78. Colorado Division of the Sons of Confederate Veterans, "Colorado and the War."

79. Smith, *Birth of Colorado*, 17, 108–09.

80. Hoig, *Sand Creek Massacre*, 58–59; "Sandcreek Massacre."

81. Department of the Interior, National Park Service, "Sand Creek Massacre National Historic Site."

82. PBS, "New Perspectives on the West."

83. Hersey, "Colorado Constitution," 67.

84. Simms, "Colorado as a Territory."

85. Hersey, "Colorado Constitution," 68.

86. Larkspur Historical Society, "Ft. Washington."

87. Town of Castle Rock, official website, "History of Castle Rock"; Lowenberg, *Castle Rock*, 5.

88. Appleby, *Fading Past*, xi.

89. Chapman, *Story of Colorado*, 128; Peterson, "John Long Routt."

CHAPTER 6

90. *Denver Post*, "Tuberculosis in Colorado History"; Varnell, *Women of Consequence*; Davis, *Intangibles of Leadership*.

91. Webb, *Perry Park Story.*

92. Appleby, *Fading Past.*

93. Thompson, *Walk with Our Pioneers*, 27.

94. Ibid., 19.

95. Ibid., 19–21.

96. *Douglas County News*, "Territorial Road—Daniel's Park Area."

97. Douglas County History Research Center Clippings Notebook Collection, Douglas County History Research Center, Castle Rock, Colorado.

98. Webb, *Perry Park Story*, 9.

99. Douglas County History Research Center Clippings Notebook Collection, Douglas County History Research Center, Castle Rock, Colorado.

100. Thompson, *Walk with Our Pioneers*, 7.

101. Douglas County, Colorado, Historic Preservation, County Landmarks, "Schweiger Ranch."
102. Wikipedia, "Castle Rock."
103. Douglas County History Research Center Clippings Notebook Collection, Douglas County History Research Center, Castle Rock, Colorado.
104. Webb, *Perry Park Story*.
105. Douglas County History Research Center Clippings Notebook Collection, Douglas County History Research Center, Castle Rock, Colorado.
106. Thompson, *Walk with Our Pioneers*, 132.
107. Wikipedia, "John Long Routt."
108. Douglas County History Research Center, "Historic Schools of Douglas County."
109. Boyer, "Dillon"; Susan Cheney Joyce, interview with Alice Aldridge-Dennis, February 6 and March 13, 2014.
110. Wikipedia, "Castle Rock."
111. Robinson, "History of Castle Rock, Colorado."
112. Lawson, "DC Mining Found its Quarry in Rhyolite," 1–2.
113. Forstall, "COLORADO Population of Counties by Decennial Census."

CHAPTER 7

114. Library of Congress, "America at the Turn of the Century."
115. Ibid., 1–3.
116. Rosenberg, "1900s Timeline: Timeline of the 20th Century," 1–2.
117. Library of Congress, "America at the Turn of the Century," 1–3.
118. History Channel website, This Day in History, "May 9, 1887."
119. Appleby, "Castle Rock," *Fading Past*, 11–12.
120. Ibid.; Historic Douglas County, Inc., "Nationally Registered Places," 4–5.
121. Historic Douglas County, Inc., "Douglas County Venues," 4.
122. Whelchel, "A Stroll through Parker History."
123. Miller, "In the Beginning," *Parker Colorado*, 25–26.
124. Ibid.
125. McLaughlin, "Ruth Memorial Chapel," *Guidebook to Historic Sites*, 50–51; Ibid., "Parker Schoolhouse," *Guidebook to Historic Sites*, 40–41.
126. Miller, "Business and Industry," *Parker Colorado*, 43–50.
127. *Record-Journal*, "Free Traveling Libraries in Colorado," 1.
128. Marr, *Douglas County*, 132–34.

129. "Fly'n B House History and Renovation Considerations"; Boldrey, "Fly'n B House to be Restored," *Highlands Ranch Herald*, 2.

130. Appleby, "Louviers," *Fading Past*, 115–20.

131. Machann, *Sedalia: 1882–1982*, 2–4.

132. Machann et al., *Sedalia: People, Places and Memories*, 4, 6–9, 20–21.

133. Historic Douglas County, Inc., "Nationally Registered Places," 11.

134. "A Walk through Larkspur: Past and Present"; Douglas County, Colorado, Historic Preservation, County Landmarks, "Frink House"; Thompson, "Larkspur," *Walk with Our Pioneers*, 274–75.

135. Historic Douglas County, Inc., "Nationally Registered Places," 7.

136. Appleby, "Franktown," *Fading Past*, 50–51.

137. Historic Douglas County, Inc., "Nationally Registered Places," 6.

138. Ibid., "Douglas County Venues," 3.

139. Schlupp, "Breeds, Brands, and Ranches...of Early Douglas County."

140. William Noe and Beverly Higginson Noe, interview with Alice Aldridge-Dennis and Susan Rocco-McKeel, February 6, 2014.

141. Laurie Marr Wasmund, interview with Alice Aldridge-Dennis, March 19, 2014; Marr Wasmund, "XS Ranch."

Chapter 8

142. *Record-Journal*, "Letters from Our Soldier Boys," 1.

143. Ubbelohde, Benson and Smith, *Colorado History*, 279.

144. Freedman, *War to End All Wars*.

145. McNeese, *Discovering U.S. History*, 8.

146. *Denver Post*, "List of All Colorado's World War I Dead Is Compiled."

147. Ubbelohde, Benson and Smith, *Colorado History*, 280.

148. *Denver Post*, "Men Called to the Colors."

149. Larkspur Historical Society, "Huntsville-Larkspur Timeline."

150. World War I War Records 1/5, Douglas County History Research Center.

151. World War I War Records 1/6, Douglas County History Research Center.

152. *Record-Journal*, "Home Guard to Be Organized."

153. Clarke, "American Women and the World War."

154. Livesay, "Weekly Newsletter No. 33," 1.

155. *Record-Journal*, "Reading Matter for Our Soldiers," 1.

156. Baker, "How to Send Magazines and Books to Our Soldier," 1.

157. Byerly, *U.S. Military and the Influenza Pandemic of 1918–1919*.

158. Ellis and Smith, *Colorado: A History in Photographs*, 114.

159. Denver Public Library, "Influenza Pandemic of 1918 in Colorado."

160. *Record-Journal*, "Influenza and its Treatment," 1.

161. Douglas County, Colorado, Historic Preservation, County Landmarks, "Louviers Village Club."

162. U.S. Department of Health and Human Services. "Snapshot of the World in 1918."

163. Seacrest, "20th Century Colorado in the Roaring 20's," 1–48.

164. Ellis and Smith, *Colorado: A History in Photographs*, 116.

165. *Record-Journal*, "Motor Cars and Grade Crossings," 116.

166. Creighton, "Essay 2: The Small Town Klan in Colorado," 175–97.

167. Ellis and Smith, *Colorado: A History in Photographs*, 114–18.

168. Seacrest, "20th Century Colorado in the Roaring 20's," 1–48.

169. Ellis and Smith, *Colorado: A History in Photographs*, 115; *Record-Journal*, "A Shudder in Every Line," 4.

170. *Record-Journal*, "Ku Klux Klan Meeting," 1.

171. *Alamosa Journal*, "From Other Pens: Ku Klux Klan," 6.

172. Ellis and Smith, *Colorado: A History in Photographs*, 115.

173. Colorado Historical Society, "Hood and the Robe," 17–19.

174. *Record-Journal*, "All for All Colorado," 4.

175. Hanson, *Cultural History of the United States*, 34.

176. West, "Of Lager Beer and Sonorous Songs," 109.

177. Prohibition, "Unintended Consequences."

178. Hanson, *Cultural History of the United States*, 28.

179. Larkspur Historical Society, "Spring Valley Cheese Factory"; *Record-Journal*, "Pouppirts Nabbed on Booze Charges," 1; "Moonshiners Plead Guilty and Penalties Assessed," 1; "Sheriff McKissack Nabs Big Still," 1; "Sheriff Captures Another Still," 1; "Officers Destroy Big Booze Plant Near Larkspur," 1; "Douglas County Resort Proprietors are Arrested," 1; "Officers Nab Four on Bootleg Charge," 1.

180. *Record-Journal*, "Sheriff and Deputies Hunt for Bootleg and Locate Poker Game," 1.

181. Ibid., "Chicago Wants 'Diamond Jack,'" 1.

182. Ibid., "Diamond Jack Not Wanted," 1.

183. Ibid., "Sheriff Gets Valuable Gift from 'Diamond Jack,'" 1.

184. Ibid., "'Diamond Jack' Quit-Claims Douglas County Property," 1.

185. Prohibition, "Roots of Prohibition."

186. *Record-Journal*, "Holdups Loot Bank at Parker After Banking Hours on Tuesday," 1.

187. Ibid. "Held Up on the Streets of Castle Rock," 1.

188. Archives of Hilltop Historic Schoolhouse, "History #2."

189. Louise West, interview with Susan Rocco-McKeel, Hilltop School House, Douglas County, November 14, 2013.

190. Westerbert, *Castles of Colorado*, 1.

191. Sammons, *Riding, Roping and Roses*, 38, 41.

192. Ibid., 44.

193. Douglas County Open Space, "Cherokee Ranch Conservation Easement."

194. Douglas County, Colorado, Historic Preservation, County Landmarks, "American Federation of Human Rights."

195. Rosario Menocal, interview with Susan Rocco-McKeel, January 15, 2014, telephone.

196. Larkspur Historical Society, "American Federation of Human Rights."

Chapter 9

197. Noel and Smith, *Colorado: The Highest State*, 232.

198. Smith, *Newland Gulch Gold Mining*.

199. Steinal, *History of Agriculture in Colorado*, 498.

200. Ubbelohde, Benson and Smith, *Colorado History*, 298–99.

201. Ibid., 299.

202. Ibid., 288.

203. Sims, "Colorado and the Great Depression," 15.

204. State Planning Commission and Workers of the Writers' Program of the Work Projects Administration in the State of Colorado, *WPA Guide to 1930s Colorado*; Noel and Faulkner, *Colorado: An Illustrated History of the Highest State*, 110; Bill Noe, interview with Susan Rocco-McKeel and Alice Aldridge-Dennis, Larkspur, February 6, 2014.

205. McElvaine, *Great Depression*, 7.

206. Noel and Smith, *Colorado: The Highest State*, 234.

207. Bill Noe, interview with Susan Rocco-McKeel and Alice Aldridge-Dennis.

208. Noel and Smith, *Colorado: The Highest State*, 231.

209. *Record-Journal*, "Directors Close Castle Rock State Bank," 1.

210. Noel and Smith, *Colorado: The Highest State*, 231.

211. PBS, American Experience, "The New Deal."

212. Ellis and Smith, *Colorado: A History in Photographs*, 121.

213. Social Security Administration, "FAQs."

214. PBS, American Experience, "Works Progress Administration."

215. *Record-Journal*, "WPA Workers Finish Bridge Projects; Total Cost, $38,065.46," 1; "WPA Sewing Project Ladies Honor Mrs. Prescott," 1.

216. Ibid., "Castle Rock Streets Are Being Improved by W.P.A. Workers," 1.

217. Ellis and Smith, *Colorado: A History in Photographs*, 122.

218. Ubbelohde, Benson and Smith, *Colorado History*, 301; Hafen and Hafen, *Colorado Story*, 333.

219. Ubbelohde, Benson and Smith, *Colorado History*, 301.

220. Ibid., 315.

221. "Oral History Interview with Louise Beeman Hier and Florence Campbell Beeman," interview by Barbara Machann, 21–22.

222. *Record-Journal*, "Douglas County Schools Will Hold Track Meet Today," 1; "County School Music Festival Will Be Held Next Friday," 1; "American Legion Will Give Dance at Franktown," 1; "Hill Top Social Club Met at Home of Mrs. Nancy Walden," 1; "Douglas County Woman's Club Sponsors Filed Army Campaign," 1.

223. Boyd, "History of the Castle Rock Star."

224. Marr Wasmund, interview with Alice Aldridge-Dennis.

225. National Archives & Records Administration, National Industrial Recovery Act 1933.

226. *Record-Journal*, "Local Stores to Observe New Closing Hours," 1.

227. World's Work, "Education and Success," 7.

228. *Record-Journal*, "Colorado Schools Decrease While Pupils on Increase," 4.

229. Ibid., "Taxpayers Vote Bond Issue for High School Improvement," 1; Douglas County History Research Center, "Douglas County High School Graduation by Year, 1899–1964."

230. Douglas County Television, *Landmarks*.

231. Civilian Conservation Corp Legacy, "CCC Brief History."

232. Ibid.

233. Greyre and Alleger, *History of the Conservation Corps in Colorado*, 2.

234. Ibid.

235. Civilian Conservation Corps Legacy, "CCC Brief History."

236. John Berry, interview with Susan Rocco-McKeel, Castle Rock, March 22, 2014.

237. Civilian Conservation Corps Legacy, "CCC Brief History."

238. *Record-Journal*, "Soil Conservation Please Douglas County Ranchers," 1.

239. Douglas County Television, *Landmarks*.

240. Civilian Conservation Corps Legacy, "CCC Brief History."

241. Douglas County Television, *Landmarks*.

242. *Castle Rock Journal*, "Castlewood," 1.

243. *Record-Journal*, "Castlewood Dam," 1.

244. Castlewood Canyon State Park, "But Is It Safe?" 11–12.

245. *Record-Journal*, "Castlewood Dam Is Washed Out by Cloudburst," 1.

246. Association of State Dam Officials, "Denver to Observe 80th Anniversary of Deadly Flood."

247. Castlewood Canyon State Park, "But Is It Safe?", 11–13.

248. Ibid., "Switchboard Operators Save the Day," 19–20.

249. Cochran, "A Young Man's Adventures," 16.

250. Maker, "Tremendous Power of Water," 29.

251. Douglas County, Colorado, "State Parks and Pike National Forest."

252. *Record-Journal*, "Veterans' Contingent, Civilian Conservation Corps Is Expanded," 1.

253. Civilian Conservation Corp Legacy, "CCC Brief History."

254. Ibid.

255. Noel and Smith, *Colorado: The Highest State*, 239–40.

256. "Southwest Conservation Corps: Overview."

257. Civicore, "New Partnership to Put Young People and Military Veterans to Work."

258. John Evans, interview with Susan Rocco-McKeel, Parker, October 14, 2013.

Chapter 10

259. *Record-Journal*, "This Week in Defense, Arming of Merchant Ships," 1.

260. Ibid., Advertisement, December 12, 1941, 1.

261. Ibid., Advertisement, October 9, 1942, 1; "It Takes Both," 1.

262. Wikipedia, Douglas County, Colorado.

263. Wilbur Brunger Jr., interview with Alice Aldridge-Dennis, April 13, 2014; Belt, "Oral History Interview with Wilbur H. Brunger."

264. *Record-Journal*, "Lt. Bernard Curtis Reported Killed In Line of Duty," 1.

265. Wikipedia, "Douglas County, Colorado, 2011."

266. Clements, "Oral History Interview with George Salvador"; George Salvador, *Castle Rock News-Press*.

267. "Flying Coffins."

268. Wikipedia, "Gliding."

269. Belt, "Oral History Interview with Louis J. Zoghby"; Van Daele, "Louis J. Zoghby."

270. VFW Post 4664, "World War II, Service Record of Men and Women," 1–16.

Chapter 11

271. Jack Muse, interview with Kimberlee Gard, Highlands Ranch, November 7, 2013.

272. Saunders, interview with Stan Oliner; Bob Terwilleger, interview with Alice Aldridge-Dennis, Castle Rock, March 23, 2014.

273. Appleby, *Fading Past*, 63.

274. Saunders, interview with Stan Oliner.

275. *Douglas County News*, "Dry Weather Brings Grasshopper Woes," 1.

276. *Douglas County News*, "Changing of Street Name from 'Main' to 'Lewis,'" 1.

277. Appleby, *Fading Past*, 133.

278. Castle Rock Writers, *Douglas County, Colorado*, 134.

279. Appleby, *Fading Past*.

280. Webb, *Perry Park Story*, 51.

281. Ibid.

282. Castle Rock Writers, *Douglas County, Colorado*, 116.

283. Ibid.,118.

284. Appleby, *Fading Past*, 168.

285. Ibid.

286. Castle Rock Writers, *Douglas County, Colorado*, 72.

Chapter 12

287. Porter, "College Daze."

288. Douglas County High School Yearbook 1976; 1978.

289. Jan Lacy, interview with Alice Aldridge-Dennis, May 5, 2013; Douglas County History Timeline, Douglas County History Research Center.

290. Lacy, interview with Alice Aldridge-Dennis.

291. Bruce Hier and Robbie Hier Person, interview with Alice Aldridge-Dennis, March 12, 2014.

292. Betty Meyer, interview with Alice Aldridge-Dennis, March 24, 2014.

293. Flanagan and Flanagan, "Way Back When."

294. Debbi Buboltz, interview with Alice Aldridge-Dennis, March 17, 2014.

295. Bob Terwilleger, interview with Alice Aldridge-Dennis, March 23 and 29, 2014.

296. Steve and Gay Ramsour and Stevie Ramsour Nelson, interview with Alice Aldridge-Dennis, March 14, 2014.

297. John Berry, docent at Castle Rock Museum, interview with interview with Alice Aldridge-Dennis, March 30, 2014.

298. Marr Wasmund, interview with Alice Aldridge-Dennis.

299. Curt Cummings, interview with Alice Aldridge-Dennis, March 22, 2014.

300. Joseph "Chip" Howard Jr., interview with Alice Aldridge-Dennis, March 12, 2014.

301. Steve Howard, interview with Alice Aldridge-Dennis, March 25, 2014.

302. Kaye Marsh, interview with Alice Aldridge-Dennis, March 16, 2014.

303. Ann Milam, interview with Alice Aldridge-Dennis, March 13, 2014.

304. Douglas County History Research Center, "Events and Topics."

305. Boldrey, "Old Maps Restored, 35 Years After Fire."

306. Laurie Marr Wasmund, interview with Alice Aldridge-Dennis, March 19, 2014.

307. Rottsweb.com, Douglas County Census Data.

Chapter 13

308. ForecastChart.com, "Historical Oil Prices: 1956 to Present."

309. Bureau of Labor Statistics, "International Labor Comparisons 1980 to 2000."

310. Wikipedia, "War on Terror."

311. Wikipedia, "Savings and Loan Crisis 1986 to 1995."

312. Perrault, "Highlands Ranch at 25."

313. Mary Ellen Howard, interview with interview with Alice Aldridge-Dennis, March 14, 2014.

314. Colorado Renaissance Festival, "2013 Fact Sheet."

315. Internal Combustion, "Continental Divide Raceways, Castle Rock, CO."

316. *Douglas County News-Press*, "Despite Rain, Hail, Wind, Front Street Workers Cheer," 1, 8–9, 16.

317. Ibid., "Governor Joins 700 Others in Centennial Run Saturday," 1, 12.

318. Flanagan and Flanagan, interview with interview with Alice Aldridge-Dennis, March 25, 2014.

319. *Denver Post*, "Rainstorms, Twister Blitz Area: 1 Killed, 4 Injured in Havoc," 1-A.

320. Flanagan and Flanagan, interview with Alice Aldridge-Dennis, March 13, 2014.

321. Steve and Gay Ramsour and Stevie Ramsour Nelson, interview with Alice Aldridge-Dennis, March 21, 2014.

322. Perrault, "Highlands Ranch at 25."

323. Kenneth A. Miller, interview with John Longman, January 30, 2014, February 14, 2013.

324. Helen Lenda, interview with Alice Aldridge-Dennis, March 16, 2014.

325. Dennis Smith and Libby Smith, interview with John Longman, March 1, 2014.

326. Doubek et al., "Castle Rock, Our Hometown," 44.

327. "Excavation at Rueter-Hess Reservoir"; Tucker, interview with John Longman.

Chapter 14

328. Douglas County undersheriff Tony Spurlock, interview with Mark A. Cohen, May 30, 2013.

329. Douglas County sheriff Dave Weaver, interview with Mark A. Cohen, January 23, 2014.

330. Wikipedia, "Hayman Fire."

331. Rottsweb.com, Douglas County Census Data.

332. David Cassiano, interview with Mark A. Cohen, May 28, 2013; Town of Parker, official website.

333. Weaver, interview with Mark A. Cohen, February 15, 2014; Mike Acree, former Douglas County sheriff, interview with Mark A. Cohen, January 23, 2014; Town of Castle Rock, Colorado, official website.

334. Acree, interview with Mark A. Cohen.

335. Wikipedia, "Bill Owens: Colorado Politician"; Acree, interview with Mark A. Cohen.

336. Douglas County Sheriff, official website.

337. Weaver, interview with Mark A. Cohen, January 23, 2014.

338. Acree, interview with Mark A. Cohen.

339. Douglas County Coroner, official website.

340. Douglas County coroner Lora Thomas, interview with Mark A. Cohen, January 23, 2014.

341. Wikipedia, "Regional Transportation District."

342. Douglas County Libraries, official website.

343. Dave Rhodus, railroad conductor, interview with Alice Aldridge-Dennis, March 10, 2014.

344. Douglas County Libraries, official website.

345. Douglas County Colorado Veterans Monument Foundation, official website.

346. Henry Bohne, interview with Mike Dennis, March 15, 2014.

347. *CNN Money*, "Fastest Growing U.S. Counties."

348. *Washington Post*, "Highest Income Counties in 2011."

349. "Niobrara Shale—Niobrara Oil Formation—Niobrara Shale Map."

350. Douglas County, Colorado, official website, "Board of County Commissioners."

351. Wikipedia, "Rueter-Hess Reservoir."

352. Michlewicz, "Chambers Reservoir Nearly Ready for Water."

353. Felsburg, Holt & Ullevig, "Douglas County 2020 Transportation Plan."

354. Douglas County commissioner Jack Hilbert, interview with Mark A. Cohen, April 23, 2013.

355. Weaver, interview with Mark A. Cohen, January 23, 2014.

356. Douglas County School District, "About Douglas County School District."

357. City of Lone Tree, official website; City of Castle Pines, official website.

358. Susan Cheney Joyce, interview with Alice Aldridge-Dennis, February 6 and March 13, 2014.

359. Bruce Hier and Robbie Hier Person, interview with Alice Aldridge-Dennis.

360. Curt Cummings, interview with Alice Aldridge-Dennis, March 22, 2014.

361. Pat Friesen Salazar, interview with Alice Aldridge-Dennis, March 26, 2014.

BIBLIOGRAPHY

Books

Appleby, Susan Consola. *Fading Past: The Story of Douglas County, Colorado.* Palmer Lake, CO: Filter Press, LLC, 2001.

Barre, Janette. *Castle Rock Style: A Guide to Preserving Our Architectural Heritage.* Lakewood, CO: Preservation Publishing, 1996.

Benson, Maxine. *An Introduction to the Stephen Long Expedition of 1820.* Golden, CO: Fulcrum, Inc., 1988.

Castle Rock Writers. *Douglas County, Colorado: A Photographic Journey.* Castle Rock, CO: Douglas County Libraries Foundation, 2005.

Chapman, Arthur. *The Story of Colorado: Out Where the West Begins.* New York: Rand McNally & Company, 1925.

Cleland, Robert Glass. *This Reckless Breed of Men: The Trappers and Fur Traders of the Southwest.* New York: Alfred A. Knopf, Inc., 1963.

Davis, Richard. *The Intangibles of Leadership.* Mississauga, ON: John Wiley and Sons, 2010.

Dickinson, Terence. *The Universe and Beyond.* Richmond Hill, ON: Firefly Books, 2004.

Ellis, Richard N., and Duane A. Smith. *Colorado: A History in Photographs.* Niwot: University Press of Colorado, 1991.

Fisher, John, Jr., WND. "Observations on the Late Pleistocene Bone Bed Assemblage from the Lamb Spring Site, Colorado," *Ice Age Hunters of the Rockies.* Edited by Dennis Stanford and Jane S. Day. Niwot: University Press of Colorado, 1992.

Freedman, Russell. *The War to End All Wars: World War I.* Boston, New York: Clarion Books, 2010.

Hafen, Leroy and Ann Hafen. *The Colorado Story: A History of Your State and Mine.* Denver: Old West Publishing Co., 1953.

Hanson, Erica. *A Cultural History of the United States: Through the Decades; The 1920s.* San Diego: Lucent Books, Inc., 1999.

Heapes, Robert, and Jim Havey. *The Stephen Long Expedition: Through the Great Desert to the Alpine Tundra.* Denver: R. Heapes, 1996.

Hoig, Stan. *The Sand Creek Massacre.* Norman: University of Oklahoma Press, 1961.

Holmes, Kenneth, L. *Covered Wagon Women, Diaries & Letters From the Western Trails, 1854–1860.* Lincoln: University of Nebraska Press, 1998.

Johnson, Kirk R., and Robert G.H. Raynolds. *Ancient Denvers: Scenes from the Past 300 Million Years of the Colorado Front Range.* Golden, CO: Fulcrum, 2005.

Lowenberg, Robert L. *Castle Rock: A Grass Roots History.* Englewood, CO: Quality Press, 1986.

Machann, Barbara Belfield. *Sedalia: 1882–1982.* Sedalia, CO: self-published, 1982.

Machann, Barbara Belfield, Carole Poer Williams, Mary Douglas Young and Pamela Belfield. *Sedalia: People, Places and Memories.* Sedalia, CO: Sedalia Historic Fire House Museum, 2003.

Marr, Josephine Lowell. *Douglas County: A Historical Journey.* Gunnison, CO: B&B Printers, Inc., 1983.

McElvaine, Robert. *The Great Depression: America 1921–1941.* New York: Three Rivers Press, 1984.

McLaughlin, F.B. *A Guidebook to Historic Sites in the Parker Area.* 3rd ed. Parker, CO: Parker Area Historical Society, Inc., 2003.

McNeese, Tim. *Discovering U.S. History: World War I and the Roaring Twenties 1914–1928.* New York: Infobase Publishing, 2010.

Miller, Ruth L. *Parker Colorado: An Historical Narrative.* 4th ed. Parker, CO: Parker Area Historical Society, 2005.

Noel, Thomas J., and Debra B. Faulkner. *Colorado: An Illustrated History of the Highest State.* Sun Valley, CA: American Historical Press, 2006.

Noel, Thomas J., and Duane A. Smith. *Colorado: The Highest State.* Niwot: University Press of Colorado, 1995.

Parsons, Eugene. *The Making of Colorado: A Historical Sketch.* Chicago: A. Flanagan Co., 1908.

Pettit, Jan. "UTES, The Mountain People." In *Ute Indian Arts & Culture: From Prehistory to the New Millennium.* Edited by William Wroth. Boulder, CO: Johnson Books, 1990.

Roberts, David. *A Newer World: Kit Carson, John C. Frémont, and the Claiming of the American West.* New York: Simon and Schuster, 2000.

Sammons, Judy Buffington. *Riding, Roping and Roses: Colorado's Women Ranchers.* Montrose, CO: Western Reflections Publishing Company, 2006.

Smith, Duane A. *The Birth of Colorado: A Civil War Perspective.* Norman: University of Oklahoma Press, 1989.

Steinal, Alvin T. *History of Agriculture in Colorado: A Chronological Record of Progress in the Development of General Farming, Livestock Production and Agricultural Education and Investigations of the Western Border of the Great Plains and in the Mountains of Colorado 1858–1926.* Ft. Collins, CO: State Board of Agriculture, 1926.

Stone, Wilbur Fisk, ed. *History of Colorado.* Vol. 2. Chicago: S.J. Clarke Publishing Company, 1918, 614–16.

Sudell, Helen. *The Illustrated Encyclopedia of Dinosaurs.* London: Lorenz Books, 2006.

Thompson, Alice M. *Walk with our Pioneers: A Collection.* Grand Junction, CO: JLM Sales, LLC, 2005.

Ubbelohde, Carl, Maxine Benson and Duane A. Smith. *A Colorado History.* 8th ed. Boulder, CO: Pruett, 2001.

Varnell, Jeanne. *Women of Consequence: The Colorado Women's Hall of Fame.* Boulder, CO: Johnson Press, 1999.

Webb, Ardis. *The Perry Park Story: The Fulfillment of a Dream.* Denver: Ardis & Olin Webb, 1974. Reprint, 2009.

Westerbert, Ann. *Castles of Colorado: Scandals, Hauntings and Tales of the Past.* Boulder, CO: Johnson Books, 2008.

Whittaker, Milo Lee. *Pathbreakers and Pioneers of the Pueblo Region: Comprising a History of Pueblo from the Earliest Times.* Pueblo, CO: Franklin Press Company, 1917.

Wroth, William, ed. *Ute Indian Arts & Culture: From Prehistory to the New Millennium.* Colorado Springs: Taylor Museum of the Colorado Springs Fine Arts Center, 2000.

PERIODICALS, NEWSPAPERS, DOCUMENTS

Archaeological Society. "The Archaeology of Colorado: Part 1." *Southwestern Lore*, 34 (June 1968).

Archives of Hilltop Historic Schoolhouse. "History #2." Archival notebook accessed November 14, 2013.

Association of State Dam Officials. "Denver to Observe 80th Anniversary of Deadly Flood." Press release, July 22, 2013.

Boldrey, Ryan. "Fly'n B House to be Restored." *Highlands Ranch Herald,* June 5, 2013.

———. "Old Maps Restored, 35 Years After Fire." *Douglas County News-Press* (June 6, 2013).

Boyer, Peggy. "Dillon." Dillon Family Papers, written in 2010.

Byers, W. "Our Colors Flying." *Rocky Mountain News*, April 22, 1861.

Castlewood Canyon State Park. "But Is It Safe?" *The Night the Dam Gave Way: A Diary of Personal Accounts* (December 1997).

———. "Switchboard Operators Save the Day." *The Night the Dam Gave Way: A Diary of Personal Accounts* (December 1997).

Cochran, Harvey B. "A Young Man's Adventures." In Castlewood Canyon State Park, *The Night the Dam Gave Way: A Diary of Personal Accounts* (December, 1997).

Colorado Historical Society. "The Hood and the Robe." *SER Colorado Heritage Magazine* (Winter 1993).

Creighton, John. "Essay 2: The Small Town Klan in Colorado." *SER Essays and Monographs in Colorado History* 2 (1983). Denver: State Historical Society of Colorado.

Denver Post. "Rainstorms, Twister Blitz Area: 1 Killed, 4 Injured in Havoc." July 7, 1985.

———. "Tuberculosis in Colorado History," May 31, 2007.

Doubek, Carol. "Castle Rock, Our Home Town." In *Reflections from the Rock*. Castle Rock, CO: Castle Rock Senior Center, 2013.

Douglas County High School Yearbook 1976. Castle Rock, CO: Douglas County High School.

Douglas County High School Yearbook 1978. Castle Rock, CO: Douglas County High School.

Douglas County News. "Changing of Street Name from 'Main' to 'Lewis'." Thursday, October 15, 1953. Colorado Historic Newspaper Collection (accessed November 2013).

———. "Dry Weather Brings Grasshopper Woes." Thursday, June 9, 1995. Colorado Historic Newspaper Collection (accessed November 2013).

Douglas County News-Press. "Despite Rain, Hail, Wind, Front Street Workers Cheer." July 7, 1981.

———. "Governor Joins 700 Others in Centennial Run Saturday." July 8, 1981.

Flanagan, Amy, and Dave Flanagan. "Way Back When." *Surrey Sentinel*, October 1998–May 2000.

Fonder, Miriam D. "Personal Diary of Miriam D. Fonder." Douglas County History Research Center Collection, Glenwood Springs, Colorado.

"Franktown." Circa 1960s. Douglas County History Research Center Clippings Notebook Collection, Douglas County History Research Center, Castle Rock, Colorado. Transcript by Cecily Carnahan, December 22, 2009.

Gardner, J.F., Jr. "James Frank Gardner and Franktown." *Record-Journal*, May 3, 1946.

Greyre, L.A., and C.N. Alleger (supervised by the commanding officer of the Littleton District). *History of the Conservation Corps in Colorado: That the Work of Young America May Be Recorded.* Denver: Press of the Western Newspaper Union.

Hayes, Marita. "D.C. Oakes, Early Colorado Booster." *Colorado Magazine* 31, no. 3. (July 1954).

Hersey, Henry J. "The Colorado Constitution." *Colorado Magazine* (1926).

Jones, Clyde W. "What Happened at Russellville." *Denver Westerners Roundup* (September–October 1994).

Kirby, William S. *Castle Rock, Douglas County: 125 Years of Partnership, 1874–1999.* Douglas County Board of County Commissioners and Castle Rock Town Council, 1999.

Lawson, Chris. "DC Mining Found Its Quarry in Rhyolite: 'This Is the House That Jack Built.'" *Douglas County News-Press*, November 5, 2005, 1–2.

Maker, Mickey Gates. "The Tremendous Power of Water." In Castlewood Canyon State Park, *The Night the Dam Gave Way: A Diary of Personal Accounts.* (December 1997).

Marr Wasmund, Laurie. "The XS Ranch." Personal Collection, October 10, 1975.

"Oral History Interview with Louise Beeman Hier and Florence Campbell Beeman." Interview by Barbara Machann, May 7, 2001. Sedalia Historic Fire House Museum Oral History Project. Douglas County Research Center Oral History Project. Accession number 2001.037.

Porter, William. "College Daze." *Denver Post*, August 17, 2003.

Robinson, Michael. "History of Castle Rock, CO, Business Corridor, Part II." *Castle Rock Republican Examiner*, January 19, 2010.

Saunders, Elizabeth. Interview with Stan Oliner. Douglas County History Research Center Oral History Project, Castle Rock, March 7, 1992.

Seacrest, Clark. "20ᵗʰ Century Colorado in the Roaring 20's." *SER Colorado Heritage* (Winter 1993).

Simms, C.E. "Colorado as a Territory." *Fort Collins Courier*, 1894.

Sims, Robert Carl. "Colorado and the Great Depression: Business Thought in a Time of Crisis." Diss., University of Colorado, Boulder.

State Planning Commission and the Workers of the Writers' Program of the Work Projects Administration in the State of Colorado. *The WPA Guide to 1930s Colorado*. Lawrence: University Press of Kansas, 1941.

Town of Castle Rock Historic Preservation Board. "Walking Tour of Historic Downtown Castle Rock, Colorado." Pamphlet, 2006.

Turner, C.G., C.R. Nichol and G.R. Scott. "Scoring Procedures for Key Morphological Traits of the Permanent Dentition: the Arizona State University Dental Anthropology System." *Advances in Dental Anthropology* (1991), 13–31.

VFW Post 4664. *World War II, Service Record of Men and Women: Castle Rock, Colorado and Community*. Castle Rock, CO, 1946.

West, Elliot. "Of Lager Beer and Sonorous Songs." *Colorado Magazine* (Spring 1971).

World War I War Records 1/5. Box of papers archived at Douglas County History Research Center, accessed January 14, 2014.

World War I War Records 1/6. Box of papers archived at Douglas County History Research Center, accessed January 14, 2014.

LECTURES/VISITS

Castlewood Canyon State Park. Archaeological review, author visit, 2012.

"Excavation at Rueter-Hess Reservoir." Presentation at Parker Area Historical Society, February 11, 2014.

Schlupp, Larry. "Breeds, Brands, and Ranches...of Early Douglas County." *Historic Douglas County, Inc.*, March 11, 2014.

Trumble, Susie. Lecture, Roxbourough State Park, Colorado, 2009.

Tucker, Gordon C., Jr., PhD. Presentation on February 11, 2014, for the Parker Area Historical Society, Parker, Colorado.

"A Walk through Larkspur: Past and Present." Larkspur Historical Society talk, July 14, 2012.

Whelchel, Sandra. "A Stroll through Parker History." Parker Historical Society talk, September 14, 2013.

WEBSITES

Alamosa Journal. "From Other Pens: Ku Klux Klan." Reprinted in the *Littleton Independent,* October 12, 1923) www.coloradohistoricnewspapers.org (accessed December 12, 2013).

Ask.com. "Paleo-Indians." http://www.ask.com/web?q=paleo+indians&qs rc=364&o=0&l=dir&qo=homepageSearchBox (accessed April 16, 2014).

Baker, Charlotte. "How to Send Magazines and Books to Our Soldier." *Record-Journal,* October 5, 1917. www.coloradohistoricnewspapers.org (accessed January 22, 2014).

Belt, Barbara. "Oral History Interview with Louis J. Zoghby." Douglas County Libraries' Oral Histories, September 3, 2003 http://douglascountyhistory.org/cdm/singleitem/collection/doh/id/57/rec/2 (accessed February 14, 2014).

————. "Oral History Interview with Wilbur H. Brunger." Douglas County History Research Center Oral Histories, April 15, 2004. Accession number 2004.206. http://douglascountyhistory.org/cdm/ref/collection/doh/id/101 (accessed April 5, 2014).

Boyd, Shaun. "History of the Castle Rock Star." Douglas County Research Center. www.douglascountyhistory.org/cdm/ref/collection/documents/id773 (accessed February 1, 2014).

Bureau of Labor Statistics. "International Labor Comparisons 1980 to 2000." http://www.bls.gov/fls/flsmlr.htm (accessed March 15, 2014).

Byerly, Carol R. *The U.S. Military and the Influenza Pandemic of 1918–1919.* U.S. National Library of Medicine. National Center for Biotechnology. U.S. National Institutes of Health. ncbi.nlm.nih.gov/pmc/articles/PMC2862337/ (accessed January 22, 2014).

Castle Rock Journal. "Castlewood." September 24, 1890. www.coloradohistoricnewspapers.org (accessed January 22, 2014).

Castle Rock News-Press. "George Salvador" November 10, 2012. http://www.ourcoloradonews.com/castlerock/news/veteran-from-castle-rock-served-at-crux-of-history/article_b4bdca98-2b66-11e2-931b-0019bb2963f4.html (accessed November 30, 2013).

City of Castle Pines, Official Website. "City of Castle Pines, Colorado." http://www.castlepinesgov.com/ (accessed February 11, 2014).

City of Lone Tree, Official Website. "City of Lone Tree." http://www.cityoflonetree.com/ (accessed February 11, 2014).

Civicore. "New Partnership to Put Young People and Military Veterans to Work." November 27, 2012. http://www.civicore.com/new-partnership-to-put-young-people-and-miltiary-veterans-to-work/ (accessed March 3, 2014).

Civilian Conservation Corp Legacy. "CCC Brief History." www.ccclegacy. org/CCC_brief_history.html (accessed March 1, 2014).

Civil War Trust. "Saving America's Civil War Battlefields: John C. Frémont." http://www.civilwar.org/education/history/biographies/john-c-Fremont. html (accessed January 11, 2014).

Clarke, Ida Clyde. "American Women and the World War." New York, London: D. Appleton and Co. 1918. http://www.gwpda.org/wwi-www/ Clarke/Clarke17.htm. (accessed January 22, 2014).

Clements, Joseph M. "Oral History Interview with George Salvador." Douglas County History Research Center Oral Histories, January 18, 2013. Accession number 2013.003. http://douglascountyhistory.org/cdm/ singleitem/collection/doh/id/95/rec/3 (accessed November 30, 2013).

CNN Money. "Fastest Growing U.S. Counties." http://money.cnn. com/galleries/2010/real_estate/1006/gallery.fastest_growing_US_ counties/10.html (accessed February 13, 2014).

Colorado Division of the Sons of Confederate Veterans. "Colorado and the War." http://www.coloradoscv.org/articles/Colorado%20and%20 the%20War.htm (accessed January 11, 2014).

Colorado Renaissance Festival. "2013 Fact Sheet." www.coloradorenaissance. com (accessed April 22, 2014).

Colorado State Archives. "CO History Chronology." https://www.colorado. gov/pacific/archives/co-history-chronology (accessed April 15, 2014).

Crow Canyon Archaeological Center. "Peoples of the Mesa Verde Region." http://www.crowcanyon.org/peoplesmesaverde (accessed April 15, 2014).

Denver Post. "List of All Colorado's World War I Dead Is Compiled." August 2, 1929. Denver Library Digital Collection, Western History Department. http://www.history.denverlibrary.org/research/co_wwi_casualties.html (accessed December 29, 2013).

———. "Men Called to the Colors in Counties Outside Denver: Position in List of Names Indicated the Probability of Immediate Service in Army." July 21, 1917. Denver Library Digital Collection, Western History Department. http://digital.denverlibrary.org/cdm/ref/collection/p16079coll20/ id/14209 (accessed December 10, 2013).

Denver Public Library. "The Influenza Pandemic of 1918 in Colorado." http://History.denverlibrary.org/blog/content/influenza-pandemic- 1918-colorado (accessed December 10, 2013).

Denver's Mountain Parks, Information Pages. "Daniel's Park." http:// mountainparkshistory.org/Parks/daniels.html (accessed December 23, 2013).

Department of Interior. National Park Services. "Sand Creek Massacre National Historic Site, Resource Bulletin." http://www.nps.gov/sand/historyculture/upload/Combined-Letters-with-Sign-2.pdf (accessed February 5, 2014).

Douglas County, Colorado. Historic Preservation. County Landmarks. "American Federation of Human Rights." http://www.douglas.co.us/historic/county-landmarks/american-federation-of-human-rights/ (accessed December 12, 2013).

———. "Frink House." http://www.douglas.co.us/historic/county-landmarks/frink-house (accessed March 23, 2014).

———. "Louviers Village Club." http://www.douglas.co.us/historic/county-landmarks/louviers-village-club (accessed January 25, 2014).

———. "Schweiger Ranch." http://www.douglas.co.us/historic/county-landmarks/schweiger-ranch (accessed April 15, 2014).

Douglas County, Colorado, Official Website. "Douglas County Colorado, Board of County Commissioners." http://www.douglas.co.us/commissioners (accessed February 13, 2014).

Douglas County, Colorado. "State Parks and Pike National Forest: Castlewood Canyon State Park." http://www.douglas.co.us/dcoutdoors/state-parks-and-pike-national-forest (accessed December 10, 2013).

Douglas County, Colorado Veterans Monument Foundation, Official Website. http://www.dcvmf.org/ (accessed April 3, 2014).

Douglas County Coroner, Official Website. http://douglascountycoroner.com (accessed February 11, 2014).

Douglas County History Repository. "Prehistoric Occupations of Cherry Creek: 9000 Years on the Creek." http://www.douglas.co.us/museum/vexx11/index.htm (accessed April 14, 2014).

Douglas County History Research Center. "Douglas County High School Graduation by Year, 1899–1964." www.douglascountyhistory.org/cdm/singleitem/collection/documents/id/76/rc/3 (accessed March 3, 2014).

———. "Douglas County History Timeline." http://douglascountyhistory.org/timeline (accessed May 13, 2013).

———. "Events and Topics." http://douglascountyhistory.org/cdm/topics (accessed April 30, 2014).

———. "Historic Schools of Douglas County." http://douglascountyhistory.com/schools/index.htm (accessed March 31, 2014).

Douglas County Libraries. "Philip S. Miller Library." http://douglascountylibraries.org/Locations/PhilipSMillerLibrary (accessed February 11, 2014).

Douglas County Open Space. "Cherokee Ranch Conservation Easement." douglas.co.us/openspace/Cherokee-ranch (accessed December 12, 2013).

Douglas County School District. "About Douglas County School District." https://www.dcsdk12.org/district/about-douglas-county-school-district (accessed March 3, 2014).

Douglas County Sheriff, Official Website. http://www.dcsheriff.net/ (accessed February 11, 2014).

Douglas County Television. *Landmarks*. 2nd ed. DVD (2001–09). www.TheNetworkDC.us.

Felsburg, Holt & Ullevig. "Douglas County 2020 Transportation Plan." http://www.douglas.co.us/engineering/documents/douglas-county-2020-transportation-plan.pdf (accessed February 13, 2014).

"Flying Coffins." Waco CG-4A combat glider. https://www.asme.org/engineering-topics/articles/aerospace-defense/the-flying-coffins-of-world-war-ii (accessed November 30, 2013).

"Fly'n B House History and Renovation Considerations." http://highlandsranch.org/wp-content/uploads/2013/03/Open-House-Fact-Sheet-for-web_v2.pdf (accessed April 6, 2014).

ForecastChart.com. "Historical Oil Prices: 1956 to Present." http://www.forecast-chart.com/chart-crude-oil.html (accessed March 15, 2014).

Forstall, Richard L., ed. U.S. Bureau of the Census. "COLORADO Population of Counties by Decennial Census: 1900 to 1990." http://www.census.gov/population/cencounts/co190090.txt (accessed April 15, 2014).

Hewit Institute, University of Northern Colorado. *Doing History/Keeping the Past: Essays on Colorado History and Historic Preservation*. "Indians of Colorado." http://hewit.unco.edu/dohist/teachers/essays/indians.htm (accessed April 15, 2014).

Historic Douglas County, Inc. "Douglas County Venues on the State and County Registers." http://www.historicdouglascounty.org/douglas-county-venues-on-the-state-and-county-registers (accessed date May 13, 2013).

———. "Nationally Registered Places." http://www.historicdouglascounty.org/nationally-registered-places (accessed April 14, 2014).

History Channel website. This Day in History. "May 9, 1887: Buffalo Bill's Wild West Show Opens." http://www.history.com/this-day-in-history/buffalo-bills-wild-west-show-opens (accessed April 6, 2014).

Indians.org. "Paleo-Indians." http://indians.org/articles/paleo-indians.html (accessed April 16, 2014).

Internal Combustion. "Continental Divide Raceways, Castle Rock, CO." http://rocketcar.blogspot.com/2010/03/continental-divide-raceways-castle-rock.html (accessed April 22, 2014).

Larkspur Historical Society. "American Federation of Human Rights." http://larkspurhistoricalsociety.com/locations/larkspur/amfed (accessed January 10, 2014).

———. "Ft. Washington." http://larkspurhistoricalsociety.org/locations/perrypark/ftwashington.html (accessed March 18, 2014).

———. "Huntsville-Larkspur Timeline: All Events in Chronological Order." www.larkspurhistoricalsociety.org (accessed December 10, 2013).

———. "Spring Valley Cheese Factory." http://larkspurhistoricalsociety.org/locations/springvalley/cheese_factory.html (accessed December 20, 2013).

Library of Congress. "America at the Turn of the Century: A Look at the Historical Context." *American Memory*. http://memory.loc.gov/ammem/papr/nycamcen.html (accessed April 6, 2014).

Livesay, Dowell, ed. "Weekly Newsletter No. 33." *Colorado Council of Defense* (May 1918). www.libcudl.colorado.edu/wwi/pdf/i71730412.pdf (accessed January 22, 2014).

McNamara, Robert. "19 Century History." http://history1800s.about.com/bio/Robert-McNamara-36749.htm (accessed April 15, 2014).

Michlewicz, Chris. "Chambers Reservoir Nearly Ready for Water." http://parkerchronicle.net/stories/Chambers-Reservoir-nearly-ready-for-water,51314 (accessed February 13, 2014).

National Archives & Records Administration. National Industrial Recovery Act 1933. U.S. (2014). www.ourdocuments.gov/doc.php?flash=true&doc=66/ (accessed March 1, 2014).

"Niobrara Shale—Niobrara Oil Formation—Niobrara Shale Map." http://oilshalegas.com/niobrarashale.html (accessed February 13, 2014).

PBS. American Experience. "The New Deal." http://www.pbs.org/wgbh/americanexperience/features/general-article/dustbowl-new-deal (accessed February 13, 2014).

———. American Experience. "The Works Progress Administration." http://www.pbs.org/wgbh/americanexperience/features/general-article/dustbowl-wpa (accessed February 13, 2014).

———. "New Perspectives on the West, Archives 1856–1868." http://www.pbs.org/weta/thewest/resources/archives/four/sandcrk.htm (accessed February 5, 2014).

Perrault, Michael. "Highlands Ranch at 25." *Denver Business Journal.* http://www.bizjournals.com/denver/stories/2006/01/16/story3. html?page=all (accessed March 15, 2014).

Peterson, Mary. "John Long Routt." 100 Years of Conservation and Public Service on the Routt National Forest. Territorial Governors Collection, Colorado State Archives Website. http://www.fs.usda.gov/Internet/ FSE_DOCUMENTS/stelprdb5172965.pdf.

Prohibition: A Film by Ken Burns and Lynn Novick. "Roots of Prohibition." www. pbs.org/kenburns/prohibition/roots-of-prohibition (accessed January 20, 2014).

———. "Unintended Consequences." By Michael Lerner. http://www.pbs. org/kenburns/prohibition/unintended-consequences (accessed January 20, 2014).

Record-Journal. Advertisement. December 12, 1941. http://www. coloradohistoricnewspapers.org (accessed November 11, 2013).

———. Advertisement. October 9, 1942. http://www. coloradohistoricnewspapers.org (accessed November 11, 2013).

———. "All for All Colorado." August 21, 1925. www. coloradohistoricnewspapers.org (accessed January 10, 2014).

———. "American Legion Will Give Dance at Franktown." April 22, 1938. www.coloradohistoricalnewspapers.com (accessed January 22, 2014).

———. "Castle Rock Streets Are Being Improved by W.P.A. Workers." June 12, 1936. www.coloradohistoricalnewspapers.com (accessed January 22, 2014).

———. "Castlewood Dam." August 6, 1897. www. coloradohistoricnewspapers.org (accessed January 22, 2014).

———. "Castlewood Dam Is Washed Out by Cloudburst." August 4, 1933 www.coloradohistoricnewspapers.org (accessed January 22, 2014).

———. "Colorado Schools Decrease While Pupils on Increase." May 25, 1923. www.coloradohistoricalnewspapers.com (accessed March 1, 2014).

———. "County School Music Festival Will Be Held Next Friday." April 22, 1938. www.coloradohistoricalnewspapers.com (accessed January 22, 2014).

———. "'Diamond Jack' Quit-Claims Douglas County Property." December 24, 1926. www.coloradohistoricnewspapers.org (accessed January 10, 2014).

———. "Directors Close Castle Rock State Bank." November 4, 1932. www.coloradohistoricnewspapers.org (accessed January 22, 2014).

———. "Douglas County Resort Proprietors Are Arrested." June 12, 1931. www.coloradohistoricnewspapers.org (accessed January 10, 2014).

————. "Douglas County Schools Will Hold Track Meet Today." April 22, 1938. www.coloradohistoricalnewspapers.com (accessed January 22, 2014).

————. "Douglas County Woman's Club Sponsors Filed Army Campaign." April 22, 1938. www.coloradohistoricalnewspapers.com (accessed January 22, 2014).

————. "Free Traveling Libraries in Colorado." June 20, 1913. www.coloradohistoricnewspapers.org (accessed January 20, 2014).

————. "Held Up on the Streets of Castle Rock." May 2, 1913 www.coloradohistoricnewspapers.org (accessed January 10, 2014).

————. "Hill Top Social Club Met at Home of Mrs. Nancy Walden." April 22, 1938. www.coloradohistoricalnewspapers.com (accessed January 22, 2014).

————. "Holdups Loot Bank at Parker after Banking Hours on Tuesday." December 2, 1921. www.coloradohistoricnewspapers.org (accessed January 10, 2014).

————. "Home Guard to be Organized." July 20, 1917. www.coloradohistoricnewspapers.org. (accessed January 22, 2014).

————. "Influenza and Its Treatment." January 4, 1916. www.coloradohistoricnewspapers.org. (accessed January 22, 2014).

————. "It Takes Both." From the U.S. Treasury Department. January 29, 1943. http://www.coloradohistoricnewspapers.org (accessed November 11, 2013).

————. "The Ku Klux Klan Meeting." February 27, 1925. www.coloradohistoricnewspapers.org (accessed January 10, 2014).

————. "Letters From Our Soldier Boys." December 29, 1918 www.coloradohistoricnewspapers.org (accessed December 10, 2013).

————. "Local Stores to Observe New Closing Hours." August 4, 1933. www.coloradohistoricalnewspapers.com (accessed March 1, 2014).

————. "Lt. Bernard Curtis Reported Killed In Line of Duty." November 27, 1942. http://www.coloradohistoricnewspapers.org (accessed Nov. 11, 2013).

————. "Moonshiners Plead Guilty and Penalties Assessed." April 22, 1927. www.coloradohistoricnewspapers.org (accessed January 10, 2014).

————. "Motor Cars and Grade Crossings." November 21, 1924. www.coloradohistoricnewspapers.org (accessed January 10, 2014).

————. "Officers Destroy Big Booze Plant Near Larkspur." March 20, 1931. www.coloradohistoricnewspapers.org (accessed January 10, 2014).

————. "Pouppirts Nabbed on Booze Charges." April 22, 1927. www.coloradohistoricnewspapers.org (accessed January 10, 2014).

————. "Reading Matter for Our Soldiers." September 7, 1917. www.coloradohistoricnewspapers.org (accessed January 22, 2014).

———. "Sheriff and Deputies Hunt for Bootleg and Locate Poker Game." March 24, 1922. www.coloradohistoricnewspapers.org (accessed January 10, 2014).

———. "Sheriff Captures Another Still." October 31, 1924. www.coloradohistoricnewspapers.org (accessed January 10, 2014).

———. "Sheriff Gets Valuable Gift from 'Diamond Jack.'" February 20, 1925. www.coloradohistoricnewspapers.org (accessed January 10, 2014).

———. "Sheriff McKissack Nabs Big Still." May 23, 1924. www.coloradohistoricnewspapers.org (accessed January 10, 2014).

———. "A Shudder in Every Line." August 7, 1925. www.coloradohistoricnewspapers.org (accessed January 10, 2014).

———. "Soil Conservation Please Douglas County Ranchers." September 2, 1938. www.coloradohistoricnewspapers.org (accessed March 1, 2014).

———. "Taxpayers Vote Bond Issue for High School Improvement." May 8, 1936. www.coloradohistoricalnewspapers.com (accessed March 1, 2014).

———. "Territorial Road—Daniel's Park Area," December 22, 1875.

———. "This Week in Defense, Arming of Merchant Ships." December 5, 1941 http://www.coloradohistoricnewspapers.org (accessed November 11, 2013).

———. "Veterans' Contingent, Civilian Conservation Corps Is Expanded." May 24, 1935. wwcoloradohistoricnewspapers.org (accessed January 22, 2014).

———. "WPA Sewing Project Ladies Honor Mrs. Prescott." May 8, 1936. www.coloradohistoricnewspapers.org (accessed January 22, 2014).

———. "WPA Workers Finish Bridge Projects; Total Cost, $38,065.46." May 8, 1936. www.coloradohistoricnewspapers.org (accessed January 22, 2014).

Rosenberg, Jennifer. "1900s Timeline: Timeline of the 20th Century." About. com 20th Century History. http://history1900s.about.com.

Rottsweb.com. Douglas County Census Data. http://www.rottsweb. com/~codouglas/censusdata.html (assessed March 28, 2014).

"The Sandcreek Massacre, the Hungate Massacre, June 11, 1864." http://www.kclonewolf.com/History/SandCreek/sc-reports/08time-hungate-massacre.html (accessed February 5, 2014).

Smith, Larry T. *Newland Gulch Gold Mining: Parker Historical Society Brief.* http://parkerhistory.org/#newland (accessed March 10, 2014).

Social Security Administration. "FAQs." www.ssa.gov/history/hfaq.html (accessed February 13, 2014).

"The Southwest Conservation Corps: Overview." http://sccorps.org/about (accessed March 3, 2014).

Town of Castle Rock, Official Website. http://www.crgov.com (accessed February 11, 2014).

———. "History of Castle Rock." http://www.crgov.com/index.aspx?nid=680 (accessed December 23, 2013).

Town of Parker, Official Website. http://www.parkeronline.org/ (accessed February 11, 2014).

University of California–San Diego. "General Overview of the Ice Ages." *Calspace Courses: Climate Change, Past and Future.* http://earthguide.ucsd.edu/virtualmuseum/climatechange2/01_1.shtml (accessed February 10, 2014).

U.S. Department of Commerce. National Oceanic and Atmospheric Administration (NOAA). "Summary of 100,000 Years, Estimate of Total Human Population, 10,000 Years Ago–5,000,000." http://www.ncdc.noaa.gov/paleo/ctl/100k.html (accessed February 1, 2014).

U.S. Department of Health and Human Services. "Snapshot of the World in 1918." *The Great Pandemic: The United States in 1918–1919.* http://ww.flu.gov/pandemic/history/1918/your_state/northwest/colorado/. (accessed January 20, 2014).

Ute Indian. "Tribal History." http://www.uteindian.com/ute_tribal.htm (accessed April 15, 2014).

Van Daele, Xavier. "Louis J. Zoghby." http://www.usairborne.be/Biographie/bio_us_zoghby.htm (accessed March 1, 2014).

Various authors. "Douglas County 2030 Transportation Plan." http://www.douglas.co.us/cmp2030/documents/douglas-county-2030-transportation-plan.pdf (accessed February 13, 2014).

Washington Post. "Highest Income Counties in 2011." http://www.washingtonpost.com/wp-srv/special/local/highest-income-counties (accessed March 4, 2014).

Wikipedia. "Bill Owens: Colorado Politician." http://en.wikipedia.org/wiki/Bill_Owens_%28Colorado_politician%29 (accessed April 2, 2014).

———. "Castle Rock." http://en.wikipedia.org/wiki/Castle_Rock (accessed April 15, 2014).

———. "Colorado T-REX Project (Transportation Expansion)." http://en.wikipedia.org/wiki/Colorado_T-REX_Project_%28TRansportation_EXpansion%29 (accessed February 11, 2014).

———. "Douglas County, Colorado, 2011." http://en.wikipedia.org/wiki/Douglas_County,_Colorado (accessed January 11, 2014).

———. "Franktown Cave." http://en.wikipedia.org/wiki/Franktown_Cave (accessed April 16, 2014).

————. "Gliding." http://en.wikipedia.org/wiki/Gliding (accessed February 10, 2014).

————. "Hayman Fire." http://en.wikipedia.org/wiki/Hayman_Fire (accessed January 9, 2014).

————. "John Long Routt." http://en.wikipedia.org/wiki/John_Routt (accessed April 15, 2014).

————. "John Williams Gunnison." http://en.wikipedia.org/wiki/John_Williams_Gunnison (accessed April 15, 2014).

————. "Mountain Men and the Fur Trade: Sources of the History of the Fur Trade of the Rocky Mountain West." http://en.wikipedia.org/wiki/Rocky_Mountain_Fur_Company (accessed April 15, 2014).

————. "National Register of Historic Places Listings in Douglas County, Colorado." http://en.wikipedia.org/wiki/National_Register_of_Historic_Places_listings_in_Douglas_County,_Colorado (accessed March 12, 2014).

————. "Quaternary Glaciation." http://en.wikipedia.org/wiki/Last_ice_age (accessed February 10, 2014).

————. "Regional Transportation District." http://en.wikipedia.org/wiki/Regional_Transportation_District (accessed February 11, 2014).

————. "Rueter-Hess Reservoir." http://en.wikipedia.org/wiki/Rueter%E2%80%93Hess_Reservoir (accessed February 13, 2014).

————. "Savings and Loan Crisis 1986 to 1995." http://en.wikipedia.org/wiki/Savings_and_loan_crisis. (accessed March 15, 2014).

————. "War on Terror." http://en.wikipedia.org/wiki/War_on_Terror. (accessed March 15, 2014).

————. "Zebulon Pike." http://en.wikipedia.org/wiki/Zebulon_Pike (accessed April 15, 2014).

World's Work. "Education and Success." *Castle Rock Journal*, February 5, 1904. www.coloradohistoricalnewspapers.com (accessed March 1, 2014).

Yogi Bear's Jellystone Camp Resort. http://jellystonelarkspur.com (accessed March 18, 2014).

INDEX

ABOUT THE AUTHORS

CASTLE ROCK WRITERS

Castle Rock Writers is a Colorado 501(c)(3) nonprofit corporation whose vision is to provide education and support for the voices of pre-published and published authors through affordable conferences, workshops and ongoing critique groups, including outreach to young adult writers.

JEAN JACOBSON

Jean Jacobson is the director of the 2014 Castle Rock Writers' Conference, Castle Rock board member and a member of Highlands Ranch Historical Society. She writes nonfiction and fiction and is published in the Your Hub section of the *Denver Post* and *Glen Eagles Village Times*. When not spoiling her grandchildren, she makes and sells vintage fascinators.

ALICE ALDRIDGE-DENNIS

Alice Aldridge-Dennis is an educator and writer living in Castle Rock. Her writing credits include articles on military life, local events and church activities. She is coauthor of *Douglas County, Colorado: A Photographic Journey* (2005), founding director of Castle Rock Writers' Conference (2007–13) and facilitator of two local writing groups. She travels extensively with her husband, Mike, a commercial pilot, and sometimes their grown sons, Luke and Phil. Originally from the St. Louis area, she loves summer musicals at the St. Louis MUNY, antique Victorian furniture and anything British—especially Devonshire cream teas.

TANIA URENDA

Tania Urenda hails from Denver's sister city to the north—Calgary, Alberta, Canada—and she is happy to call Castle Rock her home. She serves on the Castle Rock Writers Board and co-facilitates its workshop group. She writes technical papers associated with her work as a medical technologist. She is a published nonfiction writer and an aspiring fiction writer. Tania holds a BS in medical technology and a BS in cellular, molecular and microbial biology and is a medical technologist (ASCP) for DVAMC.

SUSAN ROCCO-MCKEEL

Susan Rocco-McKeel has a BS in public administration and a juris doctor (law). Susan has been married to her husband, Michael, for over thirty-five years, and their sons, Nicholas and Brandon, are third-generation Coloradans. Susan has worked as an attorney, arbitrator and consultant for educators and board executives. With her love of history, she has taught educators how to integrate it into other core subjects. She is an accomplished poetry, short story and nonfiction writer. She presents workshops on writing at Parker Writers and serves on the Castle Rock Writers Board.

MARK A. COHEN

Mark A. Cohen, has a BA in photography and is a UNIX system administrator and scriptwriter who serves on the Castle Rock Writers Board and the leadership team of Parker Writers. He is an experienced nonfiction writer/blogger and public speaker on political issues, and he is an aspiring fiction writer. He and his wife live in Parker, where they enjoy being close to their adult children and their grandchildren.

JOHN LONGMAN

John Longman is a business owner, management consultant, business writer, nonfiction writer and editor. John has been the president of a public company and facilitated over twenty-five companies to become publicly traded. He has worked for two international CPA and management consulting firms. He is currently active in gas exploration and development. John enjoys traveling and serving on the Castle Rock Writers board. He graduated from Northwestern University in Evanston, Illinois, and was a member of the honorary fraternity Beta Alpha Psi.

DERALD HOFFMAN

Derald Hoffman is a retired high school history teacher who also worked as a news photographer and reporter for many years. Currently, he serves as a naturalist at Roxborough State Park and Castlewood Canyon State Park and as a docent at the historic Highlands Ranch Mansion. He teaches classes on various subjects to retirees at OLLI. He is a published nonfiction author. He is a member of both the Highlands Ranch Historical Society and Castle Rock Historical Society. At one time, he was a Nike guided missile instructor with the U.S. Army. He and his wife reside in Castle Rock.